MASTER PAINTINGS in The Art Institute of Chicago

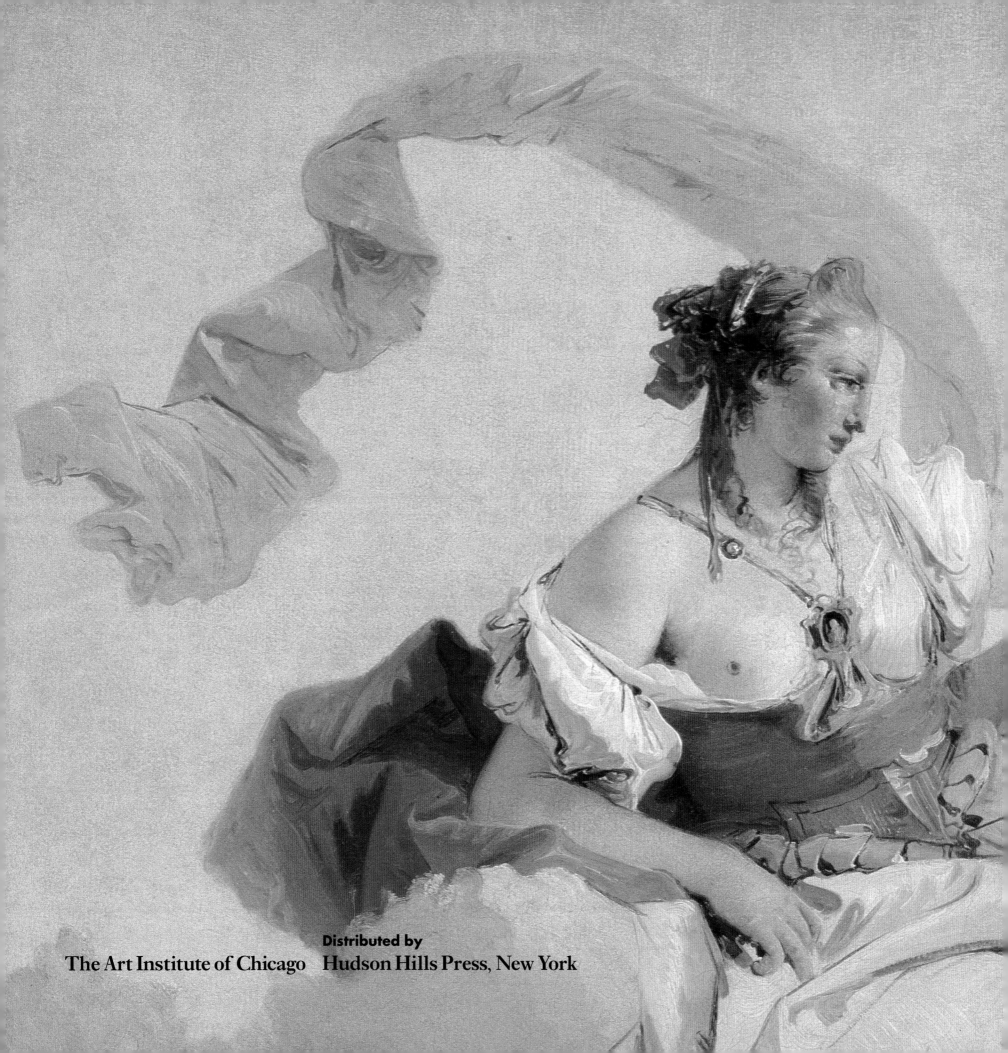

The Art Institute of Chicago Distributed by Hudson Hills Press, New York

MASTER PAINTINGS
in The Art Institute of Chicago

Selected by
James N. Wood, Director
and
Katharine C. Lee, Deputy Director

Executive Director of Publications, The Art Institute of Chicago: Susan F. Rossen

Edited by Susan F. Rossen and Thomas Fredrickson, Publications Intern

Production by Katherine Houck Fredrickson

Photography by the Department of Photographic Services, The Art Institute of Chicago, Alan B. Newman, Executive Director

Designed by Deenie Yudell; mechanical production by Eileen Delson, Los Angeles, California

Typeset in Ehrhardt and Futura by Paul Baker Typography, Inc., Chicago, Illinois

Printed and bound by Arnoldo Mondadori, Verona, Italy

Cover:
Georges Seurat, *Sunday Afternoon on the Island of La Grande Jatte* (detail), 1884-86 (see p. 64).

Frontispiece:
Giovanni Battista Tiepolo, *Rinaldo Enchanted by Armida* (detail), 1742 (see p. 40).

©1988 by The Art Institute of Chicago. All rights reserved. No part of this publication may be reproduced in any manner whatsoever without permission in writing by The Art Institute of Chicago.
Second printing, 1991
Third printing, 1992
Fourth printing, 1995
Fifth printing, 1997

Distributed by Hudson Hills Press, Inc., Suite 1308, 230 Fifth Avenue, New York, N.Y. 10001-7704.

Editor and Publisher: Paul Anbinder

Distribution in the United States, its territories and possessions, and Canada through National Book Network. Distribution in the United Kingdom, Eire, and Europe through Art Books International Ltd. Distribution in Australia through Peribo PTY Limited. Distribution in New Zealand by Nationwide Book Distributors Ltd. Exclusive representation in China through Cassidy and Associates, Inc.

Art Institute of Chicago.
 Master Paintings in the Art Institute of Chicago / selected by James N. Wood and Katharine C. Lee.
 p. cm.
 Includes index.
 ISBN 0-86559-155-5
 1. Painting – Illinois – Chicago – Catalogs.
2. Art Institute of Chicago – Catalogs. I. Wood, James N. II. Lee, Katharine C. III. Title.
N530.A674 1988 750'.74'017311 – dc19
88-9367 CIP

Contents

6 Acknowledgments

7 Introduction

11 European Paintings

73 American Paintings

105 Twentieth-Century Paintings

166 Index of Artists

Acknowledgments

The creation of a book of master paintings in The Art Institute of Chicago was a challenging task. While it was gratifying to be reminded of the richness of our holdings, it was difficult to have to limit our choices when presented with so much to choose from. This book is occasioned by the opening of the Art Institute's Rice Building, which, along with the refurbished Galleries of European Art in the Allerton Building opened in May 1987, permits us to display the museum's entire range of European and American painting, sculpture, and decorative arts for the first time. It was our intent to produce a book that would present not only many of the museum's outstanding European and American paintings but also a balanced view of the styles and eras found in the Art Institute's collection.

In selecting the works to be included in *Master Paintings in The Art Institute of Chicago*, we are grateful to have had the counsel of the curators of the departments represented here: Richard R. Brettell, Searle Curator of European Painting; Martha Wolff, Curator of European Painting before 1750; Milo M. Naeve, Field-McCormick Curator of American Arts; Neal Benezra, Curator, and Courtney Donnell, Associate Curator of Twentieth-Century Painting and Sculpture. These individuals also reviewed the text, as did Jane H. Clarke, Assistant Director, Special Projects, Department of Museum Education.

Special thanks is owed to the authors who produced the concise, informative texts that accompany the illustrations: Catharine Bock, Courtney Donnell, Thomas Fredrickson, Jean Goldman, Mary Gray, Ann Morgan, Dennis Nawrocki, Terry Ann R. Neff, Susan F. Rossen, Steve Sennott, Thomas L. Sloan, Malcolm Warner, Lynne Warren, Martha Wolff, and James Yood.

The task of organizing, editing, and preparing the text for this book belonged to Susan F. Rossen, Executive Director of Publications, and Thomas Fredrickson, Publications Intern. Production Coordinator Katherine A. Houck was responsible for its production. The elegant design is by Deenie Yudell, Los Angeles; she was assisted by production artist Eileen Delson. Photography was provided by the Department of Photographic Services; we are grateful to Alan B. Newman, Terry E. Schank, Tom Cinoman, Chris Gallagher, and Julie Zeftel.

We also are grateful to Larry Ter Molen, Vice-President for Development; Marija Raudys, Executive Director of Marketing; Robert Mars, Vice-President for Administrative Affairs; and Barry Swenson, Assistant Vice-President for Administrative Affairs, for all their help in developing this book. We also wish to acknowledge the invaluable assistance of the Trustee Advisory Subcommittee on Publications, chaired by Peter Mollman.

James N. Wood, Director Katharine C. Lee, Deputy Director

Introduction

In the years after the Great Fire of 1871, Chicago's commerce and industry were booming. While there was no shortage of money or entertainment in the city, many citizens recognized a lack of cultural institutions comparable to those in New York and Boston. Several prominent Chicagoans had a vision of the city and its needs: namely, libraries, a symphony, a university, a museum of science, and an art museum. A group of these citizens came together in 1878 to form a board of trustees for the floundering Academy of Design, which had been established in 1866. Within a year, debts completed the demise of the institution, but out of that failure came the Chicago Academy of Fine Arts, which incorporated with the goals of "the founding and maintenance of schools of art and design, the formation and exhibition of collections of objects of art, and the cultivation and extension of the arts by any appropriate means." To help establish the city as a major cultural center, William M. R. French (brother of sculptor Daniel Chester French) was selected as the institution's first director.

In December 1882, the Academy changed its name to The Art Institute of Chicago, and banker Charles L. Hutchinson was elected the first president of the Board of Trustees. Hutchinson's standing in the community, generosity, and vision established a model for the future leadership of the Art Institute. In 1887, the Art Institute moved from rented rooms on the southwest corner of State and Monroe into a building designed by the Chicago firm Burnham and Root. This Romanesque structure, located on the southwest corner of Michigan Avenue and Van Buren Street, housed school studios, lecture halls, galleries for the Society of Decorative Arts (later the Antiquarian Society), and a display of plaster casts presenting a "comprehensive illustration of the whole history of sculpture," which formed the core of the museum's collections at that time.

In 1888, the Art Institute hosted the first American Exhibition, the beginning of a series of annual (later biennial) shows for the work of living American artists. Among the exceptional paintings that have entered the permanent collection after having been in an American Exhibition are Tanner's *Two Disciples at the Tomb* (p. 109), Wood's *American Gothic* (p. 136), Hopper's *Nighthawks* (p. 142), de Kooning's *Excavation* (p. 148), Warhol's *Mao* (p. 161), and Stella's *Gobba, zoppa e collotorto* (p. 163).

The Art Institute soon outgrew its quarters. As chairman of the Committee of Fine Arts for the 1893 World's Columbian Exposition, Hutchinson arranged for the Art Institute and the Exposition to jointly finance a building that would serve as the hall for the World's Congresses during the fair and then become the new Art Institute afterwards. Designed by the Boston firm Shepley, Rutan and Coolidge, the building, on Michigan Avenue between Jackson and Monroe streets, was completed in May 1893, in time for the opening of the fair. In December, the Art Institute opened in this Beaux-Arts-style building, which it continues to occupy.

While the Art Institute's collection of plaster casts was one of the largest of its type in the country, from the

beginning it was intended that the museum collect actual masterpieces in all periods and styles. Lacking funds, the institution had to rely upon gifts and loans of art and money from private collectors and patrons. Fortunately, Chicago collectors active in the late nineteenth century were blessed with the means and the taste to assemble some of the finest private collections in the United States at that time. In 1895, Hutchinson, Martin Ryerson, and other private donors seized the opportunity to make a purchase specifically for the museum. Thirteen works by Dutch masters were acquired from the collection of Prince Anatole Demidoff, including Hobbema's *Wooded Landscape with a Water Mill* (p. 36) and van Ostade's *Merrymakers in an Inn* (p. 37). A second seminal acquisition was made just over a decade later, in 1906. Convinced by the enthusiasm of artist Mary Cassatt (see p. 99) for the central portion of an early altarpiece by El Greco that had come on the market, Hutchinson and Ryerson arranged the purchase of *The Assumption of the Virgin* (p. 23) with private contributions. A gift in 1915 from Nancy Atwood Sprague allowed the temporary donors to be reimbursed. El Greco's *Assumption* is still considered by many to be the greatest single work in the museum.

The Friends of American Art was founded in 1910 with the goal of purchasing the work of living American artists. Soon, however, the organization was acquiring works of all styles from all periods. Purchases include Stuart's *Major-General Henry Dearborn* (p. 77), Cole's *Niagara Falls* (p. 82), Homer's *Croquet Scene* (p. 84), Kensett's *Coast at Newport* (p. 87), Eakins's *Mary Adeline Williams* (p. 104), and Glackens's *Chez Mouquin* (p. 107).

The Art Institute continued its support of contemporary art when, in 1913, it hosted the landmark "International Exhibition of Modern Art," known as the Armory Show. It inspired Chicagoan Arthur Jerome Eddy (see p. 103) to buy works for what was to become a pioneering collection, some of which was given to the museum in 1931. Included in Eddy's bequest was Wassily Kandinsky's *Improvisation with Green Center* (p. 119). The Art Institute's commitment to modern art intensified in the 1920s. In 1921, Joseph Winterbotham, a Chicago businessman, donated $50,000 to be invested and used as capital for the purchase of European paintings. The unique stipulation of the Winterbotham plan was that only thirty-five paintings should be purchased; once this number was reached, any painting could be sold or exchanged to acquire a work of superior quality or significance. This farsighted gift has resulted in the purchase of some of the museum's most important modern works, including van Gogh's *Self-Portrait* (p. 63), Léger's *Follow the Arrow* (p. 126), Miró's *Portrait of a Woman* (p. 125), Delaunay's *Champs de Mars* (p. 116), Chagall's *Praying Jew* (p. 130), Magritte's *Time Transfixed* (p. 140), Balthus's *Patience* (p. 144), and Dubuffet's *Genuflection of the Bishop* (p. 153).

In 1922, one of the first major bequests from a private collector entered the museum. Mr. and Mrs. Potter Palmer began their collection in the 1880s with works by living American artists, and their interests remained resolutely modern. Mrs. Palmer's attention turned to French painting and the works of Jean Baptiste Corot, Eugène Delacroix, and others; eventually, she discovered the Impressionists. On annual trips to France between 1888 and 1895, she acquired the majority of the Impressionist works in her collection. The Palmers loaned many works to the Art Institute; after Mrs. Palmer's death in 1916, the museum selected a group of paintings, according to the generous terms of her will. This gift, which helped to establish the Art Institute's pre-eminence in nineteenth-century French art, included Corot's *Interrupted Reading* (p. 51), Monet's *On the Seine at Bennecourt* (p. 54), and Renoir's *Two Little Circus Girls* (p. 61).

The Helen Birch Bartlett Memorial Collection was given to the Art Institute late in 1926 by Frederic Clay Bartlett in memory of his second wife. It contained such works as Seurat's *Sunday Afternoon on the Island of La Grande Jatte* (p. 64), Picasso's *Old Guitarist* (p. 108), Modigliani's *Jacques and Berthe Lipchitz* (p. 123), and Matisse's *Woman before an Aquarium* (p. 129). A few years later, Bartlett added such masterpieces as van Gogh's *Bedroom at*

Arles (p. 66), Toulouse-Lautrec's *At the Moulin Rouge* (p. 70), and Cézanne's *Basket of Apples* (p. 69). With this extraordinary group of paintings mounted in a single room, the Art Institute became the first American museum to feature a gallery of Post-Impressionist art, three years before the opening of the Museum of Modern Art, New York, in 1929. Another benefactor who greatly augmented the museum's collection of nineteenth-century French art was Mrs. Lewis Larned Coburn, whose 1933 bequest included Degas's *Uncle and Niece* and *The Millinery Shop* (pp. 57, 60), Manet's *Reader* (p. 62), Gauguin's *Old Women of Arles* (p. 67), and Monet's *Japanese Bridge at Giverny* (p. 72).

In 1933, the Art Institute received the bequest of Mr. and Mrs. Martin A. Ryerson. Their collection ranks as the greatest gift ever to enter the museum. Unlike other private collections, the Ryersons' reflected the breadth of all of Western art. The bequest included textiles, European decorative arts and sculpture, prints and drawings, and over 227 European and American paintings. Among them are a suite of panels by Giovanni di Paolo (see pp. 14-15); another series by an unknown French artist from Picardy (see pp. 16-17); Hey's *Annunciation* (p. 19); Renoir's *Woman at the Piano* (p. 56); Monet's *Arrival of the Normandy Train at the Gare Saint-Lazare* (p. 59); Homer's *Herring Net* (p. 89); and Sargent's *Venetian Glass Workers* (p. 91).

Charles H. and Mary F. S. Worcester built their collection to correspond to the needs of the Art Institute's holdings. Among the works by German and Italian masters the Worcesters gave to the museum between 1925 and 1947 are Moroni's *Gian Lodovico Madruzzo* (p. 22), Manfredi's *Cupid Chastised* (p. 26), Rubens's *Wedding of Peleus and Thetis* (p. 29), and Piazzetta's *Pastoral Scene* (p. 39). The fund established by the Worcesters has resulted in the purchase of Snyders's *Still Life with Dead Game, Fruits, and Vegetables in a Market* (p. 31), Largillière's *Self-Portrait* (p. 38), and Caillebotte's *Paris, a Rainy Day* (p. 58).

Since the founding of the museum, paintings had been hung according to the collector who had loaned or given them regardless of historical or stylistic considerations, which emphasized the role of the individual patron. In 1933 and 1934, the Art Institute hosted two large-scale exhibitions that changed this. Organized by director Robert B. Harshe and consisting of works from the Art Institute and from private and public collections from around the world, the shows were held in concert with the "Century of Progress" exposition held in Chicago and proved to be the museum's first real international success, attracting over 700,000 visitors. Their lasting significance for the Art Institute, however, lay in the purely geographical and chronological manner in which the works of art were grouped in the galleries. Though he was director during the decade when many of the most important collections came to the museum, and though he played a critical role in assuring their arrival, Harshe's redistribution demonstrated the effectiveness and sense of an historical arrangement of the museum's holdings and ended the era of the Art Institute as an assembly of private collections.

In 1940, a new auxiliary organization, the Society for Contemporary American Art, was formed in response to the success of the Winterbotham Fund, which acquired only works by foreign artists, and the demise of the Friends of American Art. The organization's original intent was to purchase only contemporary American paintings for the permanent collection; in 1968, the group voted to include European art in its interests and changed its name to the Society for Contemporary Art. Among the paintings it has acquired for the museum are Sheeler's *Artist Looks at Nature* (p. 143), Pollock's *Grayed Rainbow* (p. 149), and Golub's *Interrogation II* (p. 164). An important source for the Art Institute's collections has been right within its walls: the School of the Art Institute. Among the artists who attended the School, maintained a close relationship with the museum, and whose art later assumed a prominent place in the permanent collection are Georgia O'Keeffe (see p. 133), Grant Wood (see p. 136), Ivan Albright (see p. 135), and Leon Golub (see p. 164).

For the first seventy-five years of the Art Institute's existence, the director of the museum also acted as curator of paintings, reflecting the primacy of the paintings collection. After joining the museum staff in 1927, Daniel Catton Rich was named director in 1938. Rich's distinguished tenure included outstanding scholarship (his monograph on Seurat's *Grande Jatte* was one of the first books ever devoted to the study of a single work), important exhibitions (O'Keeffe, 1943; Cézanne, 1952), and significant acquisitions (he was primarily responsible for forming the Coburn and Worcester collections). In the 1950s, the growth of the museum's collections, increasing specialization in the art world, and greater interest in modern art led to a number of changes. In 1954, Frederick A. Sweet and Katharine Kuh were appointed Curator of American Paintings and Sculpture and Curator of Modern Paintings and Sculpture, respectively. Kuh acquired for the museum such important works as Picasso's *Mother and Child* (p. 131), Picabia's *Edtaonisl* (p. 118), Matisse's *Bathers by a River* (p. 124), and Beckmann's *Self-Portrait* (p. 141).

By the end of the 1960s, an autonomous Department of Twentieth-Century Painting and Sculpture had been formed. In 1975, the evolution of the paintings collection into three branches was completed with the formation of a Department of American Arts. The tripartite division — European Painting, American Arts, and Twentieth-Century Painting and Sculpture — continues today and is reflected in the organization of this book. These departments carry on the tradition of collecting the finest paintings available for the Art Institute, sustained by the generosity of a new generation of collectors and donors. The works contained in *Master Paintings in The Art Institute of Chicago* reflect the vision and ambition — shaped and maintained by Chicago collectors and museum curators, directors, and trustees — that have helped the Art Institute grow, since its founding more than a century ago, from an outpost of culture on the Midwestern prairie to one of the world's great museums.

European Paintings

Bernardo Martorell

Spanish, c. 1400 - 1452

Saint George Killing the Dragon, 1430/35.

Tempera on panel.

61⅛ x 38⁹⁄₁₆ in./155.3 x 98 cm.

Gift of Mrs. Richard E. Danielson,

Mrs. Chauncey McCormick, 1933.786.

As a model of Christian knighthood, Saint George was a very popular figure in the late Middle Ages. The most frequently represented scene from his legend was the episode in which he saved a town threatened by a dragon, at the same time rescuing the beautiful princess who was to be sacrificed to the beast. Bernardo Martorell, the greatest Catalan painter of the first half of the fifteenth century, included a wealth of details in his version of the scene: animal and human bones litter the fore-ground; lizards — or perhaps baby dragons — crawl around the crevice where the dragon lives; the princess's parents and throngs of onlookers crowd the town's battlements to view the action, while neatly cultivated fields give a sense of the more ordinary life of the town.

Catalonia, the region of Spain on the Mediterranean bordering France, was particu-larly open to outside influences. Martorell's panel reflects French, Flemish, and northern Italian currents of the elegant manner known as the International Gothic style. *Saint George Killing the Dragon* was the central panel of an altarpiece devoted to the saint and was originally surrounded by four smaller panels (Musée du Louvre, Paris). Its rich narrative detail is un-usual for a Catalan altarpiece, since, more typi-cally, the saint was depicted in a rigid, frontal manner as a cult figure (an object used in the performance of religious rituals). Catalan paintings often incorporated raised stucco decoration, which Martorell applied here with wonderful inventiveness to model the armor, halo, and the scaly body of the dragon.

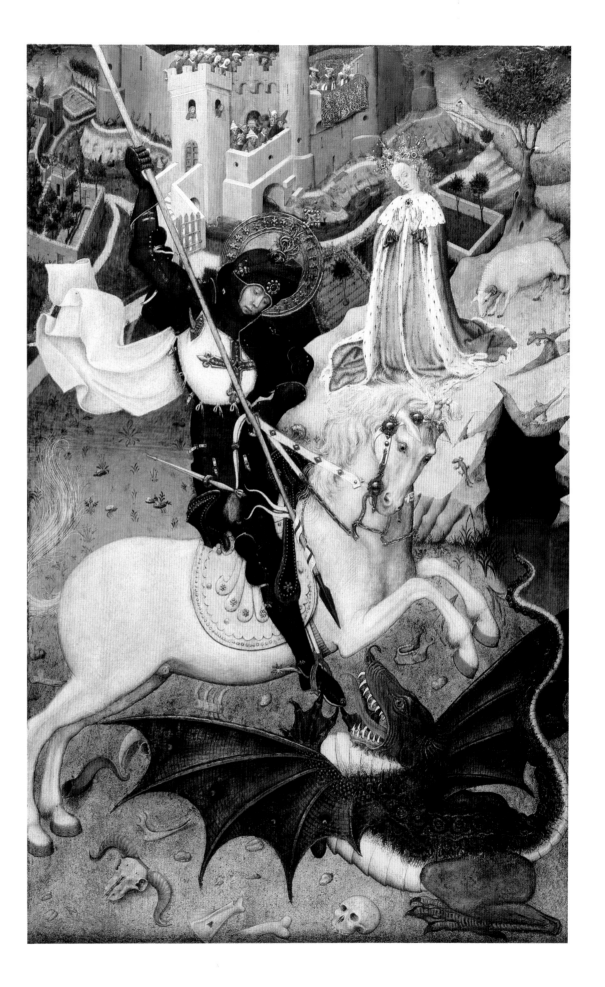

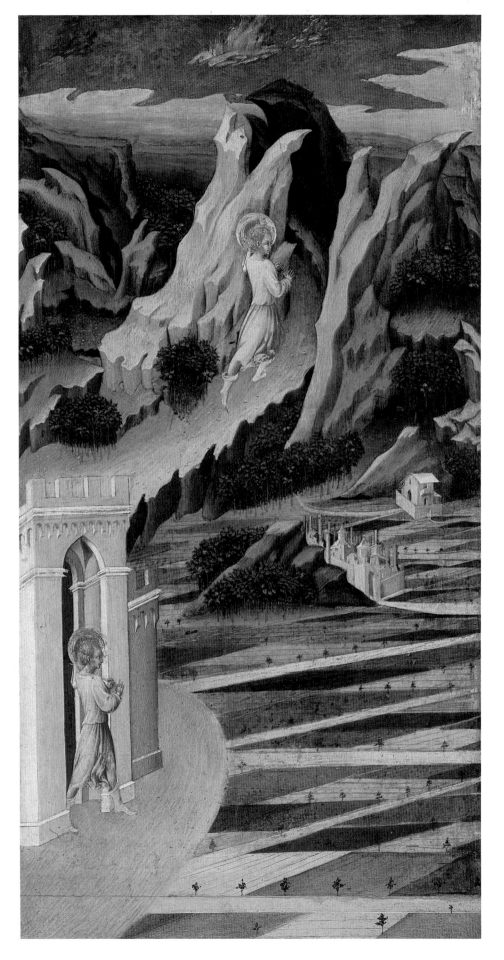

Giovanni di Paolo

Italian, c. 1402 - c.1482

Saint John the Baptist in the Wilderness,
1450/60.

Tempera on panel.

27 x 14¼ in. /68.6 x 36.3 cm.

Mr. and Mrs. Martin A. Ryerson Collection,
1933.1010.

The Beheading of Saint John the Baptist,
1450/60.

Tempera on panel.

27¹/₁₆ x 15³/₈ in. /68.7 x 39.1 cm.

Mr. and Mrs. Martin A. Ryerson Collection,
1933.1014.

Giovanni di Paolo was probably the most important painter working in Siena in the fifteenth century. The combination of emotion and decorative poetry in his work is an individual extension of the great tradition of fourteenth-century Sienese painting. *Saint John the Baptist in the Wilderness* and *The Beheading of Saint John the Baptist* are two of twelve scenes from the life of the saint, which must have been Giovanni di Paolo's most impressive narrative work.

Eleven of the original twelve panels survive: six in the Art Institute and the remainder scattered in various European and American collections. From the shape and condition of the panels, it is clear that they were arranged in two large, movable wings, each with two groups of scenes disposed in three registers, the panels of the upper register all having arched tops. The function of these wings is not clear: they may have been framed in a niche with a sculpted figure of John the Baptist, or they may have formed the doors of some sort of reliquary shrine.

John the Baptist was the cousin of Jesus and the last in a long line of prophets who, according to the Gospel account, foretold Christ's com-

ing. With a wonderful feeling for detail and for the rhythm of the story, Giovanni di Paolo related the circumstances of John's birth to the elderly Elizabeth, his departure for a hermit's life in the wilderness, his prophesy of Christ's coming, his baptism of Jesus, and his beheading as a result of the scheming of Queen Herodias and her daughter Salome (see also p. 34). These scenes are enacted in complex settings that exploit the tall, slender proportions of the panels and set off the elegant poses of the figures. To unite the narrative, the artist made masterful use of repeated figures and settings. Thus, the geometrically patterned fields and jagged mountains of *Saint John the Baptist in the Wilderness* extend across two other panels from the same wing, and the elegant little prison in which John is confined in *The Beheading of Saint John the Baptist* is repeated in another of the Art Institute's panels. This scene gains in intensity from such exaggerated effects as the elongated neck and spurting blood of the decapitated prophet.

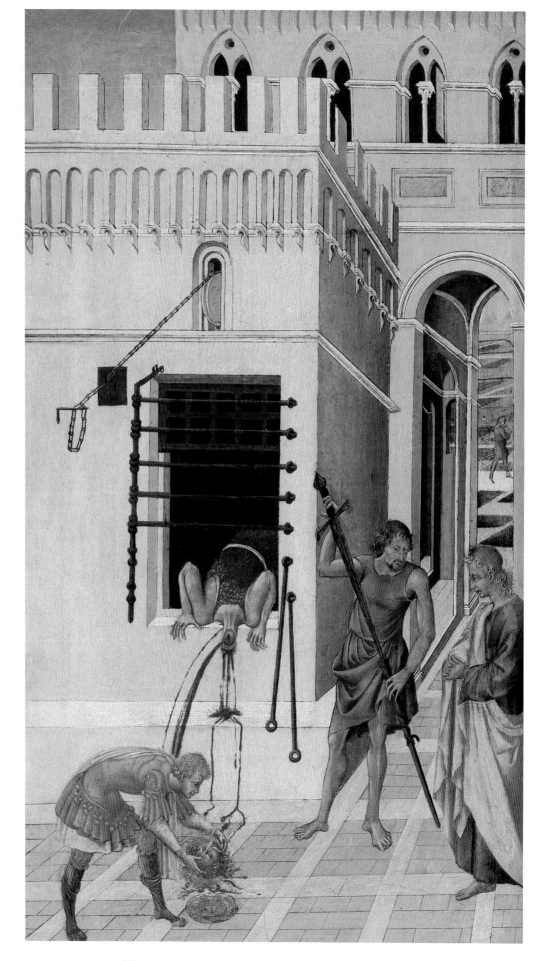

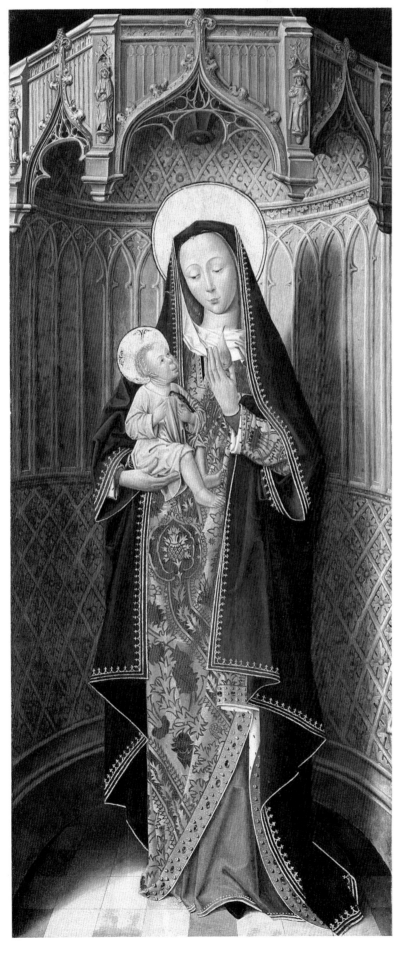

French (Picardy)

Madonna and Child, 1490/95.
Oil on panel.
46³/₁₆ x 20 in. /117.3 x 50.8 cm.
Mr. and Mrs. Martin A. Ryerson Collection,
1933.1054.

The Last Supper, 1490/95.
Oil on panel.
46¹/₈ x 20 in. /117.2 x 50.9 cm.
Mr. and Mrs. Martin A. Ryerson Collection,
1933.1056.

Large altarpieces combining sculpture, gilded decoration, and painting adorned churches in France, Germany, and the Netherlands in the late Middle Ages. Their lofty forms frequently dominated the church nave. Because they could be opened or closed to celebrate the seasons and holy days of the church year and because they contained both cult figures and instructional narratives, altarpieces played an important role in the religious life of the community.

The altarpiece that once dominated the church of the Charterhouse of Saint-Honoré in Thuison-les-Abbeville, France, was the chief monument of a local painting style in the region of Picardy in northern France. The altarpiece was dismantled in the late eighteenth century, and seven of the main painted scenes eventually found their way to the Art Institute (an eighth is in the Hermitage, Leningrad). These scenes formed wings that could be opened to reveal a splendid carved and gilded Crucifixion scene in the center of the altarpiece. The brightly colored narrative paintings of the Passion of Christ — the entry into Jerusalem, Last Supper, Ascension, and Pentecost — were visible on feast days when the altarpiece was open. The somber figures standing in niches on the reverse of the panels were visible when the wings were closed and depicted the saints that were the

patrons of the monastic community, the most important of them being the Virgin Mary. These figures were later split from the narrative scenes so that they could be displayed separately.

These panels are remarkable for their fresh variations on the sophisticated style of neighboring Netherlandish painters. The long face and arched brows of the Madonna reflect the influence of painters like Rogier van der Weyden and Dieric Bouts (see p. 18), but their precise delineation and doll-like quality are expressive of the provincial directness of this anonymous northern French artist. In *The Last Supper*, the arrangement of the figures, even the dog and the bread basket, is taken from a Netherlandish engraving, yet it is the forceful variations on this model — the drastic foreshortening of the table, canopy, and view out the window; the emphatic gestures and abrupt profile poses; the play of lively color and areas of flat pattern — that give the image its impact.

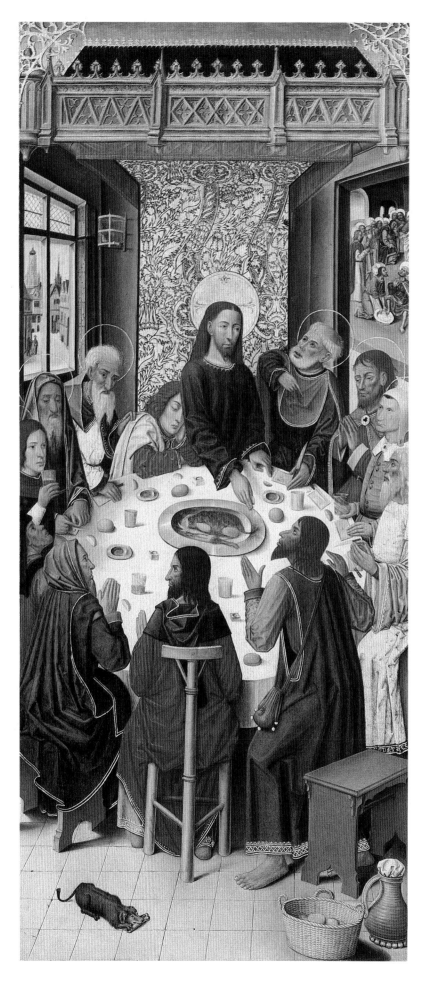

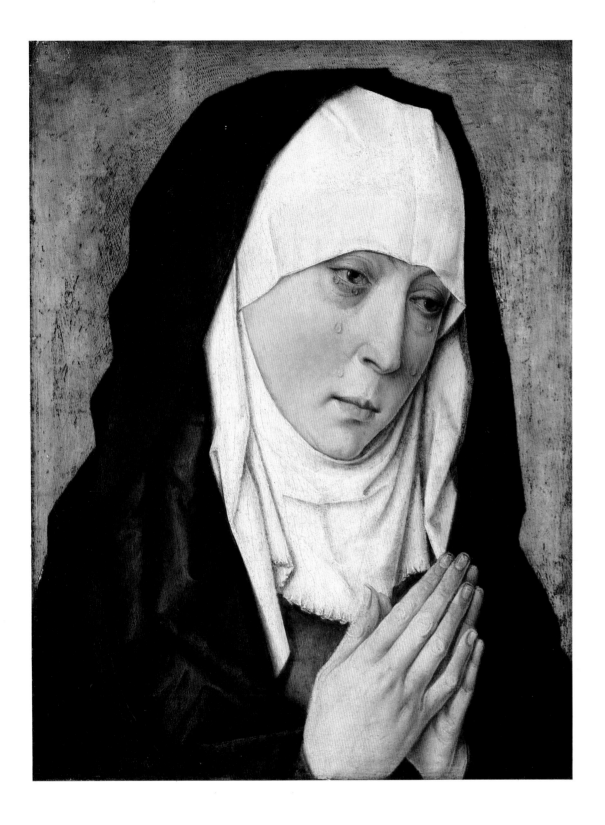

Dieric Bouts

Netherlandish, c. 1420-1475
Mater Dolorosa, c. 1460.
Oil on panel.
15¼ x 12 in. /38.8 x 30.4 cm.
Chester D. Tripp Endowment, Chester D.
Tripp Restricted Gift funds; Max and Leola
Epstein Fund by exchange, 1986.998.

In northern Europe, the fifteenth century was a time of transition from the Middle Ages to the Renaissance. The great Netherlandish painters, including Dieric Bouts, combined traditional forms expressing medieval piety with sensitive observation of the natural world to create new, movingly human devotional images. Outstanding among these is Bouts's *Mater Dolorosa,* a painting that struck a particularly responsive chord in its own time, to judge by the many contemporary copies made after it.

By focusing on the head and hands of the Virgin against a simple gold background, Bouts gave the painting the detached and timeless quality of an icon. This quality would certainly have been intensified by the lost frontal image of Christ crowned with thorns with which it was originally paired. According to Catholic theology, the Virgin is the chief intercessor with Christ for the salvation of mankind. With her gently elongated features swathed in simple and somber drapery, the Virgin is removed from a specific time and place. What Bouts has projected with great specificity is her emotional state, her eyes brimming over with tears and her tender, absorbed gaze as she contemplates her son's sufferings. The exquisite sensitivity of the effects of light and surface reveal an eagerness for a direct and personal experience of God, concerns that would characterize the Renaissance.

Jean Hey
(The Master of Moulins)

French, active c. 1490 - 1510
The Annunciation, c. 1500.
Oil on panel.
28⅜ x 19¾ in. / 72 x 50.2 cm.
Mr. and Mrs. Martin A. Ryerson Collection,
1933.1062.

The Netherlandish painter Jean Hey was employed by the regents of France, Pierre de Bourbon and Anne de Beaujeu, at their court in Moulins. While reliant on themes of the late Middle Ages, his art nevertheless displays a self-consciousness and an interest in antiquity that belong to the emerging Renaissance. In this painting, the archangel Gabriel tells Mary the news of Christ's coming birth in a richly carved and vaulted chamber whose stone ornamentation recalls the vocabulary of the ancient world. The aloof expressions of Gabriel and Mary and their controlled gestures link them to Hey's portraits of princes and princesses of the French court. At the same time, his Flemish background is evident in the careful rendering of Gabriel's silk robes and of the shadows in the room.

The Annunciation is not an independent work. Rather, it seems to have formed the right end of a long panel with scenes honoring the Virgin Mary, including scenes of her parents, Joachim and Anne (National Gallery, London), and a central section of the Virgin and Child enthroned (now lost). This form explains an awkwardness in the composition of the Art Institute's panel: Hey compressed the action so that Mary looks and gestures modestly toward what would have been the focus of the altarpiece, the image of herself enthroned. The glowing colors, complex light effects, and elegantly observed figures of *The Annunciation* and other works by Hey make him the finest painter at the end of the fifteenth century in France.

Correggio (Antonio Allegri)
Italian, c. 1494 - 1534
Virgin and Child with
Saint John the Baptist, c. 1515.
Oil on panel.
25¼ x 20¹⁄₁₆ in. / 64.2 x 51 cm.
Clyde M. Carr Fund, 1965.688.

Correggio lived and worked in the provincial city of Parma, executing a body of work that is remarkable for its inventiveness and sophistication, given his remoteness from the great artistic centers of Renaissance Italy. This small panel, executed when Correggio was only about twenty years of age, was intended for use as a private devotional object.

The handling of the light, color, and form reveal an artist searching for his own personal style. The somewhat angular drapery, gold ornament, brightly contrasting colors, and strong overall lighting refer back to the art of the preceding generation of northern Italian artists. On the other hand, the pyramidal structure of the figures and the softness and fullness of the forms show the influence of the High Renaissance styles of artists such as Leonardo and Raphael. Correggio's own sensibility can be seen in the tenderness of the figures for one another — conveyed through glance and gesture — the gentle sensuousness of the forms, and the overall poetic mood.

Adding to the charm of the panel is the exquisite painting of the details and the landscape beyond. The expressive and idyllic quality of this painting would become more pronounced in Correggio's mature work.

Jan Sanders van Hemessen

Netherlandish, c. 1500 - c.1575

Judith, c. 1540.

Oil on panel.

39¼ x 30⁷⁄₁₆ in. /99.8 x 77.2 cm.

Wirt D. Walker Fund, 1956.1109.

Judith was considered one of the heroic women of the Old Testament. When her city was besieged by the Assyrian army, the beautiful young woman gained access to the quarters of the Assyrian general Holofernes. After gaining his confidence and getting him drunk, she took his sword and cut off his head, thereby saving the Jewish people. A model of civic virtue, she was often shown richly and exotically clothed and proudly upright in her bearing. Van Hemessen chose to present her as a monumental nude figure, aggressively brandishing her sword even after severing Holofernes's head. The muscular body and its elaborate, twisting pose pay homage to the art of antiquity and the High Renaissance then being imported from Italy to the Netherlands. At the same time, the use of the nude figure here suggests a certain ambivalence on the part of van Hemessen and his audience toward the seductive wiles Judith may have employed to disarm Holofernes.

Van Hemessen was one of the chief proponents of a style, popular in the Netherlands in the first half of the sixteenth century, that was deeply indebted to the sculptural forms of classical art as well as of the art of Michelangelo and Raphael. In van Hemessen's work, monumental figures are combined with precisely rendered textures, as in the hair and beard of Holofernes, Judith's gauzy headdress, and her brocaded bag. The interplay between the straining, staring pose of his figures, the dramatic lighting, and the fastidiously recorded surfaces serve to heighten the power of his original compositions.

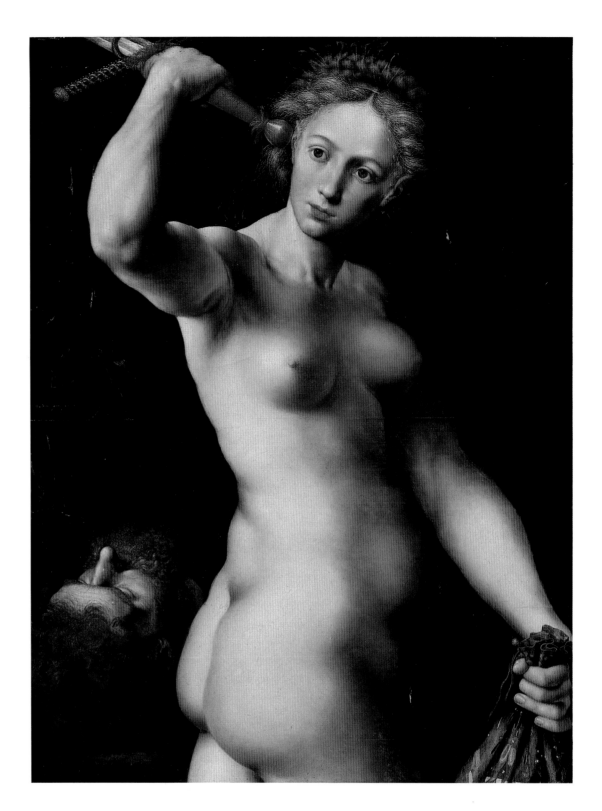

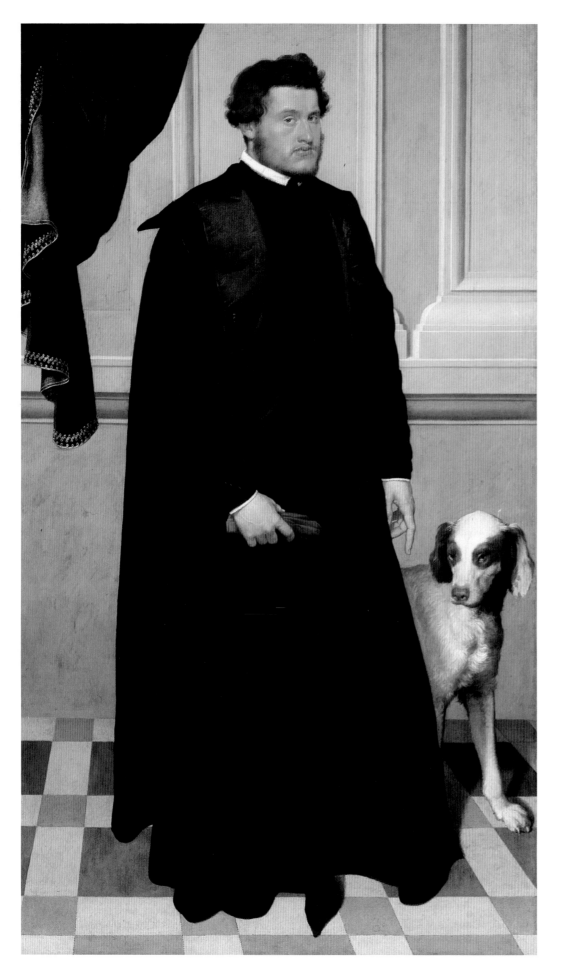

Giovanni Battista Moroni

Italian, 1520/24 - 1578
Gian Lodovico Madruzzo, 1551/52.
Oil on canvas.
79¾ x 46 in. /202.6 x 116.9 cm.
Charles H. and Mary F. S. Worcester
Collection, 1929.912.

Giovanni Battista Moroni was one of the great portrait painters of the sixteenth century. He spent much of his career depicting the distinguished citizens of his native Bergamo. The Madruzzo family was important in northern Italy. The young man in the Art Institute's portrait became a cardinal and achieved fame for his funeral sermon for Charles V at the Diet of Augsburg. His uncle, Cardinal Cristoforo Madruzzo (whose portrait was painted by Titian), was bishop of Trent and helped organize the Council of Trent, which passed measures promoting the Counter-Reformation.

Moroni's portraits are characterized by a naturalism tempered by restraint. While he sought to present objective likenesses of his sitters, he kept them at a certain psychological distance through the austerity of his compositions and colors. As in many of Moroni's full-length portraits, the figure of Gian Lodovico is posed easily in a simply constructed, narrow space. The composition is enlivened by the contrast of the flat, architectural forms and terrazzo-floor patterns with the curved, hanging drapery and undulating hem of the subject's garment. Madruzzo's aristocratic status is signaled by the choice of the full-length format, traditionally reserved for images of emperors and princes, and by the inclusion of his hunting dog, a symbol of privilege. Madruzzo's steady, yet reserved, gaze aptly suggests his ease in this role.

El Greco (Domenico Theotocopuli)

Spanish, 1541 - 1614
The Assumption of the Virgin, 1577.
Oil on canvas.
158 x 90 in. /401.4 x 228.7 cm.
Gift of Nancy Atwood Sprague in memory of
Albert Arnold Sprague, 1906.99.

The art of the great Mannerist painter El Greco is a supremely effective synthesis of the tradition of his native Greece, the art of the Renaissance masters of Italy (he spent nearly a decade in Venice and Rome), and the deep spiritualism of the late Counter-Reformation, which was particularly strong in Spain, where the artist finally settled.

The Assumption of the Virgin, undoubtedly the Art Institute's most important Old Master painting, was part of El Greco's first major commission in Toledo, comprising nine paintings for the high altar of the church of Santo Domingo el Antiguo. The monumental painting is a work of stirring drama and impassioned religious feeling. The composition is divided into two zones, the earthly sphere of the apostles and the celestial sphere of angels, who welcome and celebrate the Virgin as she rises from her grave upon a crescent moon (a symbol of her purity). Into a tall vertical format, El Greco compressed many figures, whose faces and gestures express a range of feelings — confusion, disbelief, excitement, peace, awe. Their elongated bodies, covered with ample, beautifully rendered draperies painted in high-keyed colors, are so filled with energy and feeling that the composition seems to burst from the frame. Here, and in many other works, El Greco used broad, free brushwork, flickering hues and rich color harmonies, brilliant illumination, and bold figural arrangements to arouse mystic fervor in the viewer and impart the deep sense of faith that he himself felt.

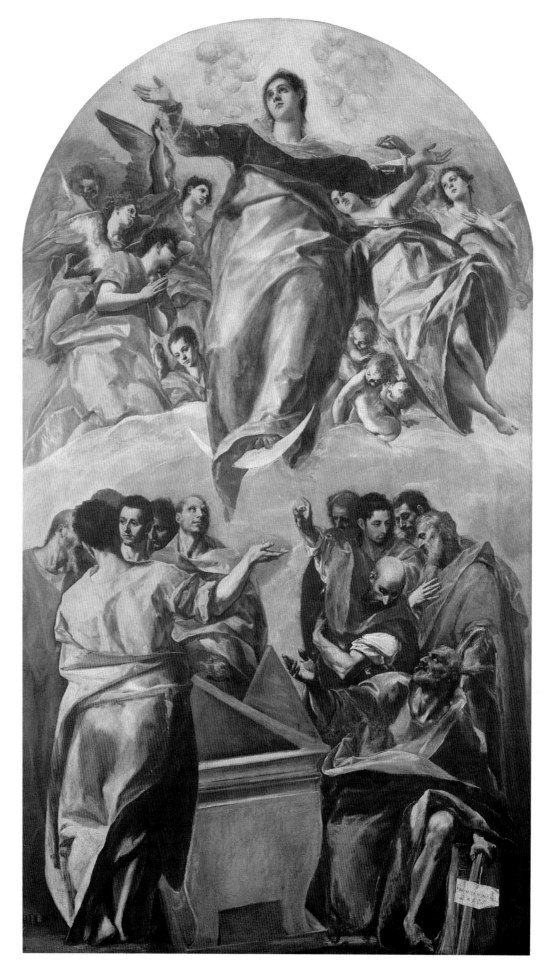

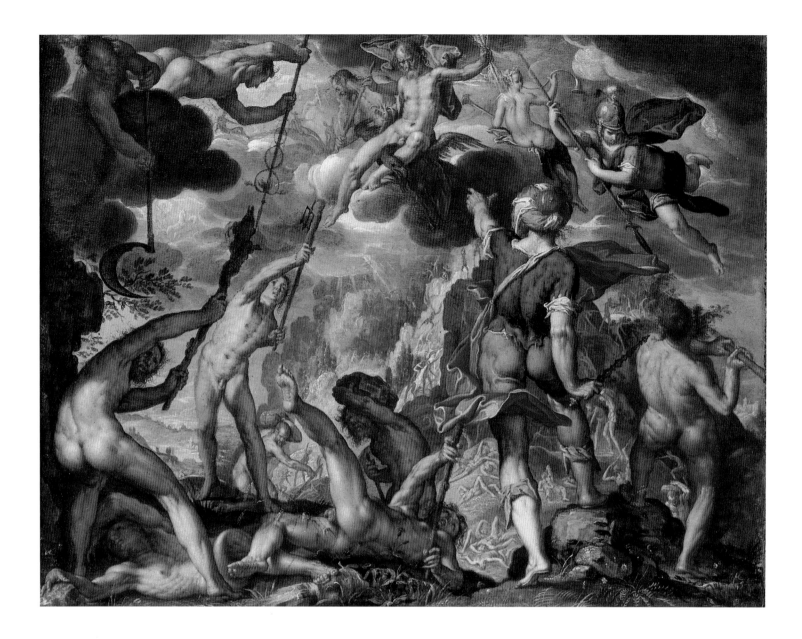

Joachim Antonisz. Wtewael

Dutch, 1566-1638

*The Battle between the Gods
and the Titans,* c. 1600.

Oil on copper.

6⅛ x 8 in. /15.6 x 20.3 cm.

George F. Harding Fund by exchange,
1986.426.

The two decades after 1585 saw a flowering in Holland of the refined, courtly style known as late Mannerism, an international movement growing out of earlier developments in the courts of Florence, Rome, and the Holy Roman Empire. Joachim Wtewael was probably the most accomplished painter of the Dutch Mannerist group. After several years of study in Italy and France, he established himself as a painter in his native Utrecht in 1592. In addition to large canvases, Wtewael executed a number of exquisite cabinet pictures on copper or wood aimed at the sophisticated collectors who were the chief audience for works in this style.

In the foreground of Wtewael's small work on copper, the doomed ancient race of Titans struggles with crude clubs and rocks against the gods of Olympus, who recline in relative security in the heavens. The gods are identified by the attributes that they brandish against the Titans: Zeus's thunderbolts, Neptune's trident, and Mercury's caduceus (a winged staff en- twined by serpents). The battle, recounted in *Metamorphoses*, the ancient Roman text by Ovid, provided Wtewael with an excuse for the drama- tic poses and manipulation of space that are the hallmarks of Mannerist art. With its exqui- site finish, bold composition, and involved mythological subject, *The Battle between the Gods and the Titans* elicits a complex response from the viewer that is the ideal counterpart to the painter's self-conscious display of skill.

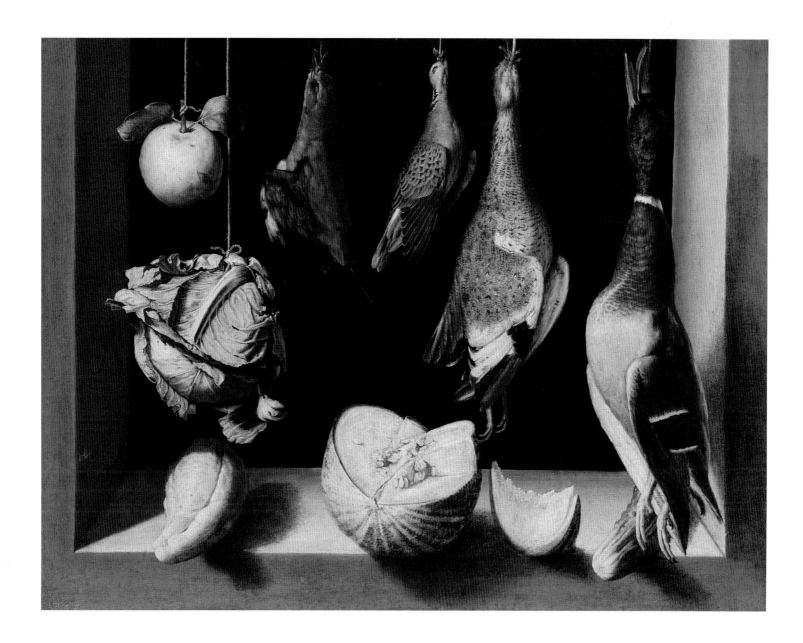

Juan Sánchez Cotán

Spanish, 1561 - 1627
Still Life, c. 1602.
Oil on canvas.
26¹¹⁄₁₆ x 34¹⁵⁄₁₆ in. /67.8 x 88.7 cm.
Gift of Mr. and Mrs. Leigh B. Block,
1955.1203.

The turning point in Juan Sánchez Cotán's life occurred in 1603, when he left the Spanish city of Toledo and a successful artistic career of some twenty years to become a lay brother of the Carthusian order at the Charterhouse of Granada. Cotán, who had specialized in still lifes, turned to religious pictures. The Art Insti-tute's *Still Life,* dating from the period just before the artist left Toledo, is the museum's earliest European still-life painting. The rise of still life as an independent subject occurred in the sixteenth century, when artists began to specialize in such categories as landscape, por-traiture, and scenes of daily life. Some, like Cotán, became interested in displaying their skill at depicting inanimate objects.

Cotán's known still lifes are all conceived in the same format: precisely rendered forms are displayed in a shallow, windowlike space. In some compositions, few objects have been depicted; in others, like the Art Institute's, they fill the space. Cotán organized the composition with extreme rigor. The mathematical precision with which the objects are placed is echoed in the geometry of their shapes: the apple, cabbage, and melon are spherical; the birds are conical. The strong, raking light creates a lively play of light and shadow over each object. The design is further enlivened by a subtle com-positional device — the hanging objects are arranged not perpendicular to the bottom edge of the painting, but on a barely perceptible diag-onal. In these ways, Cotán was able to infuse simple objects in a simple setting with great presence and drama.

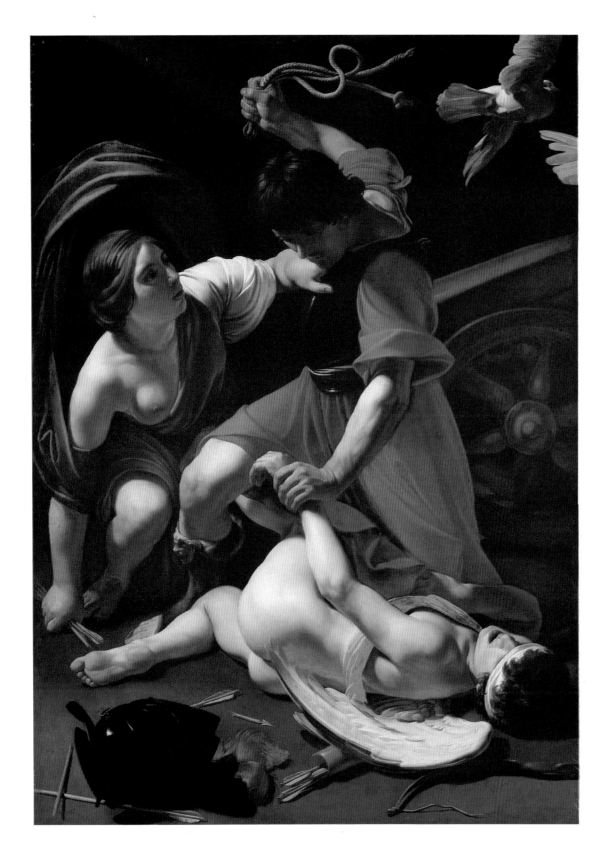

Bartolomeo Manfredi

Italian, c. 1580 - c. 1620
Cupid Chastised, 1605/10.
Oil on canvas.
69 x 51⅜ in. /175.3 x 130.6 cm.
Charles H. and Mary F. S. Worcester
Collection, 1947.58.

Following the example of the revolutionary artist Caravaggio, Bartolomeo Manfredi chose not to interpret the stories of the Bible and classical mythology as idealized subjects enacted by heroic protagonists. Caravaggio's example had shown Manfredi and an entire generation of European artists that such lofty themes could be transformed into everyday events experienced by ordinary people. Using dramatic light effects and depicting the action as close to the viewer as possible, these artists were able to convey the meaning of these stories with great immediacy and power.

Cupid Chastised depicts a moment of high drama: Mars, the god of war, beats Cupid for having caused his affair with Venus, which exposed him to the derision and outrage of the other gods; Venus attempts in vain to intervene. Surrounded by darkness, the three figures are lit by a beam of light that breaks across faces, torsos, limbs, and drapery, intensifying the dynamism and impact of the composition. The sheer physicality of the figures — the crouching Venus whose broad, almost coarse, face is far from any classical ideal; the powerful Mars whose musculature and brilliant red drapery seem to pulsate with rage; and Cupid, whose naked flesh and prone position render him so vulnerable — makes vivid and palpable the terrible violence of the scene. On one level a tale of domestic discord, the story also symbolizes the eternal conflict between love and war, and the helplessness of love in the face of wrath.

Francisco de Zurbarán

Spanish, 1598 - 1664
The Crucifixion, 1627.
Oil on canvas.
114⅝₆ x 65³⁄₁₆ in. /290.3 x 165.5 cm.
Robert A. Waller Memorial Fund, 1954.15.

The religious strife in sixteenth-century Europe between Catholics and Protestants prompted intense campaigns on the part of all factions to recruit believers. Recognizing the educational and inspirational value of visual images, the Catholic Church encouraged in artists a style of easy readability and dramatic fervor.

In 1627, Francisco de Zurbarán, then living and working in the provincial Spanish town of Llerena, painted this *Crucifixion* for the monastery of San Pablo el Reale in prosperous Seville. The painting created quite a stir, as is evident from the way it is mentioned in an invitation extended to the artist two years later by the city council of Seville urging him to move there. In the dimly lit sacristy where it was installed, the figure of Christ awed the faithful. Later commentators noted that it appeared to be a sculpture rather than a painting. Emerging from a dark background, the austere figure has been both idealized, in its quiet, graceful beauty and elegant rendering, and humanized by the individualized face and insistent realism. Strong light picks out anatomical detail, the delicate folds of the white loin cloth, a curled scrap of paper on which the the artist's name and the date of the painting are inscribed.

Zurbarán envisioned the crucified Christ suspended outside of time and place. Conforming with Counter-Reformation dictates, the event occurs not in a crowd but in isolation. Painted with extreme simplicity in a limited color range, the *Crucifixion* conveys intense religious feeling and inspires a deeply meditative response.

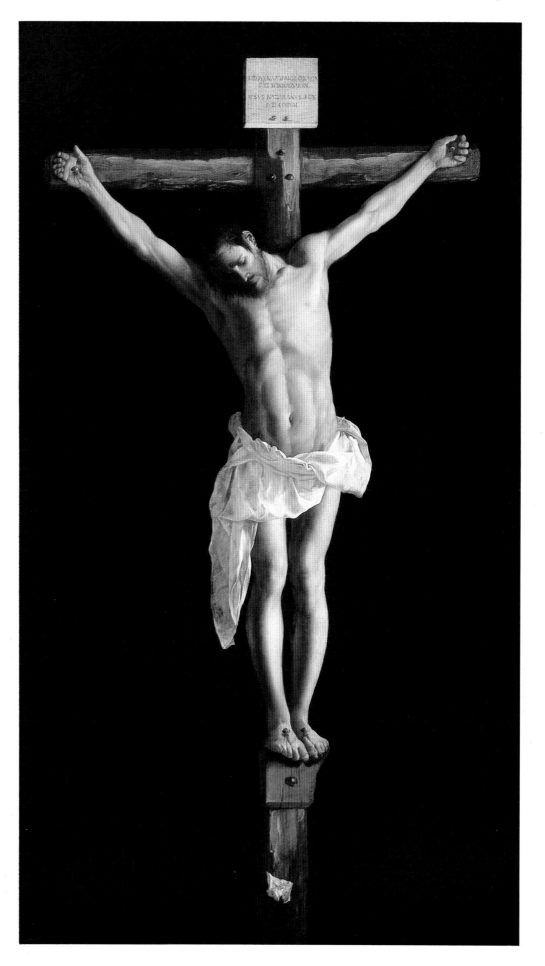

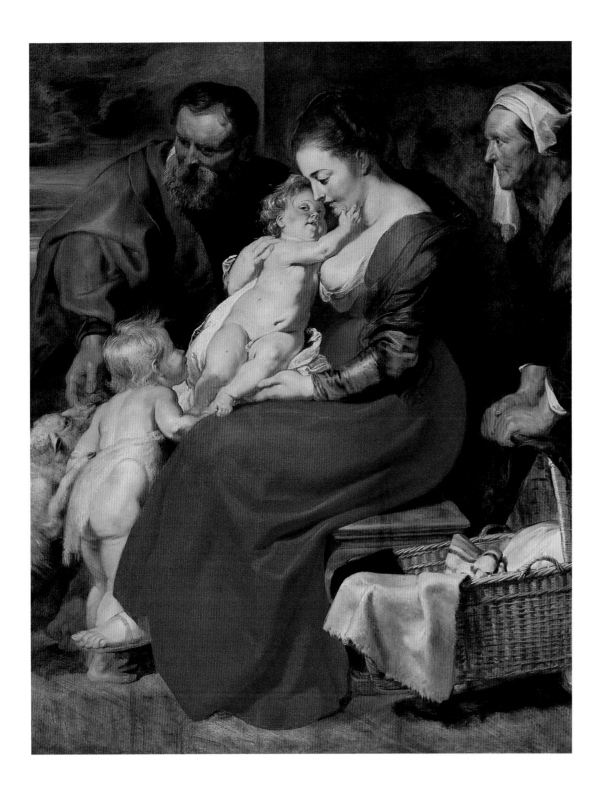

Peter Paul Rubens

Flemish, 1577 - 1640
*The Holy Family with Saints
Elizabeth and John the Baptist*, c. 1615.
Oil on panel.
45⅛ x 36 in. /114.5 x 91.5 cm.
Major Acquisitions Fund, 1967.229.

By the beginning of the seventeenth century, it was the custom for young Flemish painters to complete their education in Italy. Peter Paul Rubens, who went to Italy in 1600, was exceptional in the length of time he stayed there (eight years) and in the degree to which he assimilated what he saw. His absorption of the art of the great Renaissance painters in Rome and Venice, as well as the most recent advances in early Baroque painting in Rome, enabled him to dominate the artistic scene when he returned to his native Antwerp. The paintings he completed after his return, with their flashing light and dramatic movement, showed the influence of Caravaggio's revolutionary work, but his style soon became more classical. A series of paintings of the Madonna and the Holy Family, undertaken between 1610 and 1620 — of which this work is a fine example — reflect this trend in their balanced compositions, clearly defined forms, and crisply rendered surfaces.

The figure of the Madonna dominates this composition through the brilliant red of her dress, the emphatic curves of her body, and the solid and contained profile view in which she is presented. The bold diagonal movement of the two infants — John the Baptist eagerly rushing forward and Jesus twisting away from him — is an effective counterbalance to the Madonna's solid form. Saints Joseph and Elizabeth frame this pyramidal group, as aged and more passive protectors.

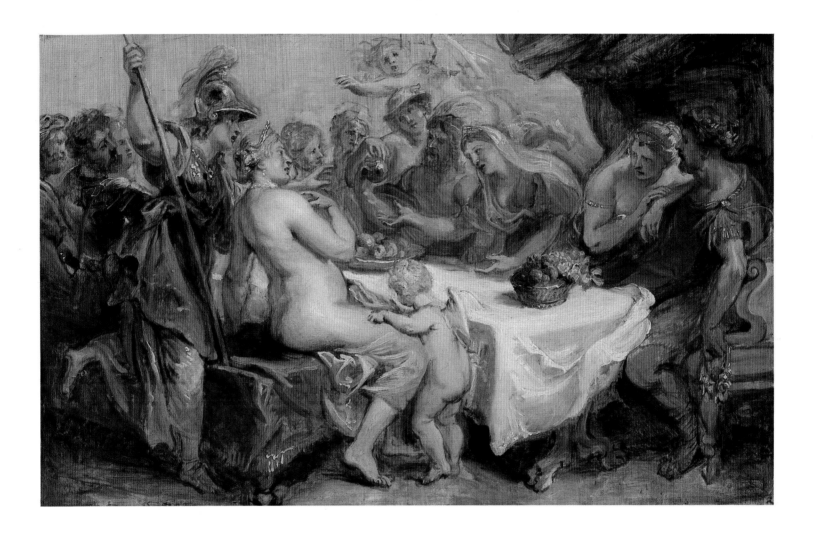

Peter Paul Rubens

Flemish, 1577 - 1640
The Wedding of Peleus and Thetis, 1636.
Oil on panel.
10¾ x 16⅞ in. /27.3 x 42.9 cm.
Charles H. and Mary F. S. Worcester
Collection, 1947.108.

The well-traveled, classically educated Peter Paul Rubens was sent on several diplomatic missions by the Hapsburg rulers of the southern Netherlands. While at the court of Philip IV of Spain, the artist had a chance to study the superb Titians in the royal collection, and their influence is felt in Rubens's luscious and broadly painted late style. His direct contact with the king of Spain, as well as the close family ties between the rulers of the southern Netherlands and the king, resulted in one of Rubens's most important commissions in his last years, a series on the theme of the loves of the gods for the Torre de la Parada, the new royal hunting lodge. Rubens made rapid oil sketches as models for large canvases executed by artists in his workshop.

This sketch, which served as a model for a canvas by Jacob Jordaens (Prado, Madrid), is one of the finest and most fully developed of Rubens's series. It depicts the event that, according to Greek mythology, precipitated the Trojan War. Eris (goddess of discord and strife, daughter of Zeus and Hera), angered at being excluded from the assembly of the gods attending the wedding of Peleus and Thetis, threw a golden apple labeled "for the fairest" among the guests. The rivalry that resulted between Aphrodite, Athena, and Hera led eventually to the war. The armor-clad Athena, Aphrodite accompanied by Eros, and Hera, who leans on Zeus's shoulder, are prominently featured and their reactions are depicted with particular care. The warm tones and rapid, juicy brushstrokes of Rubens's late style are well suited to the lyrical subject of this scene and the series as a whole.

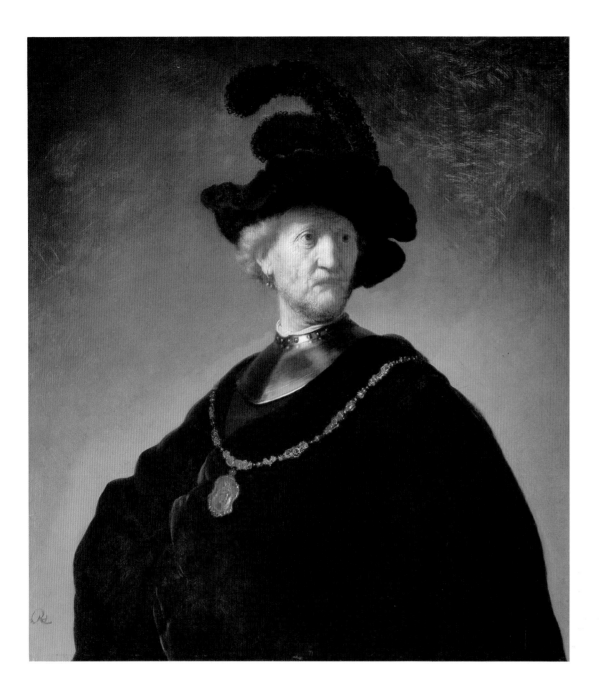

Rembrandt Harmensz. van Rijn
Dutch, 1606 - 1669
Old Man with a Gold Chain, c. 1631.
Oil on panel.
32¾ x 29¾ in. /83.1 x 75.7 cm.
Mr. and Mrs. W. W. Kimball Collection,
1922.4467.

Rembrandt van Rijn was very much a product
of the Protestant, city-dwelling culture of seven-
teenth-century Holland. Yet, he stands apart
from other Dutch artists of his time because
of the deep humanity and individuality that he
brought to his paintings of religious and histor-
ical subjects, as well as the rich and suggestive
treatment of color and light that he developed
over his long career. Though it is an early work,
probably painted just after Rembrandt left his
hometown of Leiden to become a fashionable
portrait painter in Amsterdam in 1631, *Old Man
with a Gold Chain* treats a subject that was
to preoccupy him for the rest of his life — a
character penetratingly observed and height-
ened through dramatic contrast of light and
shade and through fanciful costume.

Old Man with a Gold Chain is not a portrait
as such. The sitter was a favorite model of
Rembrandt, so much so that he has been
considered, without any evidence, to be
Rembrandt's father. He appears in many bibli-
cal scenes, but the subject here is the implied
character of the model himself. The proud, old
man is further ennobled by the chain of office,
a soldier's steel gorget, and the plumed beret.
Rembrandt used the silhouette of the bulky
figure against the light background to convey
both an active watchfulness and stability. At the
same time, there is a flourish to the figure, in
the twist of the body and in the flamboyant
outline of the hat, that reveals the ambition of
the youthful artist as much as the character of
the sitter.

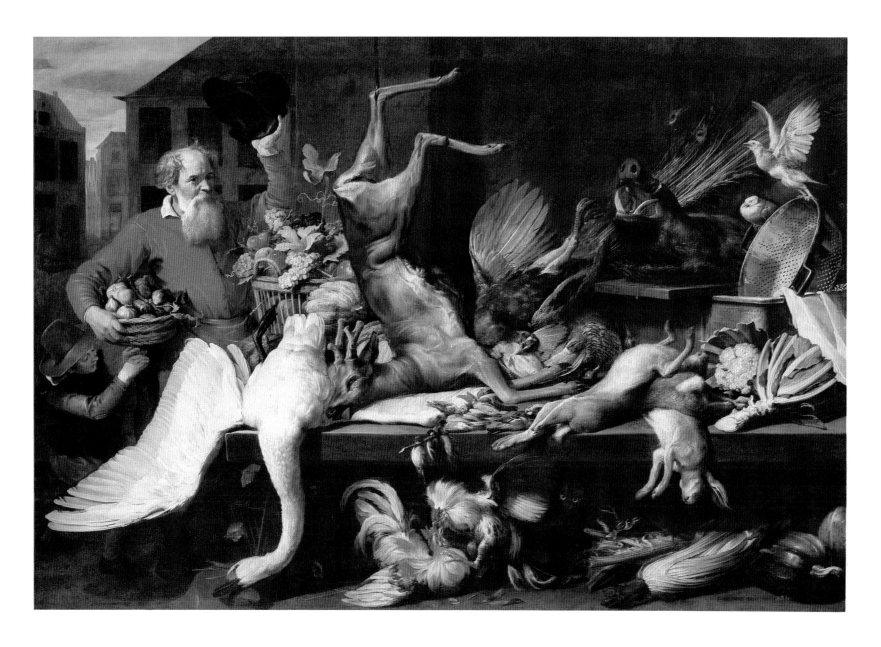

Frans Snyders

Flemish, 1579 - 1657
*Still Life with Dead Game, Fruits,
and Vegetables in a Market*, 1614.
Oil on canvas.
83½ x 121¼ in. / 212.1 x 308.6 cm.
Charles H. and Mary F. S. Worcester Fund,
1981.182.

Antwerp, with its long tradition of trade, especially in luxury items, was an active artistic center in the seventeenth century. A number of artists, including Peter Paul Rubens (see pp. 28, 29), made the first half of the century a golden age of painting in Antwerp. Among them

was Frans Snyders, who brought a new level of drama to still life. His almost life-sized combinations of living and dead creatures in a market setting seem to have been stimulated by collaboration with Rubens in 1613. However, by 1614, beginning with the Art Institute's painting, the theme of the overflowing market scene became his specialty.

In *Still Life with Dead Game, Fruits, and Vegetables in a Market*, the effect of the market stall is built up through a series of opposing diagonals and contrasting groups of animals, which give the painting a pulsating vitality. A dead peacock's rich plumage contrasts with the flight of the dove at the right. The languid lines of the hanging deer and swan are set off by the

frenzied motion of the roosters fighting below them in a drama intensified by the cat, which waits with glowing eyes to pounce on the weaker of the two birds. Meanwhile, the old stall keeper, who, by his gesture and glance, helps to place the viewer in the picture, has his pocket picked by the darting boy.

Snyders's large-scale compositions were much in demand to decorate Flemish town houses and foreign hunting lodges and established a type of Flemish still-life painting whose popularity lasted through the seventeenth century.

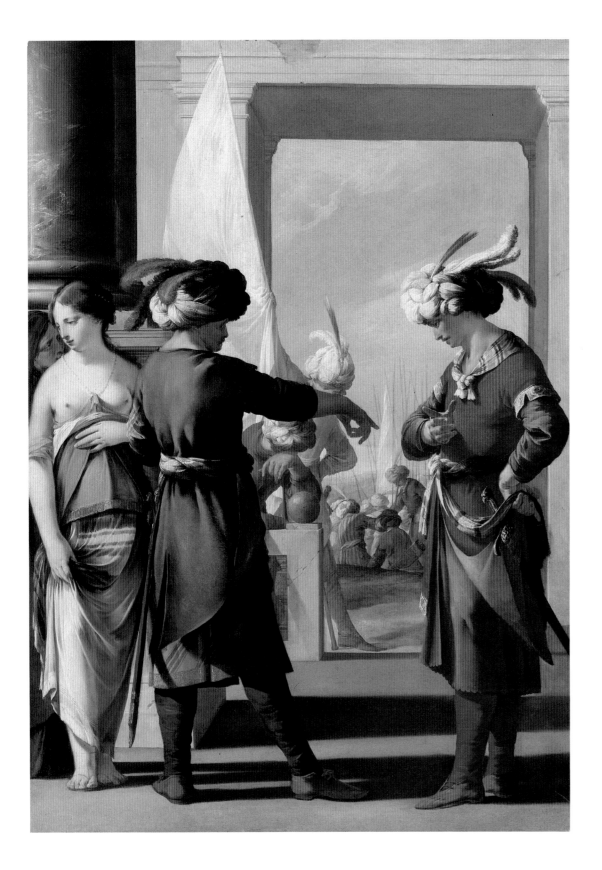

Laurent de La Hyre

French, 1606-1656
Panthea, Cyrus, and Araspus, c. 1638.
Oil on canvas.
55⅞ x 40⅛ in. /141.9 x 102 cm.
Major Acquisitions Fund, 1976.292.

Among the many artists who were important and admired in their day, but who now are almost forgotten, is the painter and engraver Laurent de La Hyre. His early works reveal his love of luminous colors and clear atmosphere. Later, influenced by the paintings of his countryman Nicolas Poussin (see p. 33), he developed a highly individual form of classicism marked by precise draftsmanship, restraint, and serenity.

It has been thought that the subject of this painting may have been drawn from François Tristan L'Hermite's little-known tragedy *Panthée,* first staged in 1638. This work tells the story of Panthea, Queen of Susa, who is taken prisoner by Cyrus the Great of Persia. The king entrusts Panthea to his friend Araspus, who falls in love with his prisoner and declares his passion. Offended, Panthea asks to be placed in the care of Cyrus, who is outraged by the conduct of his confidant. Panthea nevertheless pleads for Araspus's pardon. La Hyre depicted here the moment when Panthea rejects Araspus and Cyrus gestures reprovingly at his friend.

The architectural setting, a shallow stage for the action, suggests the painting's theatrical origin. The protagonists' broad gestures and careful arrangement in the scene have been used to express the high moral lesson of L'Hermite's play. The exotic costumes, unusual coloration, sensuousness, and refined elegance attest to the originality of La Hyre's style.

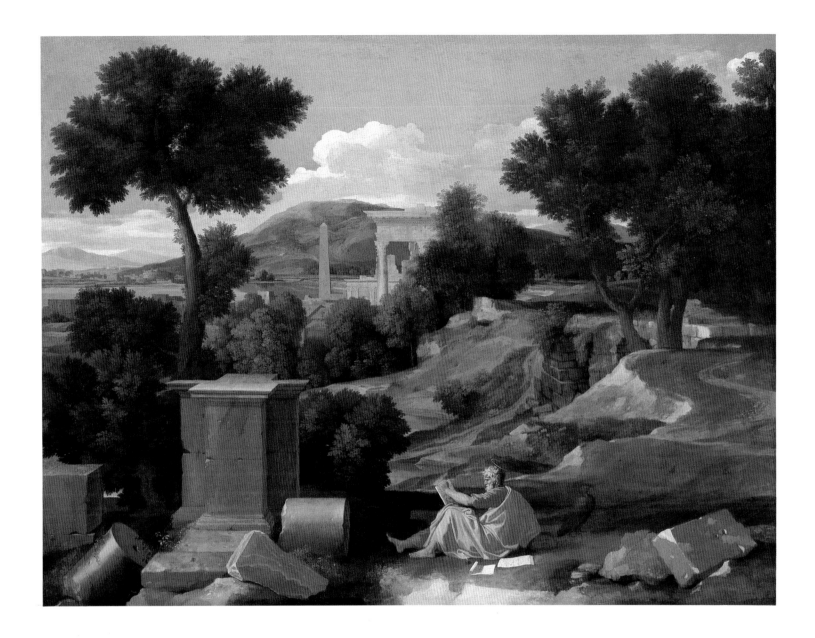

Nicolas Poussin

French, 1594 - 1665
*Landscape with Saint John
on Patmos,* 1640.
Oil on canvas.
40 x 53½ in. /101.7 x 136 cm.
A. A. Munger Collection, 1930.500.

The art of Nicolas Poussin, more than that of any other seventeenth-century artist, has become synonymous with the ideals of classicism. Although French in origin and training, Poussin spent almost his entire career in Rome painting classically inspired works for a group of highly educated connoisseurs.

This serene and solemn landscape, replete with references to antiquity, seems a perfect setting to inspire Saint John as he writes the biblical book of Revelations. The classically draped figure reclines beside his symbol, the eagle. The group of ancient ruins in this composition includes an obelisk, a temple, and column fragments, which symbolize the vanished glory of antiquity and its importance as the world in which the new faith took root. The painting formed a pair with *Landscape with Saint Matthew* (Gemäldegalerie, Berlin), and was possibly part of a projected series on the four evangelists. In these and other works, Poussin carefully constructed an idealized landscape, reshaping and adjusting natural and man-made forms according to geometric principles and arranging them parallel to the picture plane to reinforce the measured order of the scene. Even Saint John is seated in profile, in total concert with the classical landscape that surrounds him.

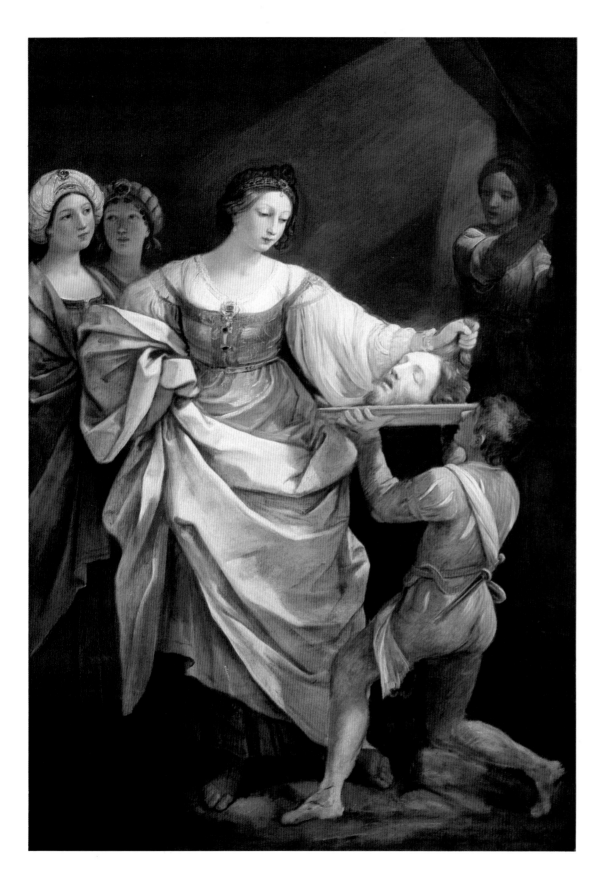

Guido Reni

Italian, 1575 - 1642
*Salome with the Head of Saint John
the Baptist,* 1639/40.
Oil on canvas.
97¾ x 88½ in. /248.5 x 224.8 cm.
Louise B. and Frank H. Woods Fund, 1960.3.

The elegant figures that fill this large canvas enact one of the New Testament's most macabre stories, the death of Saint John the Baptist. The imprisoned prophet had earned the wrath of Herodias because he had reprimanded her new husband, Herod, for having married his sister-in-law. A dance presented by Herodias's daughter, the beautiful Salome, so pleased Herod that he offered her whatever she wanted. Prompted by her vengeful mother, she asked for the head of Saint John. It is the moment when the decapitated head is presented to Salome that Guido Reni chose to depict in this striking composition.

Salome is a prime example of Reni's late style. He achieved fame in Rome early in his career, working in a dramatic Baroque style for popes and princes, but subsequently settled in his native Bologna. In the Art Institute's painting, as in other works from the end of his life, Reni lightened his palette, restricting himself to a narrow range of cool illumination and color. The broad handling of the forms and paring down of unnecessary details of costume and setting add to the monumental, contemplative quality of the work.

The painting's technique raises the question of whether it was completed, which is the central, unresolved issue of Reni's late work. *Salome* displays the luminous transparency of his late phase and is also extremely sketchy in the definition of areas such as the legs of the page and the feet of Salome — so much so, in fact, that these parts may indeed have been left unfinished.

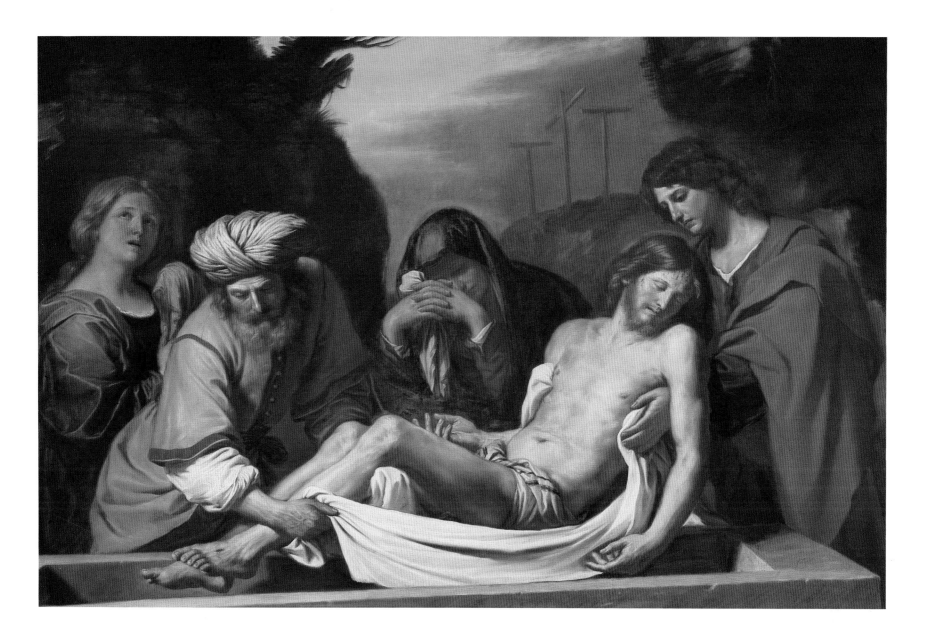

Guercino
(Giovanni Francesco Barbieri)

Italian, 1591 - 1666

The Entombment of Christ, c. 1656.

Oil on canvas.

57¾ x 87¹⁄₁₆ in. /146.7 x 221.2 cm.

Wilson L. Mead Fund, 1956.128.

Guercino worked in Rome before returning to his native Cento and then moving to Bologna, where he succeeded Guido Reni (see p. 34) as the city's leading artist. While his early works are full of dramatic movement and bold contrasts of light and shade, *The Entombment* belongs to his mature phase, dominated by clarity and calm.

In this painting, Saint John and Nicodemus carry the body of Christ on a traditional burial shroud and lower it into the tomb. Behind them stand the quietly mourning figures of the Virgin Mary and the Magdalen. The scene has been structured so that the viewer regards the picture frame as a window through which to view the event. The figures have been arranged in a row reminiscent of a classical frieze. The compression of the protagonists into a shallow space intensifies the painting's emotional impact: their closeness to the viewer compels one to share in their deep sorrow. The delicate brushwork, subtle rhythmic relationship between the figures themselves and the landscape background, and atmospheric and diffused light are typical of Guercino's late, classicizing style and are well suited to the muted drama and controlled emotional content of *The Entombment*.

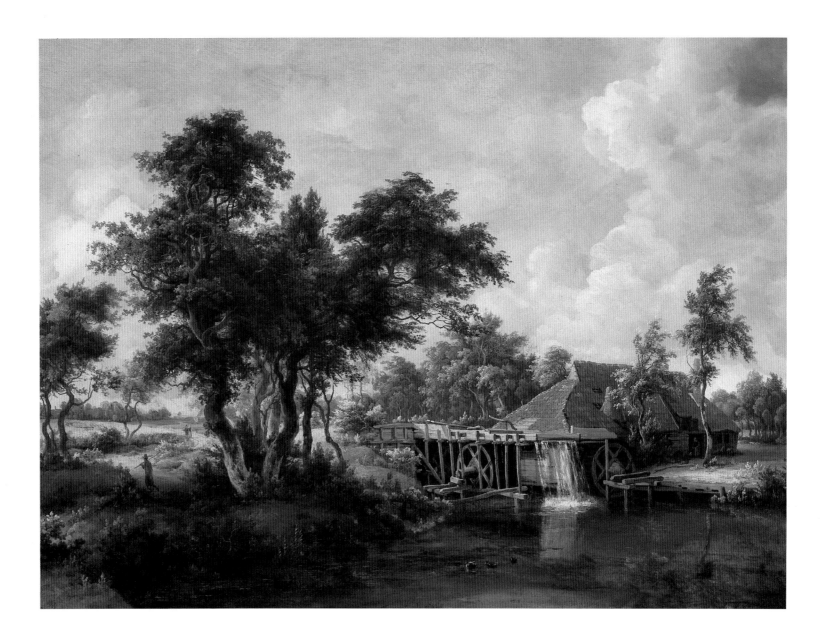

Meindert Hobbema

Dutch, 1638-1709
*Wooded Landscape with
a Water Mill,* c. 1662/64.
Oil on canvas.
32 x 43¼ in. /81.3 x 110 cm.
Gift of Mr. and Mrs. Frank G. Logan,
1894.1031.

The seventeenth century was a period of extraordinary artistic production in Holland, both in terms of the number of painters working and the level of quality they achieved. The dunes, waterways, forests, and fields of Holland, as well as more exotic Scandinavian mountains and Italian hills, furnished subjects for a wealth of often highly specialized landscape painters. Meindert Hobbema focused almost exclusively on woodland scenes, painting them with a breadth and grandeur that are characteristic of Dutch art in general at midcentury and with a serenity and openness that are his own distinct contribution.

Wooded Landscape with a Water Mill is among the artist's finest works. It treats one of his favorite subjects, a picturesque and somewhat dilapidated mill in a wooded setting. The composition is anchored by the still expanse of water in the foreground and by the dappled sunlight that plays across the fine spray of water over the mill, silhouettes the trees, and draws the viewer's eye back along the twisting path into the distance at the left. The dominant silvery tonality and the lively, almost decorative, treatment of leaves and tree trunks are characteristic of Hobbema's art.

Adriaen van Ostade

Dutch, 1610 - 1684
Merrymakers in an Inn, 1674.
Oil on panel.
18⅜ x 16⅛ in. /46.7 x 41 cm.
George B. and Mary R. Harris Fund,
1894.1028.

Groups of convivial merrymakers were among the favorite subjects of seventeenth-century paintings of everyday life. Images depicting this theme tend to fall into two broad trends based on social class — peasant scenes and middle-class amusements. In contrast to the violent or rude behavior and satirical intent of his earlier peasant scenes, which belong to the tradition of the Flemish artist Pieter Brueghel the Elder and others, Adriaen van Ostade's later works, such as the Art Institute's painting, interpret these gatherings with a new dignity, as well as an increased clarity of space and color.

In a lofty and picturesque tavern interior, merrymakers of all ages gather around a digni-fied elderly couple who dance in the center of the room. Despite the varied poses and expres-sions of the figures and the disordered furniture in the foreground, all have been carefully arranged to focus attention on the dancing cou-ple. Although most of the merrymakers are engrossed in their wine or beer, including a very small child behind the dancing man, the couple at the right and the man with a pipe gaze respectfully at the dancers. Musicians playing violin and tongs, a man embracing a woman who laughingly pushes him away, and a boy and a dog dancing in time to the music further enliven the scene. These elements, picked out by light and color and by attentive observation of facial expression, give the scene an air of simple and prosperous contentment.

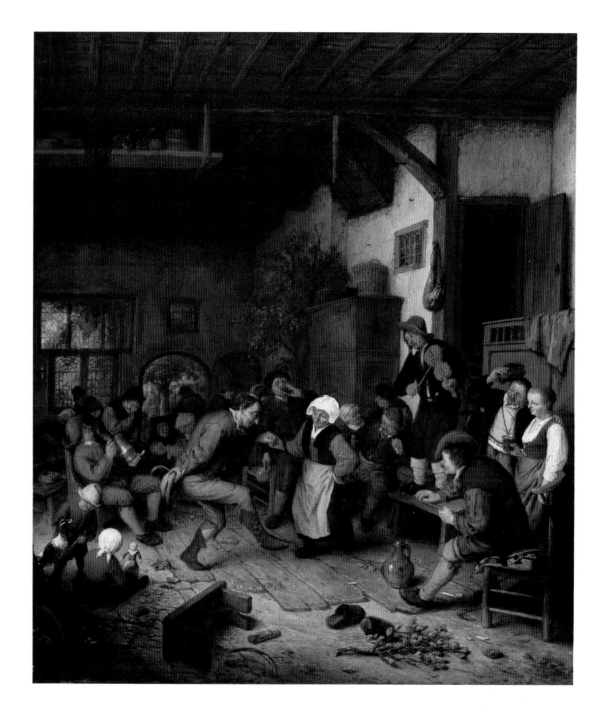

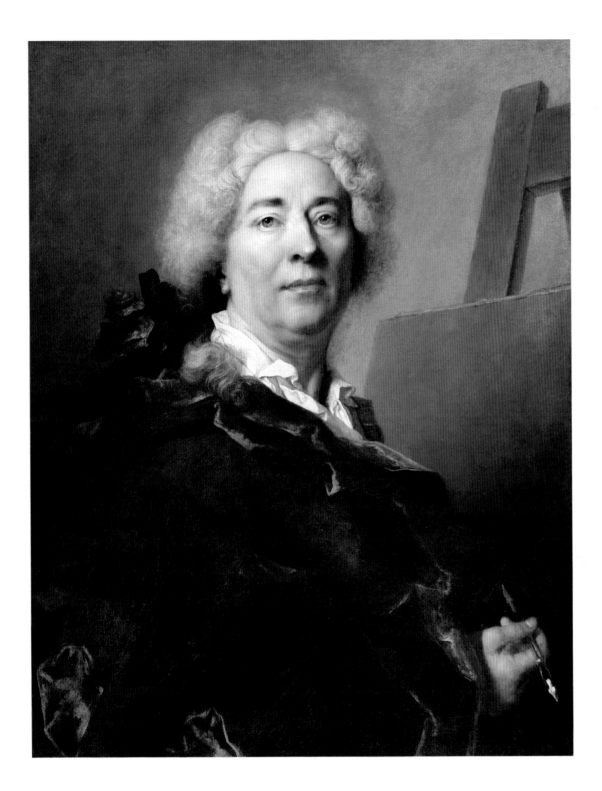

Nicolas de Largillière

French, 1656-1746
Self-Portrait, c. 1725.
Oil on canvas.
33 ¼ x 25 ⅝ in. / 81.7 x 65 cm.
Charles H. and Mary F. S. Worcester
Collection Fund, 1987.57.

Nicolas de Largillière played a key role in creating the elegant and intimate portrait style of the Rococo period. Over this French artist's very long career, he depicted some of the most illustrious figures of his time, including members of the royal family. He excelled as a painter of luscious textures and surfaces who displayed his sitters' status and personality to advantage. By contrast, this relatively late self-portrait is exceptional in its intimacy and immediacy.

Largillière portrayed himself quite frequently. In this work, a variant of a composition of 1711 (Musée National du Château de Versailles), the artist represented himself in his studio. Attired in a wig, simple linen shirt, and casually draped velvet cloak, he holds a drawing implement and gazes intently at the viewer, as if he were about to portray us on the primed, blank canvas before him. His pyramidal form fills the canvas, increasing our sense of his presence. The soft light playing across the artist's face focuses our attention on his steady gaze, strong nose, and the firm set of his head. The wonderfully rich texture of the purple-brown velvet cloak and the elegant touches in the shirt, wig, and eyes demonstrate Largillière's consummate skill. The portrait conveys admirably the self-confident air of an extremely successful man who is asking us to remember him as a dedicated artist and keen observer of the world.

Giovanni Battista Piazzetta

Italian, 1682 - 1754
Pastoral Scene, 1740.
Oil on canvas.
75½ x 56¼ in. /191.8 x 143 cm.
Charles H. and Mary F. S. Worcester
Collection, 1937.68.

The Venetian Giovanni Battista Piazzetta's dark colors and brooding, shadowy figures do not follow the early eighteenth-century Rococo taste for chromatic brilliance and light and airy compositions. As large and complex images of everyday life, *Pastoral Scene* and its companion piece, *Figures on the Shore* (Wallraf-Richartz Museum, Cologne), are unusual even in Piazzetta's work. Both were commissioned by the avid collector Marshal von der Schulenburg. The enigmatic interaction of the figures, their melancholy demeanor, and the unusually large size of both paintings suggest a more serious intent than the representation of rustic life; and the possibility of a deeper meaning has been frequently and inconclusively debated. Why do the two male figures behind the rock whisper together? Why does the young woman, her arm outstretched and her dress slipping enticingly from her shoulder, seem to engage the viewer so wistfully? And what is the meaning of the half-nude child and dogs chasing a duck? *Pastoral Scene* could be a poetic allegory on the meaning of life, a form of social commentary, or an image of amorous dalliance.

Interestingly, when Piazzetta himself prepared the inventory of Schulenburg's collection in 1741, he discussed this painting by describing the disposition of the figures, which suggests that any more elaborate meanings were subjective and allusive. Nevertheless, *Pastoral Scene* and its pendant are among the most commanding and evocative of Piazzetta's works.

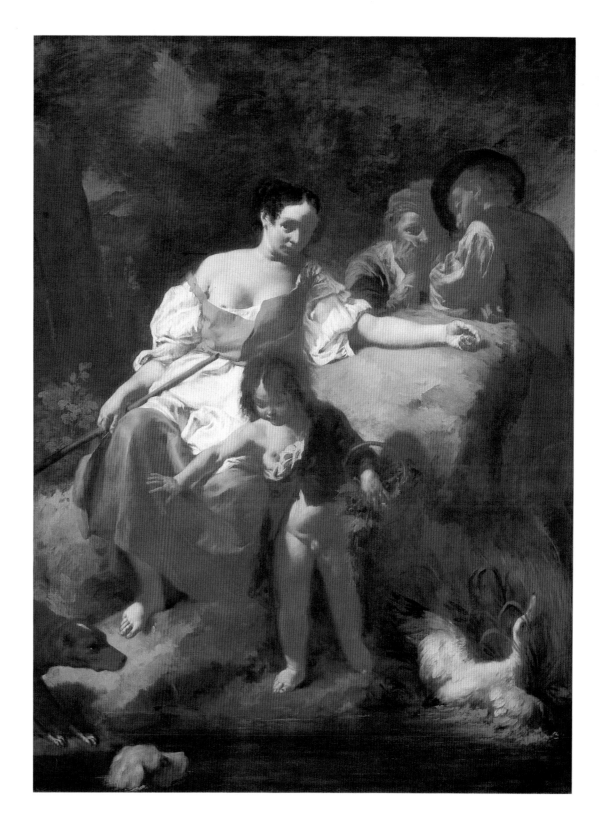

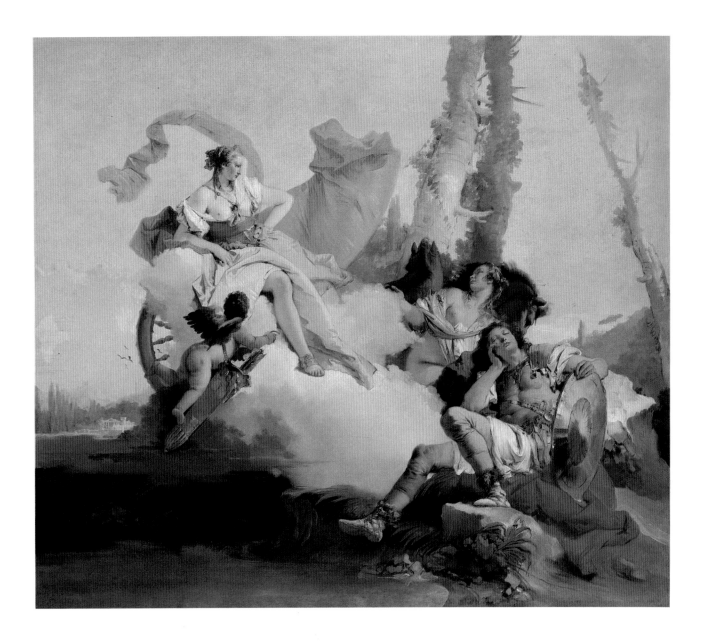

Giovanni Battista Tiepolo

Italian, 1696 - 1770
Rinaldo Enchanted by Armida, 1742.
Oil on canvas.
73¹³⁄₁₆ x 85³⁄₈ in. /187.5 x 216.8 cm.
Bequest of James Deering, 1925.700.

The Venetian Giovanni Battista Tiepolo was one of the eighteenth century's greatest artists. His light and high-keyed palette, virtuoso drawing, speed and spontaneity of execution, along with his mastery of perspective and illusionism, were perfectly suited to the large-scale architectural spaces he decorated in rapid succession in Italy, Germany, and Spain.

The Art Institute's suite of canvases relating the story of Rinaldo and Armida exemplifies the exuberant, Rococo style Tiepolo had evolved by the 1740s. In the first canvas, illustrated here, Rinaldo, the hero of Tasso's epic poem "Gerusalemme Liberata," is diverted by the beautiful sorceress Armida from his crusade to save the Holy Land from the infidels. In this imaginative version of the seduction, Armida appears to the sleeping crusader, suspended on a billowing cloud, her shawl and drapery wafting behind her, as if a gentle wind had blown this mirage to Rinaldo. The painting's luminous, airy atmosphere is created by a vast, open expanse of sky and landscape behind the figures. The complex and elaborate arrangement of figures, draperies, and clouds, and the gentle diagonals of the trees, landscape, and other details further animate the composition. Thick, creamy paint surfaces enhance the extraordinary pictorial beauty of this magical, pastoral world. With seemingly effortless facility, Tiepolo achieved here one of his most poetic works.

François Boucher

French, 1703 - 1770
Are They Thinking About the Grape?, 1747.
31¾ x 27 in. /80.8 x 68.5 cm.
Oil on canvas.
Martha E. Leverone Endowment, 1973.304.

No art epitomizes the light-hearted sensuality, fancifulness, and grace of the Rococo style better than that of François Boucher. The nineteenth-century critics the de Goncourt brothers described him as "one of those men who typify the tastes of a century, who express it, personify it, and incarnate it." In a period that demanded decorative ensembles and encouraged artists to design for many mediums, Boucher mastered every branch of the decorative arts and painting. Championed by Madame de Pompadour, mistress of Louis XV, he became First Painter to the King in 1765 and played an important part in the remodeling of Fontainebleau and Versailles. His sure sense of design and ability to use color, texture, and linear rhythms to create images of a pleasing world somewhere between fantasy and reality endeared him to his sophisticated patrons.

Are They Thinking About the Grape? was inspired, like many of Boucher's subjects, by a play. A lovestruck shepherd and shepherdess feed each other grapes as the shepherd gazes ardently at his beloved. Boucher's tongue-in-cheek title underscores the gentle voluptuousness of the scene. The arrangement of the landscape elements is contrived, the animals more toylike than realistic, the figures too opulently dressed and aristocratic in their gestures for their rustic origins. Yet, Boucher's authoritative draftsmanship and understanding of nature provide the underpinnings for such artifice. Included in the official exhibition of the French Academy, the Salon, in 1747, this bucolic fantasy was very popular and was reproduced in an engraving and a tapestry.

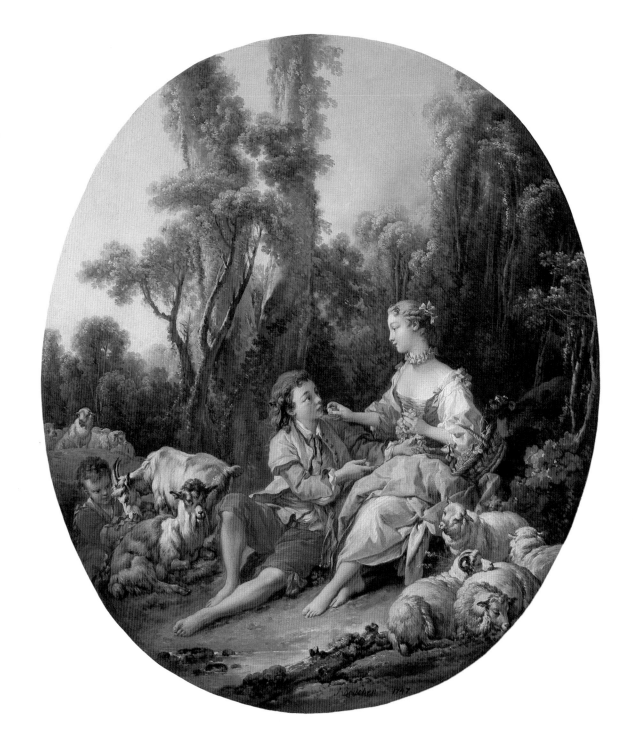

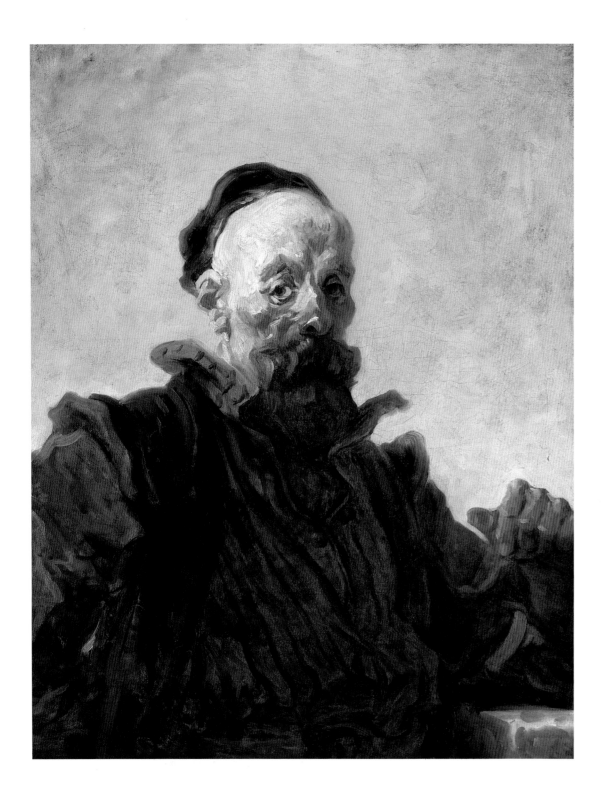

Jean Honoré Fragonard

French, 1732 - 1806
Portrait of a Man, 1769.
Oil on canvas.
31 11/$_{16}$ x 25½ in. /80.5 x 64.7 cm.
Gift of Mr. and Mrs. Leigh B. Block
in honor of John Maxon, 1977.123.

One of the most brilliant eighteenth-century French artists, Jean Honoré Fragonard painted mythological subjects, sweeping landscapes, and witty scenes of everyday life among the privileged and the humble. His work rarely attained the degree of finish then deemed appropriate to a carefully prepared and executed work. Instead, the paint was richly and impetuously applied, so that his paintings often have the character of quick sketches.

Portrait of a Man belongs to a series of fantasy portraits which, in many ways, summarizes Fragonard's highly personal art. They were painted in rapid, virtuoso strokes — some carried a declaration that they were painted in an hour. While a few of the sitters can be identified as Fragonard's patrons and friends, their features are never very specific. They are treated not only as portraits, but as vibrant types — an old soldier, a coquette, a singer. Their seventeenth-century costumes reflect Fragonard's fascination with earlier painting and his appropriation of the style and subjects of his great predecessors, notably Peter Paul Rubens (see pp. 28, 29). In fact, in *Portrait of a Man* (which used to be called *Don Quixote*, without basis), the beard and mustache and the striped garment with extended shoulders relate to styles of the early Baroque period. The restricted color range gives added force to the man's head, silhouetted against a luminous background. His large, world-weary eyes dominate the picture and contrast poignantly with the undulating contour of his costume.

Joshua Reynolds

British, 1723 - 1792
Lady Sarah Bunbury Sacrificing to the Graces, 1763 - 65.
Oil on canvas.
95¼ x 59⅝ in. /242 x 151.5 cm.
Mr. and Mrs. W. W. Kimball Collection,
1922.4468.

Joshua Reynolds flattered his sitters by portraying them as citizens of the classical world. Dressed in a loose, vaguely Greek or Roman costume and surrounded by architecture, sculpture, and artifacts of antiquity, Lady Sarah Bunbury is cast as a priestess of the Three Graces. These were mythical followers of the goddess Venus who symbolized the blessings of generosity, both the giving and receiving of gifts. They are normally represented with the central Grace facing in the opposite direction from her companions, but Reynolds showed them all facing Lady Sarah and returning her sacrifice with their own tribute to her: a wreath. It is as if the statue has miraculously come to life and the Graces themselves, recognizing the beauty and good nature of Lady Sarah, are inviting her to join them.

Though only eighteen when the portrait was begun and twenty when it was finished, Lady Sarah was already a famous aristocratic beauty. The young King George III had fallen in love with her, but political considerations had prevented him from taking her as his queen. Her marriage to Sir Charles Bunbury, a baronet, was to end in divorce after she had a love affair with her cousin Lord William Gordon, bore his child, and eloped with him. At the age of thirty-six, she married Colonel the Hon. George Napier and had another eight children. One contemporary remarked that she "never *did* sacrifice to the Graces; her face was gloriously handsome, but she used to play cricket and eat beefsteaks on the Steyne at Brighton."

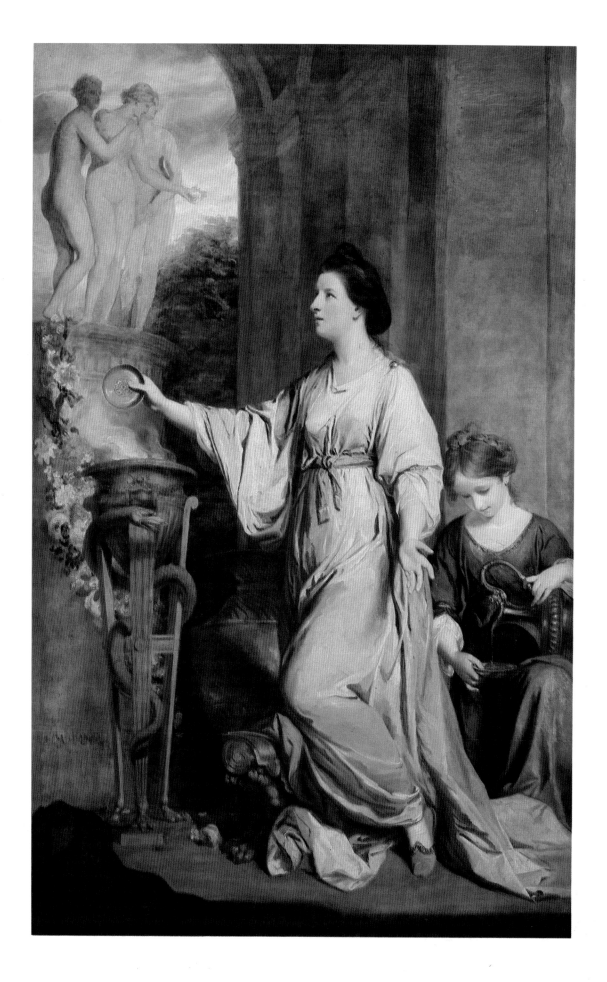

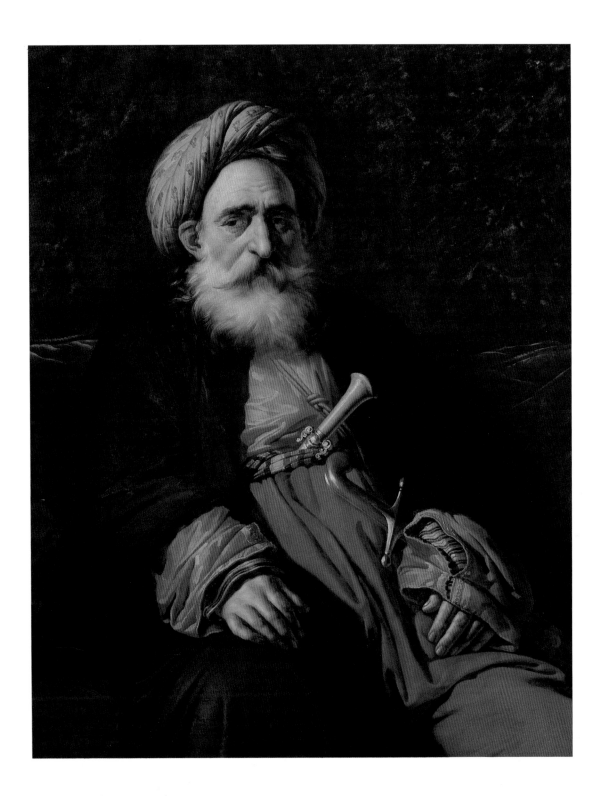

Anne Louis Girodet de Roucy-Trioson

French, 1767-1824
Portrait of the Katchef Dahouth, Christian Mameluke, 1804
Oil on canvas.
57 x 44½ in. /144.7 x 113 cm.
Gift of Frank H. and Louise B. Woods by exchange; Art Institute funds, 1987.260.

Anne Louis Girodet de Roucy-Trioson was one of the most gifted students of France's leading artist during the period of the Revolution, Jacques Louis David. After leaving David's studio, Girodet challenged the boundaries of his master's severe Neoclassicism, creating a body of work that helped define the transition to Romanticism. Girodet was regarded by his peers as one of the greatest painters of the era, but his renown declined and, in the late nineteenth century, many of his paintings were lost.

Portrait of the Katchef Dahouth, Christian Mameluke is one of several recently discovered paintings by Girodet. This monumental portrait was submitted in 1804 to the annual exhibition of the French Academy, the Salon, where it was a great critical success. The painting's brilliant colors, bold brushwork, and deeply felt characterization exemplify Girodet's style. The subject of the painting reflects French fascination with the Near East, inspired, in part, by French military exploits in the Middle East under Napoleon. This preoccupation with the exotic on the part of artists would find its fullest expression in the works of Théodore Géricault and Eugène Delacroix (see p. 49).

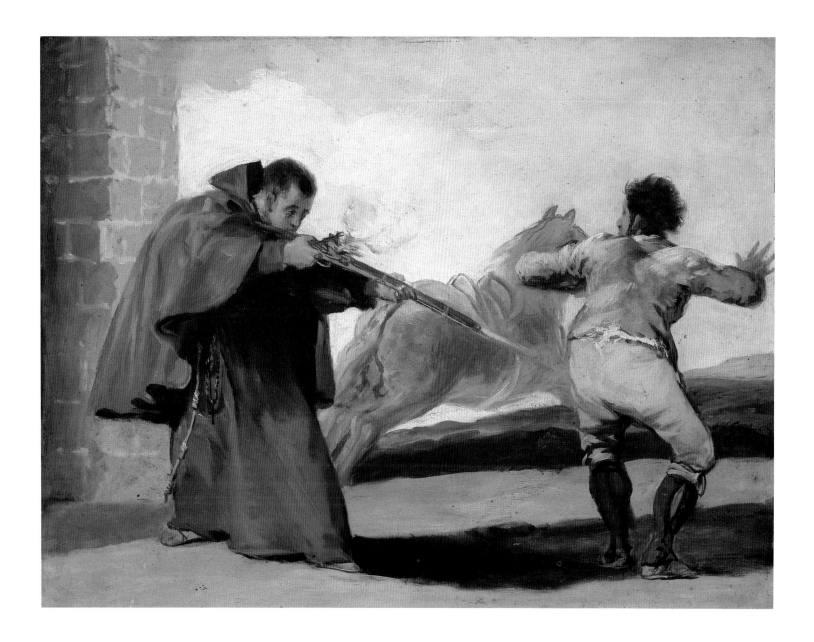

Francisco José de Goya y Lucientes

Spanish, 1746-1828
*Monk Pedro de Zaldivia Shoots
the Bandit Maragato,* 1806/07.
Oil on panel.
11 15/16 x 15 11/16 in. /30.3 x 39.9 cm.
Mr. and Mrs. Martin A. Ryerson Collection,
1933.1075.

The story of how the feared and villainous bandit Maragato was overpowered and captured by a lowly monk, Pedro de Zaldivia, swept through Spain soon after it happened in 1806. Celebrated in poetry and song, the tale had its comic aspects: the supposedly peace-loving and docile lay brother becoming a lion of action, the quintessential underdog overcoming the quintessential bully in true David-and-Goliath fashion; certainly, the wounds Monk Pedro delivered to Maragato's posterior provided the public with another amusing detail.

Francisco Goya was indeed what the art-history texts tell us, one of the great artists of his or any time, a deep thinker and commentator on human existence. This small and delightful painting demonstrates how Goya's interests embraced the whole human comedy. It is one of a series of six works in the Art Institute which, like a modern-day comic strip, tells us how Monk Pedro was assaulted and then overcame his attacker. This sequence of panels, almost certainly done for the artist's own amusement, illustrates Goya's active and flickering brushwork, unerring eye for psychologically charged moments, and an almost cinematic sense of storytelling. This series reminds us that one of the core functions of the visual arts has been to pictorialize, to render visible the oral and written word. Caught somewhere between high art and illustration, and combining the best qualities of both, Goya's panels show how rich and vibrant a tradition that can be.

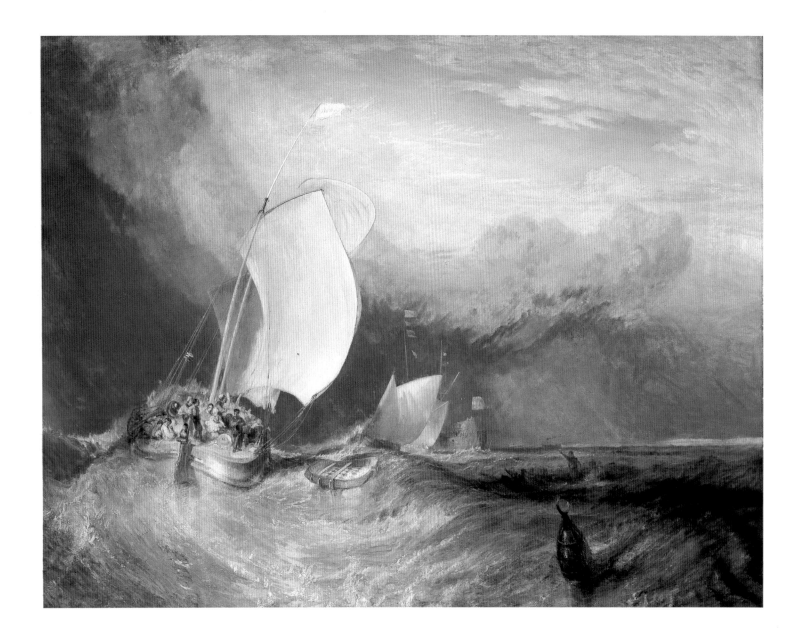

Joseph Mallord William Turner

British, 1775 - 1851
Dutch Fishing Boats, 1837/38.
Oil on canvas.
68¹¹/₁₆ x 88½ in. /174.5 x 224.9 cm.
Mr. and Mrs. W. W. Kimball Collection,
1922.4472.

In *Dutch Fishing Boats*, Joseph Mallord William Turner pursued a theme of long-standing personal interest, the sea. Beginning in the 1790s with scenes of moonlight reflected in water, Turner soon began to paint depictions of boats violently tossed by raging seas, as well as dramatic sunrises and sunsets.

When it was first exhibited in London in 1838, *Dutch Fishing Boats* bore the title *Fishing Boats with Hucksters Bargaining for Fish*. On board the large vessel with billowing sails in the left foreground are several roughly painted figures, who presumably will do business with a standing figure gesturing with an upraised arm in a small boat to the right. With these few figurative details, the "bargaining for fish" takes place, in the presence of ominously threatening sea and sky. The low horizon line, as well as the subject itself, derive from Turner's exposure during his formative years to seventeenth-century Dutch sea paintings. *Dutch Fishing Boats* dates from an important transitional phase of Turner's style in the mid-1830s, when he was becoming increasingly absorbed in rendering the effects of atmosphere and light.

In a small, yet not insignificant, detail, Turner alluded to the arrival of a new era at sea. Plying the calmer waters of the distant horizon is a steam-driven vessel, emitting a trail of dark smoke. Thus, Turner appears to have achieved two notable results in *Dutch Fishing Boats*: subtly opposing tradition and progress, while celebrating the moods and vicissitudes of nature.

Thomas Lawrence

British, 1769 - 1830
Mrs. Jens Wolff, 1803 - 15.
Oil on canvas.
50½ x 40⁵⁄₁₆ in. /128.2 x 102.4 cm.
Mr. and Mrs. W. W. Kimball Collection,
1922.4461.

Deep in thought, their costumes brilliant with sheens and glints, the sitters in Thomas Lawrence's paintings are the very image of Romantic heroes and heroines. Lawrence knew Isabella Wolff well, and was rumored to have had a love affair with her. When he began this portrait, she was living near London with her husband, a wealthy Anglo-Danish timber merchant and ship broker. But the work was left unfinished in the studio for over ten years, and by the time the artist took it up again, in 1814, the couple had separated and Mrs. Wolff was living with one of her sisters in a village in Kent.

In this portrait, she contemplates the figure of the Delphic Sibyl from the Sistine Chapel ceiling in a volume of engravings after Michelangelo, and her pose ingeniously echoes that of another Sibyl in the same work. The Sibyls were priestesses of classical legend who made enigmatic judgments and prophecies. They are often depicted in exotic costumes and settings, a tradition Lawrence followed in the turban, the shawl, and the Oriental rug on the desk. Over the sitter's shoulder, we glimpse another noble figure of the ancient world, that of Niobe in the famous classical sculpture in the Museo degli Uffizi in Florence. Lawrence's intention was clearly to represent Mrs. Wolff as a present-day embodiment of the feminine ideal celebrated in classical and Renaissance art.

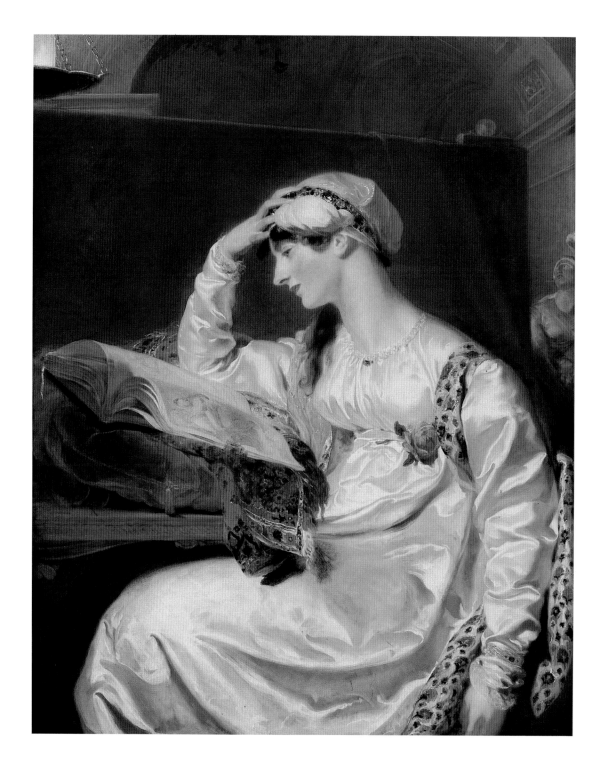

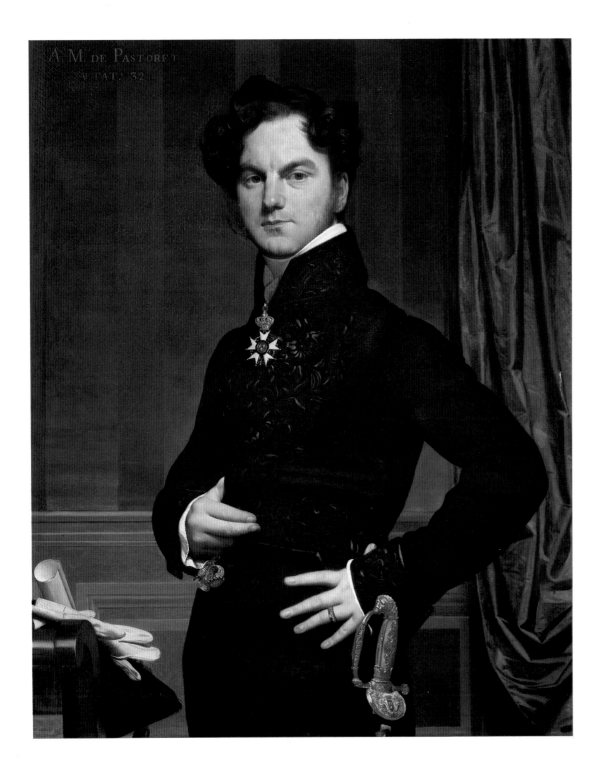

Jean Auguste Dominique Ingres

French, 1780 - 1867
Amédée-David, Marquis de Pastoret,
1823 - 26.
Oil on canvas.
40½ x 32¾ in. / 103 x 83.5 cm.
Bequest of Dorothy Eckhart Williams; Robert
Allerton Purchase, Bertha E. Brown, Major
Acquisitions funds, 1971.452.

The aesthetic rivalry of the two painters who dominated French art in the first half of the nineteenth century is one of the legends of art history: Eugène Delacroix (see p. 49), the great Romantic, whose canvases are celebrations of color, movement, and passion; and Jean Auguste Dominique Ingres, master of the eloquent line, whose exacting eye and love of precise, measured details indicate his devotion to classical ideals.

Ingres preferred to think of himself as a painter of epic moments in history and of the heroes and stories of the Bible and classical mythology. Yet, for many years, Ingres's livelihood came from his portraits, whether paintings or drawings, and it is these works that have accounted for the great esteem in which he is held today. Amédée-David, Marquis de Pastoret, was a young nobleman who seems to have assisted Ingres to become a member of the French Academy. From the marquess's elegant silhouette to the precisely rendered details of his sword hilt and medal of the Legion of Honor, everything about Ingres's portrait indicates the fastidiousness and sensitivity that characterize his art. The young man's slightly swaggering pose, elegant costume, long fingers, and even the tilt of his head proclaim his aristocratic status, along with something of the arrogance of his personality. All elements of the painting express not only the confidence and self-absorption of the sitter but also the assurance of a painter totally in command of his art.

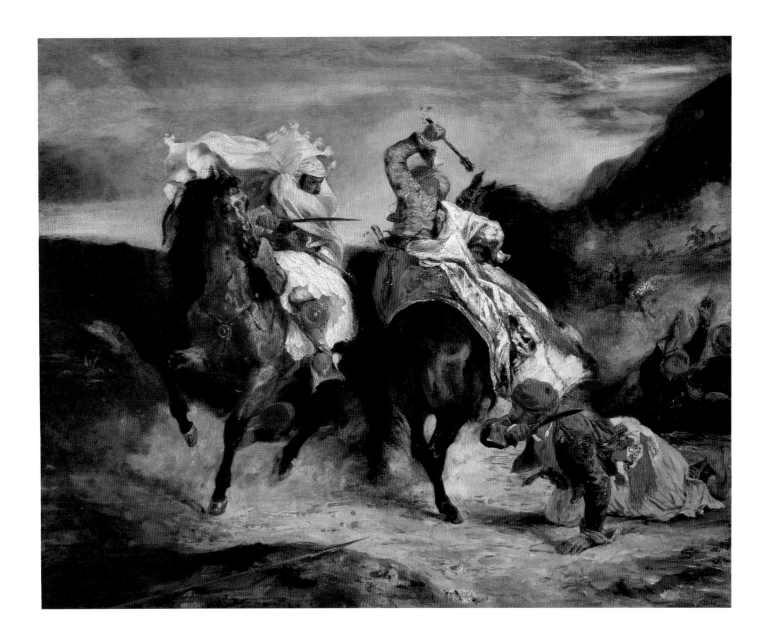

Eugène Delacroix

French, 1798-1863

Combat between the Giaour and Hassan in a Ravine, 1824-26.

Oil on canvas.

23½ x 28⅞ in. /59.6 x 73.4 cm.

Gift of Bertha Palmer Thorne, Mrs. Rose Movius Palmer, Mr. and Mrs. Arthur M. Wood, Mr. and Mrs. Gordon Palmer, 1962.966.

Admiration for Lord Byron's poem "The Giaour" (written in 1813 and translated into French in 1824) inspired Eugène Delacroix to interpret visually its themes of adventure and love. In *Combat between the Giaour and Hassan,* Delacroix depicted the dramatic climax of the story related in Byron's poem of a Venetian known as the "Giaour" (a Turkish word for Christian infidel or non-Muslim), who seeks to avenge his mistress's death at the hands of a Turk called Hassan, from whose harem she had fled. Set on a Greek battlefield, the painting focuses on the two men, mounted on spirited horses, facing each other in mirror-image poses, their weapons raised. Considered the finest of the six known versions Delacroix based

on the theme of Byron's poem, the Art Institute's painting was begun in 1824, the year Byron died fighting for Greek independence from the Turks. Completed two years later, it was first shown in Paris in 1827 at an exhibition to benefit the Greek cause.

The vigorous interaction of glowing colors, forms in motion, and dramatic subject are characteristic of Delacroix's art. The numerous Greek and Turkish battle scenes of his early years represent not only his identification with the Greek war of liberation, but also his preoccupation with exotic lands and themes of passion.

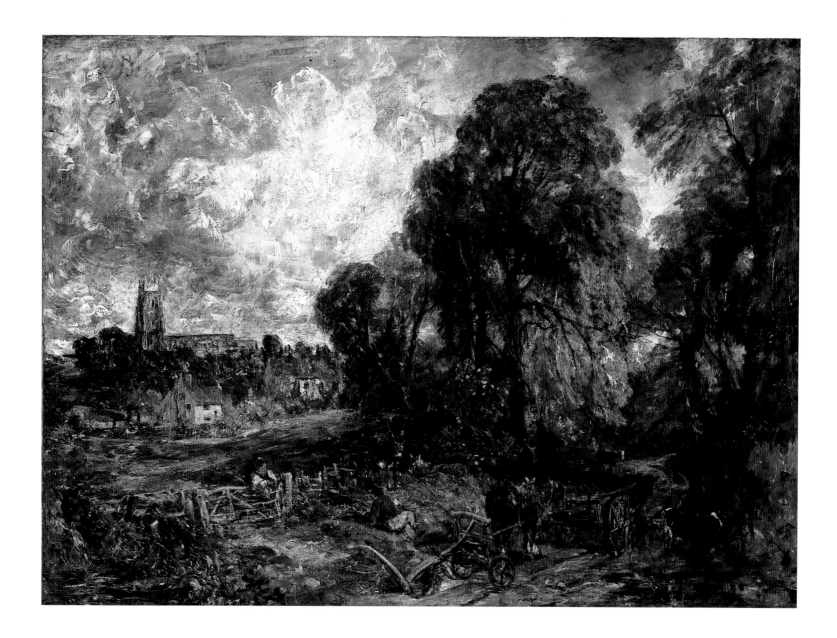

John Constable

British, 1776-1837
Stoke-by-Nayland, 1836.
Oil on canvas.
49⅝ x 66½ in. /126 x 169 cm.
Mr. and Mrs. W. W. Kimball Collection,
1922.4453.

Even after living for many years in London, John Constable continued to draw his subjects from the countryside dear to him from boyhood. Stoke-by-Nayland lies a few miles from his native village of East Bergholt in Suffolk. In this view from the south, the brilliant, airy vista toward the village contrasts with the shady, tun-nel-like country lane leading off to the right. Constable explained that the time is meant to be eight or nine o'clock on a summer's morning, with the land still dewy and damp from a light rain shower during the night. One of the means he employed to suggest the fertility of the land was to emphasize the abundance of water, fleck-ing the surface with white highlights to create effects of sparkling wetness. Here, the whole scene appears doused, with a stream and pud-dles in the foreground and a central tree that droops as if heavy with moisture.

Painted as much with a palette knife as with brushes, *Stoke-by-Nayland* lacks the finish that Constable gave the pictures he brought before the public at exhibitions. It was either simply left unfinished or meant as a full-scale sketch for a work that was never realized. Yet, his delight in freely scribbling and scraping the image into existence is obvious. What is lost in detail is gained in atmosphere and the sense of changeability of the weather. The roughness of the surface mimics the textures of nature, and the painterly fusion of manmade and natural elements embodies an ideal of harmony ger-mane to Constable's vision of rural England.

Jean Baptiste Camille Corot

French, 1796 - 1875
Interrupted Reading, c. 1870.
Oil on canvas mounted on board.
36⁵⁄₁₆ x 25⁵⁄₈ in. /92.5 x 65.1 cm.
Potter Palmer Collection; bequest of Bertha
Honoré Palmer, 1922.410.

When Camille Corot painted *Interrupted Reading*, he was nearing the end of a long career devoted to gaining acceptance for landscape painting in France. Only in later years, after landscape had achieved an elevated status, did Corot turn to other subjects. *Interrupted Reading* recalls a well-established tradition that was especially popular in Romantic art: the reading figure. This subject appears in other works by Corot, including his landscapes. The unidentified woman in the Art Institute's painting is pensive, solitary, and melancholic, the very essence of the Romantic sensibility. Books have often been included in works of art as attributes and symbols to identify a person, to represent learning and inspiration, or simply to establish a mood. The inclusion here of an open book — which the woman is, for the moment, not reading — creates for her an aura of muselike contemplation.

This painting's theme is its only traditional element. The brushwork is as direct and bold as that of Edouard Manet (see pp. 52, 62). It is complemented by Corot's obvious love of detail — the ribbon in the sitter's hair, the earrings, the necklace. In this work and in other figural studies, Corot explored the female form as a construction of masses that balance and support one another. Here, the curves of her upper torso are repeated in the lines of the pleated skirt. A gentle light and subtle colors infuse this formal structure with the softness and intimacy that characterize the landscapes with which the artist achieved his fame.

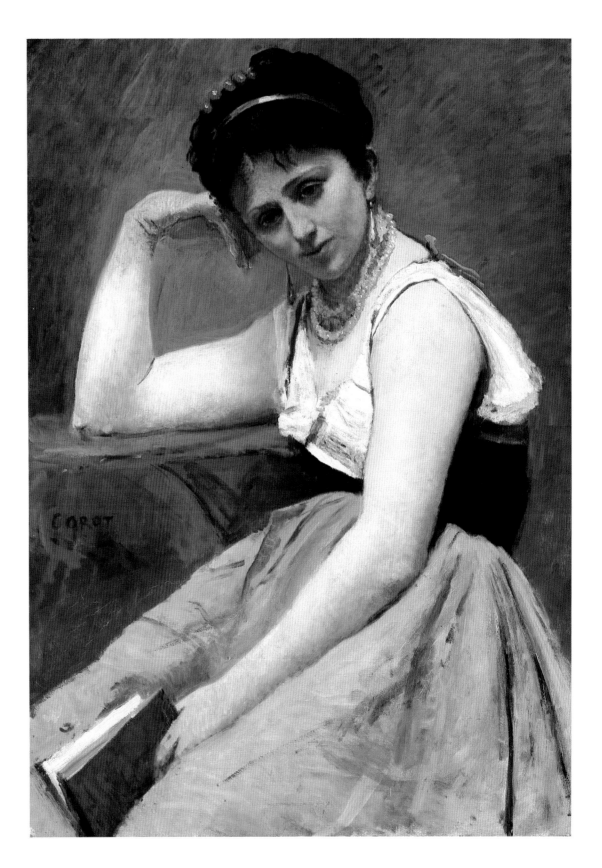

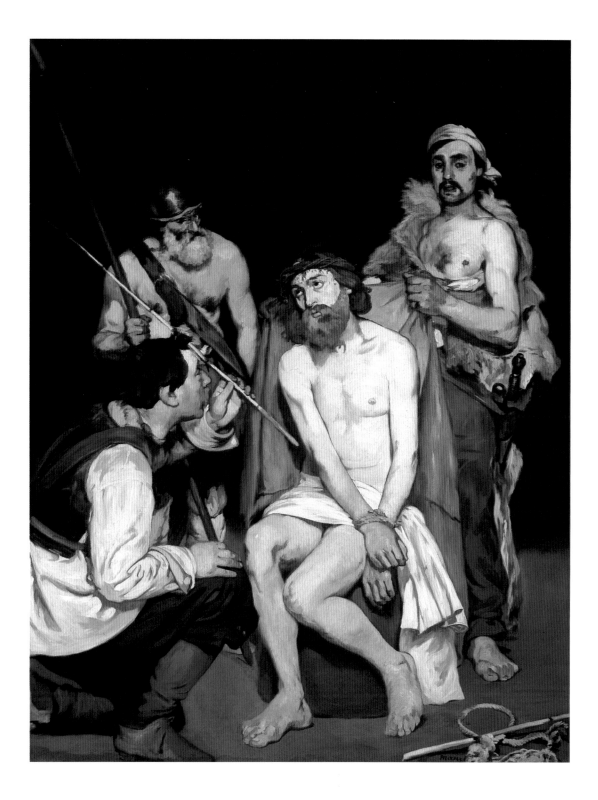

Edouard Manet

French, 1832 - 1883
The Mocking of Christ, 1865.
Oil on canvas.
74⅞ x 58⅜ in. /190.3 x 148.3 cm.
Gift of James Deering, 1925.703.

Throughout his career, Edouard Manet managed to shock and confound the public with his bold technique and unorthodox subjects. The most shocking feature of his great religious composition *The Mocking of Christ* is that it was painted at all. Since the advent of the Realist movement in earlier nineteenth-century French painting, spearheaded by Gustave Courbet (see p. 53), who said, "Show me an angel and I will paint one," religious subjects in France had not been pursued by avant-garde artists. Yet, while Manet was most certainly a painter of secular subjects — indeed, he was sophisticated and urbane in his themes and orientation — he was interested in the religious themes that had compelled artists for many centuries. It is likely that there is a connection between this interest and the popular contemporary biography *The Life of Jesus* (1863) by French philosopher and historian Joseph Ernest Renan, a controversial work that emphasizes the humanity of Jesus.

In *The Mocking of Christ*, Jesus is made very human and vulnerable by his frontal presentation and by the earthy characters around him. The painting depicts the moment when Jesus' captors mock the "King of the Jews" by crowning him with thorns and covering him with a robe. Although, according to the Gospel narrative, this taunting is followed by beatings, Manet's would-be tormentors appear ambivalent as they surround the pale, stark figure of Christ. One gazes at him, one kneels in apparent homage, and one holds a cloak in such a way as to suggest that he wishes to cover Jesus' nakedness, rather than strip him.

Gustave Courbet

French, 1819 - 1877
Mère Grégoire, 1855, 1857 - 59.
Oil on canvas.
50¾ x 38⅜ in. /129 x 97.5 cm.
Wilson L. Mead Fund, 1930.78.

In 1855, his work having been rejected by conservative official juries, the leading French Realist Gustave Courbet staged his own exhibition of paintings near the site of Paris's first Universal Exposition. In that year, he is also believed to have begun *Mère Grégoire.* Twelve years later, on the occasion of the next Universal Exposition in Paris, Courbet again mounted an independent exhibition of his works, including a painting entitled "Mère Grégoire." In the years between the painting's inception and its first public appearance, the work had undergone a significant physical transformation. Originally a small portrait of a woman's head, it was set within a larger canvas by the end of the 1850s, allowing for a more developed view of the woman's surroundings.

The subject of Courbet's painting has traditionally been identified as the wife of the proprietor of a tavern in Paris where Courbet and his colleagues met. But, recently, the woman portrayed here has been identified with a popular song with lyrics by Pierre Jean Béranger, a writer whose radical social and political views became well-known in songs he composed during the post-Napoleonic years. Béranger's Mère Grégoire is not the patroness of a respectable pub, but of a house where, for the right number of coins, sexual favors could be procured. To Courbet and others of his generation, the heroine of this song represented the rights to freedom in life and love that were forbidden under a repressive regime. Thus, the artist clearly endowed his subject with political, as well as sexual, meaning.

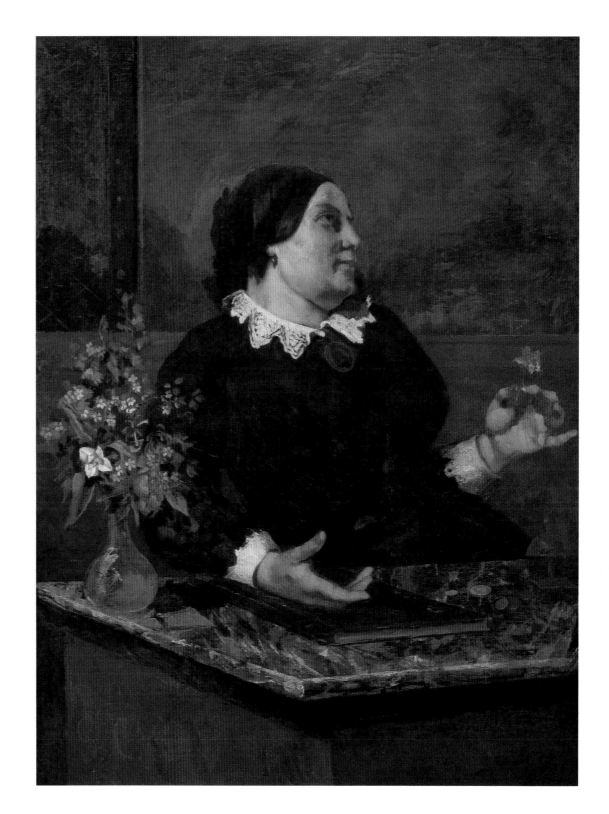

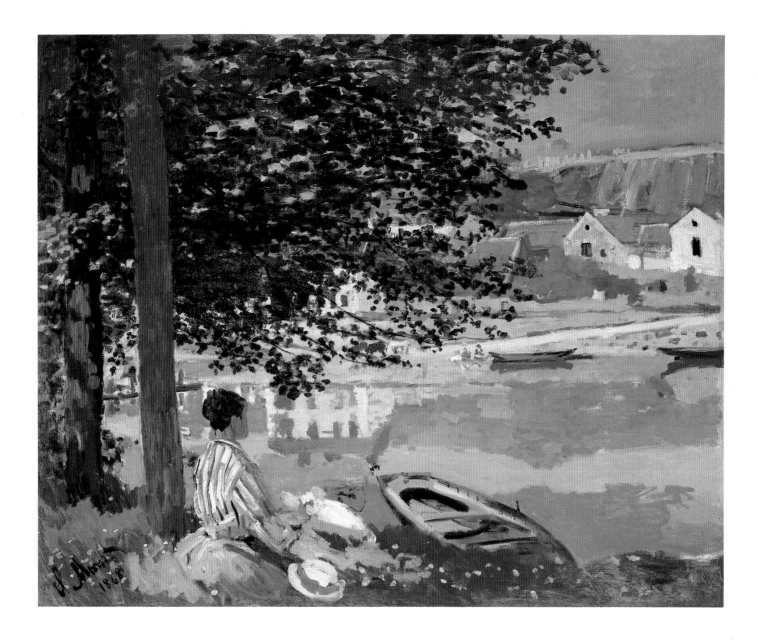

Claude Monet

French, 1840-1926
On the Seine at Bennecourt, 1868.
Oil on canvas.
32¹⁄₁₆ x 39⅝ in. /81.5 x 100.7 cm.
Potter Palmer Collection, 1922.427.

During the late 1860s and '70s, Claude Monet remained in or near Paris. These were the years during which the so-called Impressionist movement began, aided by the series of eight exhibitions that were inaugurated in 1874. Having experienced continued rejection of his early paintings, Monet waited until the 1876 Impressionist exhibition before showing *On the Seine at Bennecourt*, which he had painted nearly a decade before. This work, in which Monet's future wife Camille Donceaux is seen on the river bank gazing across at the town of Bennecourt, demonstrates all the freshness and verve of an oil sketch.

The painting's pleasant imagery — a sunny summer day in the countryside — belies the art-ist's revolutionary painting technique, which appears deliberate and crude when compared to the polished surfaces and carefully delineated details of the academic paintings that were held in such esteem at the time. Monet evolved this style in order to suggest the sparkling light, the freshness of the air, the loveliness of the day. In its evocation of the feeling of a specific time and place, the painting is an impression, a visual moment captured and fixed forever.

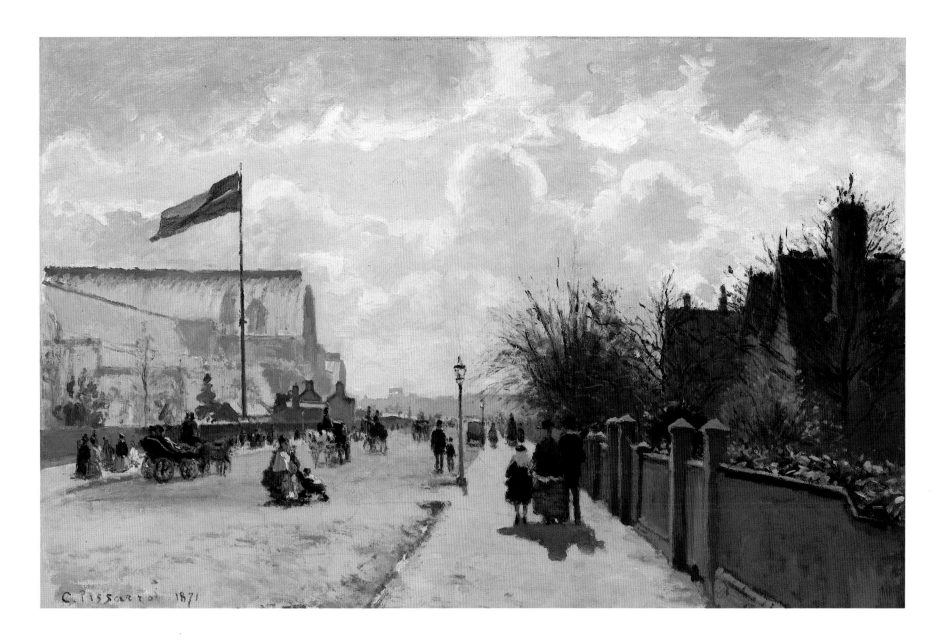

Camille Pissarro

French, 1830-1903

The Crystal Palace, 1871.

Oil on canvas.

18⁹/₁₆ x 28¹⁵/₁₆ in. /47.2 x 73.5 cm.

Gift of Mr. and Mrs. B. E. Bensinger,

1972.1164.

Although fiercely patriotic, Camille Pissarro was persuaded by his family to escape the Franco-Prussian War and the violent suppression of the Paris Commune by living in England during 1870-71. *The Crystal Palace* depicts the most celebrated architectural landmark of the London suburb where the artist and his family were living. Joseph Paxton's imposing modular glass-and-iron structure was designed for the Great Exhibition held in London's Hyde Park in 1851. Afterwards, it was dismantled and moved to nearby suburban Sydenham, where it stood from 1853 until it was destroyed by fire in 1936.

An acclaimed symbol of technological achievement in the nineteenth century, the Crystal Palace in this painting coexists almost modestly in its suburban setting with the ubiquitous red-brick residential architecture of the Victorian era. The world's largest building at the time is here seen at quite a distance from the viewer. Intended as a simplified form without much detail, its immense expanse of glass reflects light and the many forms of nearby objects, in contrast to the dark solidity of the fences, figures, and houses in the right foreground. The center of the painting is occupied by a wide road and two walkways, filled with moving pedestrians and carriages. To judge from the flag on the pole to the left, a brisk wind is blowing, and the light that rims the edges of the clouds reflects off the glass expanses of the Crystal Palace and touches the pedestrians and carriages, uniting all in a vivid image of afternoon leisure.

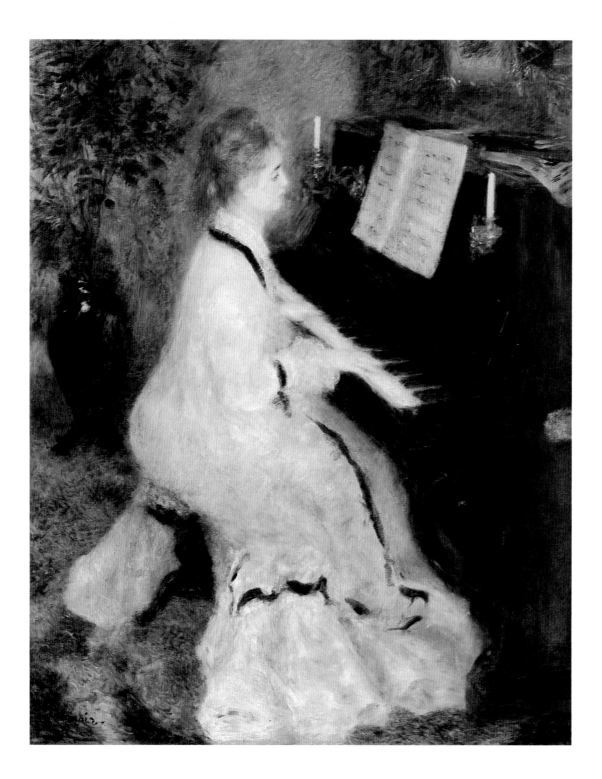

Pierre Auguste Renoir

French, 1841 - 1919
Woman at the Piano, 1875/76.
Oil on canvas.
36⅝ x 29½ in. /93.2 x 74.2 cm.
Mr. and Mrs. Martin A. Ryerson Collection,
1937.1025.

Pierre Auguste Renoir's paintings typically offer glimpses of lighthearted, pleasurable moments — at the opera, in cafés, on the banks of the Seine, in informal domestic settings. Intimate in scale and subject, *Woman at the Piano* was one of fifteen paintings by Renoir included in the second group exhibition of the Impressionists, held in 1876.

The setting of *Woman at the Piano* is bathed in gentle light, which accents the luminous tones of the young woman's white dress. Only a few objects are prominently visible in the abbreviated view of the room, but they are sufficient to suggest a genteel, well-appointed interior. A large plant, its dark vase reflecting patches of light, fills the left corner of the composition, while the piano stool, although partially obscured by the woman's voluminous dress, subtly draws attention to the variegated pattern in the carpet. The depiction of the woman is enlivened by a few well-chosen accents, especially the rhythmic, sinuous dark line gracing her dress. Renoir's "blacks" are rendered as deep blues, purples, and reds, so that even the darkness of the room is alive with color. Renoir has created a scene of refined harmonies and delicate counterpoint appropriate to the musical theme of the painting.

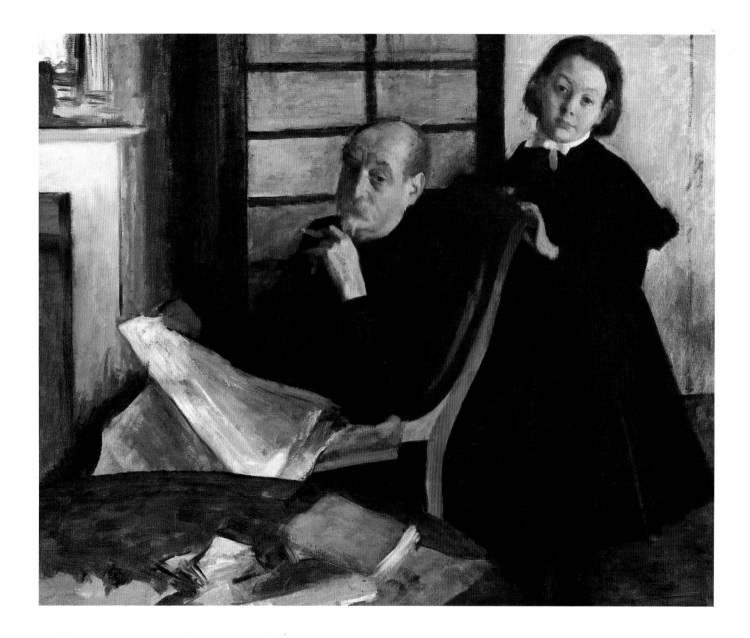

Hilaire Germaine Edgar Degas

French, 1834-1917

Uncle and Niece (Henri de Gas and His Niece Lucie de Gas), 1875/78.

Oil on canvas.

39¼ x 47³⁄₁₆ in. /99.8 x 119.9 cm.

Mr. and Mrs. Lewis Larned Coburn Memorial Collection, 1933.429.

Edgar Degas was the most subtle portrait painter in the Impressionist group. His portraits, mostly of close friends and relatives, were painted primarily in the period from the late 1850s through the 1870s. During frequent visits to his family in Florence and Naples, Degas recorded his Italian relatives with great candor. On one of his last trips to Naples, in the mid-1870s, Degas painted *Uncle and Niece*, a double portrait of his young orphaned cousin Lucie and her uncle Henri, in whose care she had recently been placed. *Uncle and Niece* depicts two people separated by many years in age, who are tentatively accepting the circumstances of their new relationship. Degas, having recently lost his own father and witnessed other family misfortunes, addressed his subjects with awareness and sensitivity.

Areas of thin paint and unresolved detail suggest that the painting was never completed. However, the spare treatment of the background effectively emphasizes the heads and upper portions of the two figures. Their connection is expressed in the similar tilt of their heads and in the black mourning clothes they wear. But their psychological distance is suggested by the contrast of the plain wall behind Lucie and the darker glass-and-wood French door behind Henri; and by the curved chair back against which the old man sits and on which the child leans. At once intimate and distant, casual and guarded, these two relatives, and the third relation who paints them on the other side of the paper-laden table, express poignantly the fragility and necessity of family ties.

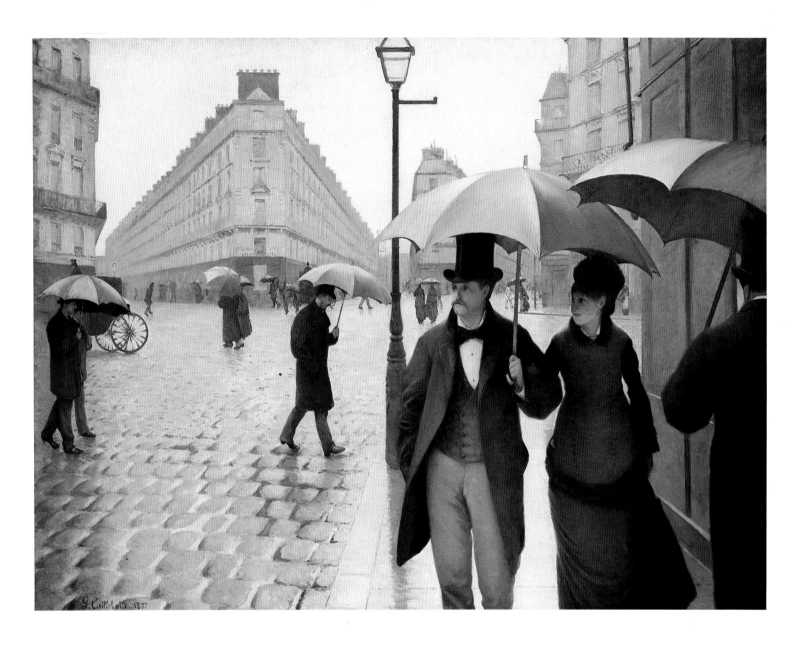

Gustave Caillebotte

French, 1848 - 1894
Paris, a Rainy Day, 1876-77.
Oil on canvas.
83½ x 108¾ in. /212.2 x 276.2 cm.
Charles H. and Mary F. S. Worcester Fund,
1964.336.

Gustave Caillebotte was the major organizing force behind the Impressionist exhibition of 1877. This show was the finest of the eight the group organized, and it was dominated by Caillebotte's masterpiece, *Paris, a Rainy Day.* The painting hung with Claude Monet's series of depictions of the Gare Saint-Lazare (see p.

59) and Auguste Renoir's *Moulin de la Galette* (Musée d'Orsay, Paris).

In *Paris, a Rainy Day*, the upraised umbrellas, reflections of water on the pavement, and pervasive gray tonalities all convey the artist's interest, shared with the Impressionists, in suggesting atmospheric conditions. Selecting a complex intersection near the Gare Saint-Lazare, the artist changed the size of the buildings and the distance between them to create a wide-angle view that becomes the visual equivalent for the sweeping modernity of this capital city. Caillebotte's fascination with perspective can be seen in the painting's careful structure, which makes calculated use of the lamppost to separate the foreground from the

middle and distant views.

While *Paris, a Rainy Day*'s highly crafted surface, monumental size, geometric order, and elaborate perspective are more academic than Impressionist in character, Caillebotte clearly made use of all these elements to underscore the power of painting to capture the momentary quality of everyday life: it is easy to imagine that, if we blink our eyes, everyone in the painting will have moved and nothing will be the same.

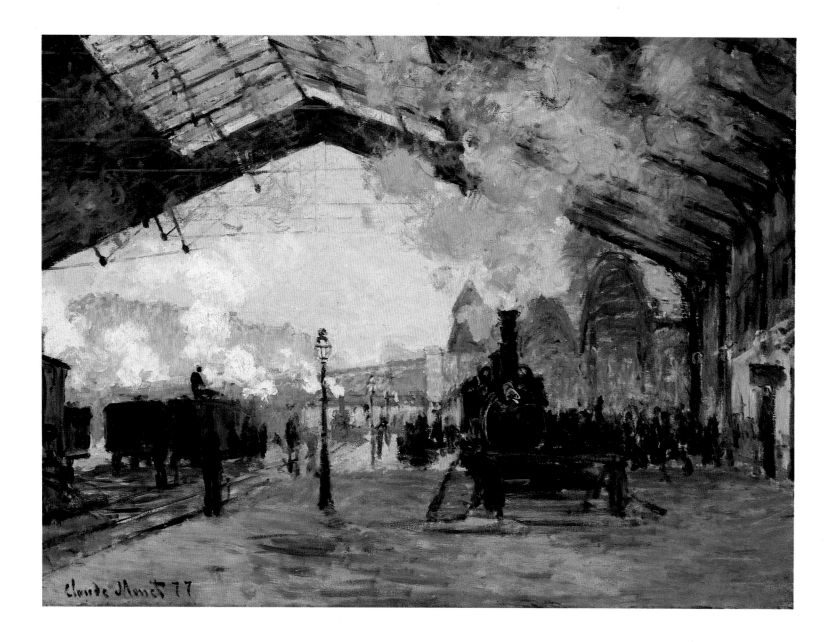

Claude Monet

French, 1840-1926
*The Arrival of the Normandy Train
at the Gare Saint-Lazare*, 1877.
Oil on canvas.
23½ x 31½ in. /59.6 x 80.2 cm.
Mr. and Mrs. Martin A. Ryerson Collection,
1933.1158.

The Impressionists frequently paid tribute to the modern aspects of Paris. Their paintings abound with scenes of grand boulevards and elegant new blocks of buildings, as well as achievements of modern construction, such as iron bridges, exhibition halls, and train sheds.

The Arrival of the Normandy Train at the Gare Saint-Lazare was an especially appropriate choice of subject for Claude Monet in the 1870s. The terminal, linking Paris and Normandy, where Monet's technique of painting out-of-doors had been nurtured in the 1860s, was also the point of departure for towns and villages to the west and north of Paris frequented by the Impressionists. Monet had completed at least seven of his twelve known paintings of the Gare Saint-Lazare in time for the third Impressionist exhibition in 1877. Probably placed in the same gallery, the works inaugurated what was to become for Monet an established pattern of painting a specific motif repeatedly, in order to capture subtle and tem-

poral atmospheric changes.

Monet chose to focus his attention on the glass-and-iron train shed, where he found an appealing combination of artificial and natural effects: the rising steam of locomotives trapped beneath the roof of the structure, and daylight penetrating the large glazed sections of the roof. Typically, Monet denied the scene any anecdotal or narrative expression in favor of capturing a transitory experience, further emphasized by the painting's sketchlike appearance in many areas.

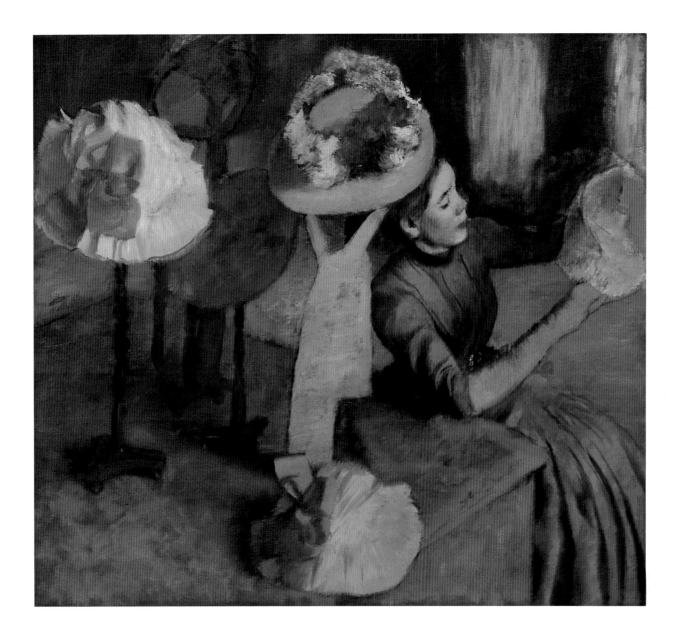

Hilaire Germaine Edgar Degas

French, 1834-1917
The Millinery Shop, 1879/84.
Oil on canvas.
39⅜ x 43⁹⁄₁₆ in. /100 x 110.7 cm.
Mr. and Mrs. Lewis Larned Coburn Memorial
Collection, 1933.428.

The women in Edgar Degas's paintings seem unaware of being watched. The artist rejected conventional poses that appeared contrived and depicted the natural movements of his models. *The Millinery Shop* portrays such a young woman, absorbed in the task of creating a hat. These colorful objects of changing fashion were for Degas symbolic of the modern bourgeois woman, and allowed him to indulge his fascination with contrasting colors. He explored the theme of hats, their making, and purchase in at least fifteen pastels and oils, all created during the early 1880s.

In *The Millinery Shop*, the viewer assumes the role of potential buyer, perhaps looking at the display of hats through the shop window. Degas's interest in Japanese wood-block prints, with their unorthodox compositions, and the newly developing art of photography, with its unexpected croppings, inspired him to find new and highly effective ways of drawing the viewer into his pictorial space: for example, the unusual angle of vision and the oddly placed figure dominated by the arrangement of hats of *The Millinery Shop*.

Degas's emphasis on composition, draftsmanship, and gesture differentiates him from most of his fellow Impressionists, who were more concerned with the shifting light effects they studied out-of-doors. In such works as *The Millinery Shop*, Degas successfully captured the fleeting gesture of a young worker, giving it a permanence that transcends time.

Pierre Auguste Renoir

French, 1841 - 1919
Two Little Circus Girls, 1878-79.
Oil on canvas.
51¾ x 39⅛ in. /131.5 x 99.5 cm.
Potter Palmer Collection, 1922.440.

Appreciation for life and the beauty of the female form enliven the art of Pierre Auguste Renoir. "For me," he said, "a picture must be a pleasant thing, . . . joyful and attractive." In many works such as *Two Little Circus Girls*, he carefully edited his world to fit his beliefs.

Depicted in a circus arena are two young girls who actually posed in costume in Renoir's studio, allowing him to paint them in daylight. They were Francesca and Angelica Wartenberg, probably acrobats in their father's famed Circus Fernando in Paris (the subject of paintings by other Impressionists; see p. 65). The two sisters have finished their act and are taking their bows at the center of the ring. One, her arms filled with oranges tossed as a reward by the audience, has turned away and faces the viewer; the other looks up at the crowd, acknowledging its admiration. While *Two Little Circus Girls* reflects the artist's enchantment with the freshness of childhood, it also suggests other, less wholesome, meanings. It is perhaps significant that the spectators, depicted in an abbreviated fashion in the background, are darkly clothed men whose leering presence suggests the sexual traffic prevalent in the nocturnal entertainment world in which these two, perhaps not so innocent, children were growing up.

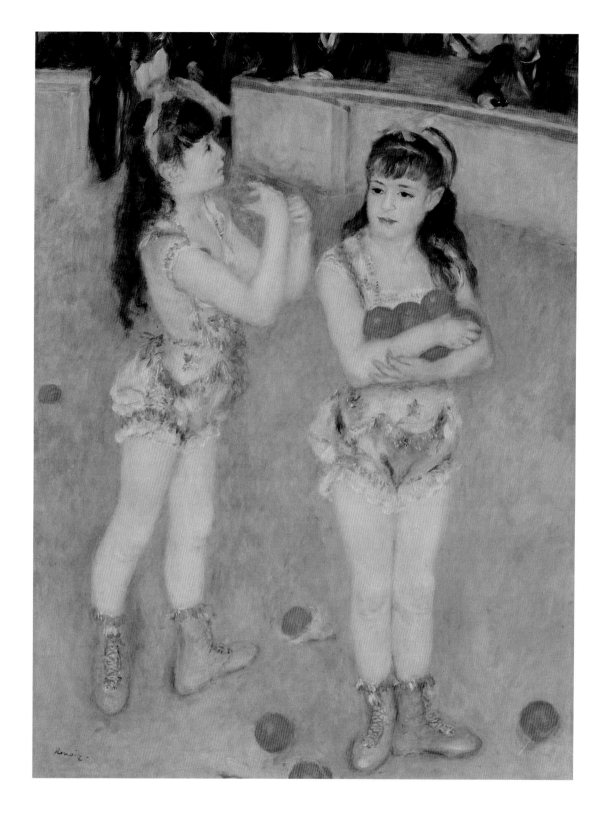

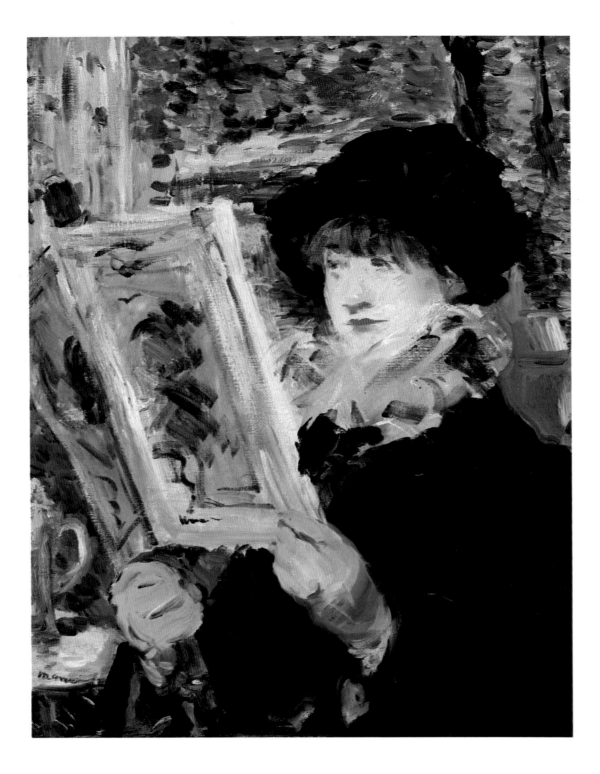

Edouard Manet

French, 1832 - 1883
The Reader, 1878/79.
Oil on canvas.
24¹⁄₁₆ x 19⁷⁄₈ in. /61.2 x 50.7 cm.
Mr. and Mrs. Lewis Larned Coburn Memorial
Collection, 1933.435.

During the late nineteenth century, Parisian cafés were the gathering places of artists and writers and were ideal for observing the urban scene. Many Impressionist paintings depict the Café Nouvelle-Athènes on the Rue Pigalle, where two tables were reserved for Edouard Manet and his circle — a group that included the painters Degas, Pissarro, Monet, and Renoir, and the writers Zola and Baudelaire.

The Reader is thought to be set in the Café Nouvelle-Athènes; Manet could well have passed by this fashionably dressed young lady on his way into the establishment. The illustrated magazine (perhaps one of the popular French periodicals of the day in which Manet's drawings sometimes appeared), which is attached to the wooden bar that the woman holds, would have been taken from the café's reading rack. Her heavy clothing suggests that she is seated at an outdoor table, that the weather is cool, and that the colorful garden view behind her is probably a painted backdrop.

The Reader is one of the most Impressionistic of Manet's paintings; the quick, free brushstrokes and light colors are characteristic of his technique late in his career. Painted only a few years before his death, this work admirably captures the fleeting moment, the sense of a quick glance that the Impressionists sought to represent.

Vincent van Gogh

Dutch, 1853 - 1890
Self-Portrait, 1886/87.
Oil on cardboard mounted on cradled panel.
16⅛ x 13¼ in. /41 x 32.5 cm.
Joseph Winterbotham Collection, 1954.326.

Vincent van Gogh's tumultuous and intense career as a painter was actually very brief. After working for an art merchant, he became a missionary. In 1886, he left his native Holland and settled in Paris, where his beloved brother, Theo, was a dealer in paintings. He actively pursued his art for a period of only five years before his suicide in 1890.

In the two years that van Gogh spent in Paris, he painted no fewer than two dozen self-portraits. The Art Institute's early example is modest in size and painted on cardboard rather than on canvas. The painting displays the bright palette he adopted in reaction to the bustling energy of Paris and to his introduction to Impressionism. The dense brushwork, which was to become a hallmark of van Gogh's style, represents his response to *Sunday Afternoon on the Island of La Grande Jatte* (see p. 64), in which Georges Seurat introduced his revolutionary "dot" technique. Van Gogh saw Seurat's painting when it was exhibited in the 1886 Impressionist exhibition. In the Art Institute's *Self-Portrait,* the sharp, direct gaze of the artist, whose eyes practically frown in concentration, dominates the dazzling array of staccato dots and strokes that animate van Gogh's shoulders and the background. When one can finally tear one's gaze away from the painter's, attention shifts to his mouth. With its tightly closed, almost pursed, lips, it seems to reveal the man's intensity and ultimately self-destructive sensitivity.

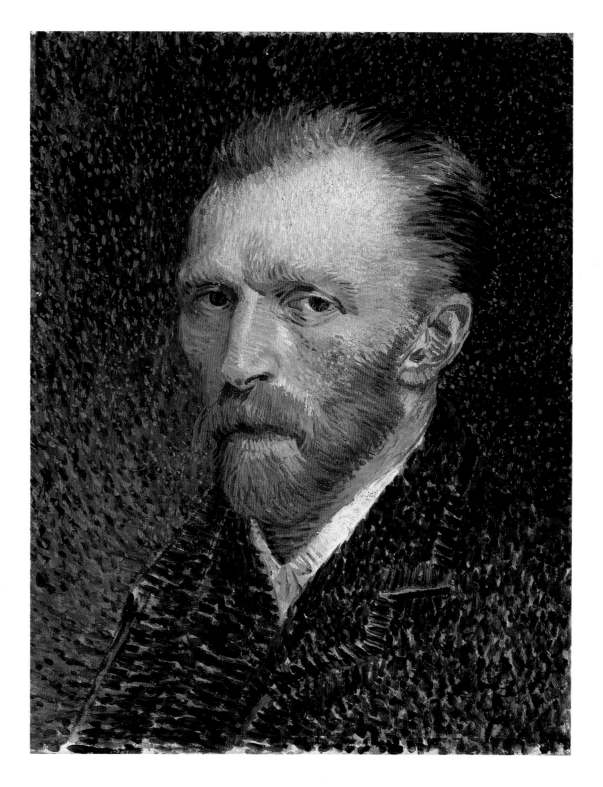

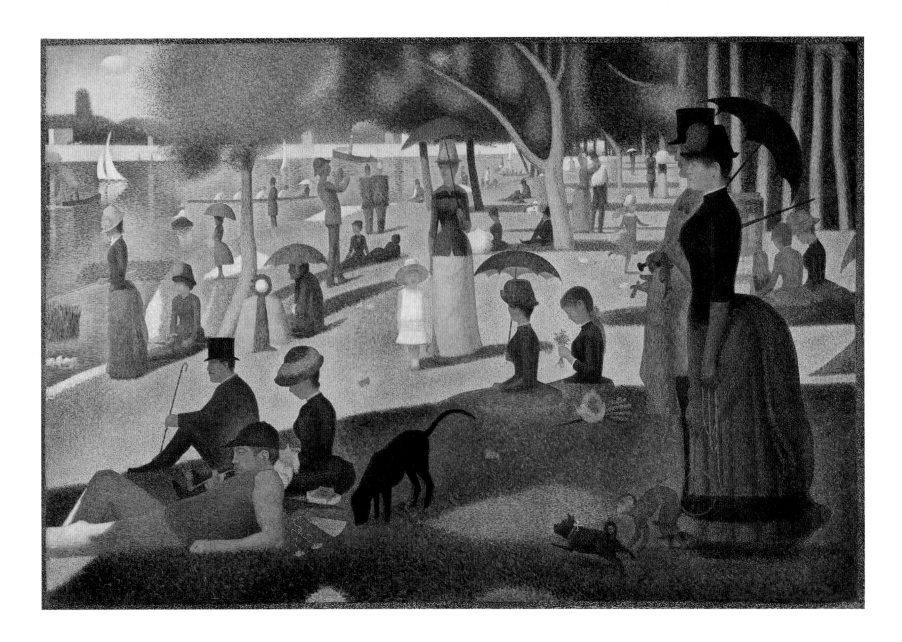

Georges Seurat

French, 1859-1891
*Sunday Afternoon on the Island
of La Grande Jatte,* 1884-86.
Oil on canvas.
81¾ x 121¼ in. /207.5 x 308 cm.
Helen Birch Bartlett Memorial Collection,
1926.224.

Georges Seurat developed his own, "scientific" approach to painting, according to which he juxtaposed tiny dots of color to create hues that he believed, through optical blending, are more intense than pure colors mixed with black or white to define three-dimensional forms. *Sun-*

day Afternoon on the Island of La Grande Jatte is generally considered Seurat's masterpiece and one of the greatest paintings of the nineteenth century, remarkable for its unusual technique, stylized figures, and enormous scale. Seurat labored over the *Grande Jatte*, doing numerous chalk drawings and oil sketches, which are brightly colored and much freer in handling than the final work. The artist Camille Pissarro (see p. 55), to whom Seurat showed the picture in 1885, seems to have criticized the canvas's extreme formality and lack of freshness, with the result that Seurat reworked the painting. He increased the curving contours of the chief figures to make them appear more relaxed and added strokes of vivid color. In a final campaign

on the picture, he added a border painted with colored dots to heighten the painting's palette even further.

The Grande Jatte is an island in the Seine just outside Paris. In Seurat's day, it was a park that attracted city residents seeking recreation and relaxation. Over the past several decades, many attempts have been made to explain the meaning of this great composition. For some, it shows the middle class at leisure; for others, it reveals, through its groupings and details, social tensions of modern city dwellers. Ironically, the Art Institute's most famous painting remains one of its most enigmatic.

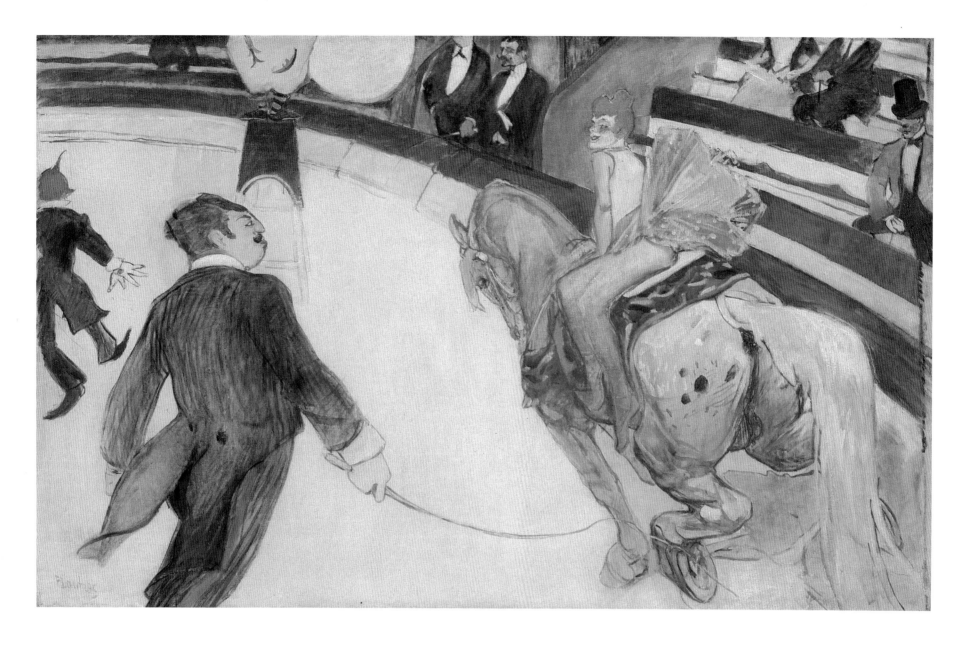

Henri de Toulouse-Lautrec

French, 1864 - 1901
In the Circus Fernando:
The Ringmaster, 1887 - 88.
Oil on canvas.
39½ x 63½ in. /100.3 x 161.3 cm.
Joseph Winterbotham Collection, 1925.523.

The Circus Fernando inspired a number of French painters both before and after it was a subject for the art of Henri de Toulouse-Lautrec: Renoir (p. 61), Degas, Seurat, and even Fernand Léger depicted the famous attraction. Born into a noble family and disabled since childhood, Toulouse-Lautrec

turned away from his birthright and sought companionship and excitement in the bawdy night life of Paris, of which the Circus Fernando was a prime attraction.

Toulouse-Lautrec was inspired by aspects of Japanese prints and the visual possibilities signaled by photography. In the painting *In the Circus Fernando: The Ringmaster*, for example, the center of the composition is empty; instead, the picture is structured by the sweeping curve of the ring. The curve is repeated continually throughout the scene: in the powerful haunches of the circus horse, the ring and gallery, the billowing trousers of a clown at the top of the picture, and, most prominently, in the extraordinary aquiline profile of the ringmaster him-

self. This menacing figure is linked by the whip in his hand and his penetrating gaze to the rider, who, from her perch atop the horse, glances over her shoulder at the ringmaster. The tension thus created is psychological as well as visual. Isolated against the pale ground of the circus ring and striding forward, his whip outthrust, the ringmaster clearly dominates the scene in ways that extend beyond the performance at hand.

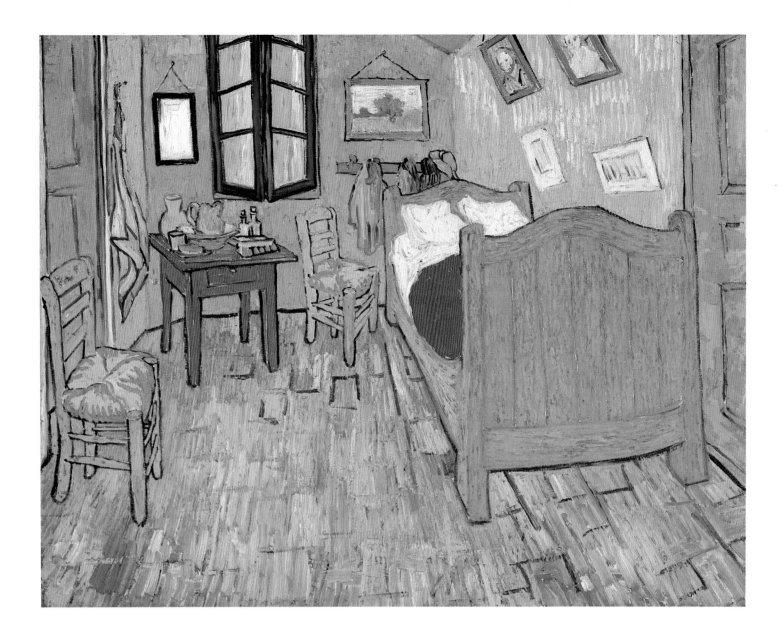

Vincent van Gogh

Dutch, 1853 - 1890
Bedroom at Arles, 1888.
Oil on canvas.
29 x 36⅝ in. /73.6 x 92.3 cm.
Helen Birch Bartlett Memorial Collection,
1926.417.

When Vincent van Gogh left Paris in 1888 for the southern French city of Arles, his intention was to create "The Studio of the South," a colony for artists. He tried repeatedly to convince his brother, Theo, and his artist friends Paul Gauguin (see pp. 67, 71) and Emile Bernard to join him in establishing a community there.

In anticipation of his friends' arrival, van Gogh set out to create paintings to decorate his home and studio; these included images of flowers, views of Arles, and the deeply revealing *Bedroom at Arles,* completed in October 1888 after a stressful period of overwork. To the artist, the picture symbolized relaxation and peace, despite the fact that, to our eyes, the canvas seems bursting with nervous energy, instability, and turmoil. Although the room looks warm and bathed in sunshine, the very intensity of the palette undermines the intended mood of restfulness, especially when combined with the sharply receding perspective and the inclusion of pictures tilting off the wall. As in all of van Gogh's pictures, each object seems almost palpable, as solid as sculpture, though modeled in paint. The result is an overwhelming sense of presence, an assertive vitality that seems to escape the confines of the canvas. Of all his early works, it was this depiction of van Gogh's bedroom that drew the most enthusiastic response from his friend and frequently harsh critic Gauguin when he did come to visit the month the painting was finished.

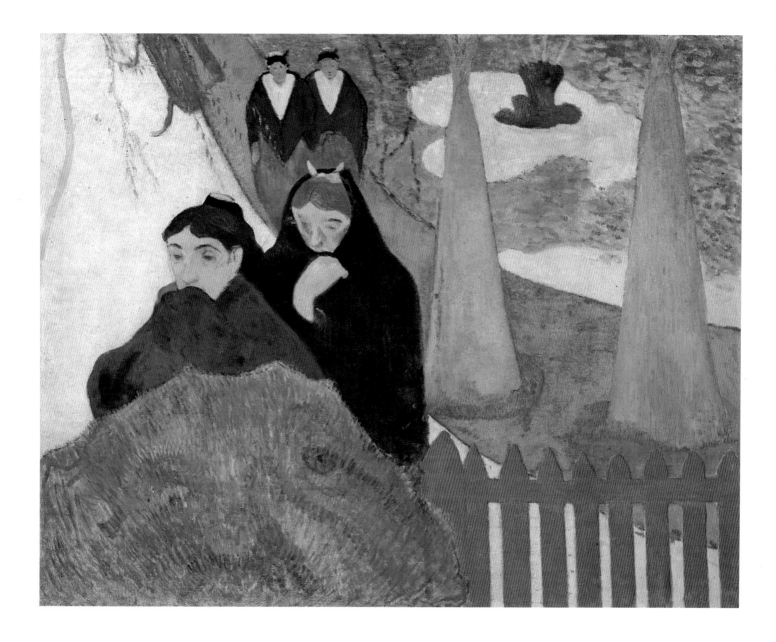

Paul Gauguin

French, 1848 - 1903
Old Women of Arles, 1888.
Oil on canvas.
28¾ x 36³⁄₁₆ in. /73 x 92 cm.
Mr. and Mrs. Lewis Larned Coburn Memorial
Collection, 1934.391.

Paul Gauguin arrived in the southern French city of Arles in October 1888, having accepted an invitation from Vincent van Gogh (see pp. 63, 66) to join him in establishing an artists' colony. The two months they spent together were difficult and, in the end, devastating for van Gogh. The deliberate and willful Gauguin was the antithesis of the fast-working, emotionally expressive Dutch painter. Gauguin's art was becoming increasingly abstract; he used color in large, flat areas and forsook traditional handling of space in order to inform his work with the visual unity and symbolism he desired.

Set in the garden opposite the house Gauguin shared with van Gogh, *Old Women of Arles* conveys an aura of repressed emotion and mysteriousness. Walking slowly through the garden are four women. Their gestures are slight, but distancing; their expressions are withdrawn, introspective. Other elements in the painting are equally elusive in meaning: the bench on the path at the upper left rises steeply, defying logical perspective, and the tall, conical objects to the right — identified recently as protective straw coverings placed over plants during the winter months — are specterlike presences. Another puzzling feature of the painting is the ghostly appearance of a face in the bush (this may have been unintentional, since such visual tricks are totally inconsistent with Gauguin's use of images in his work). In this powerful and enigmatic painting, Gauguin explored the capacity of a work of art to express the mysteries, superstitions, and emotions that he believed underlie appearances.

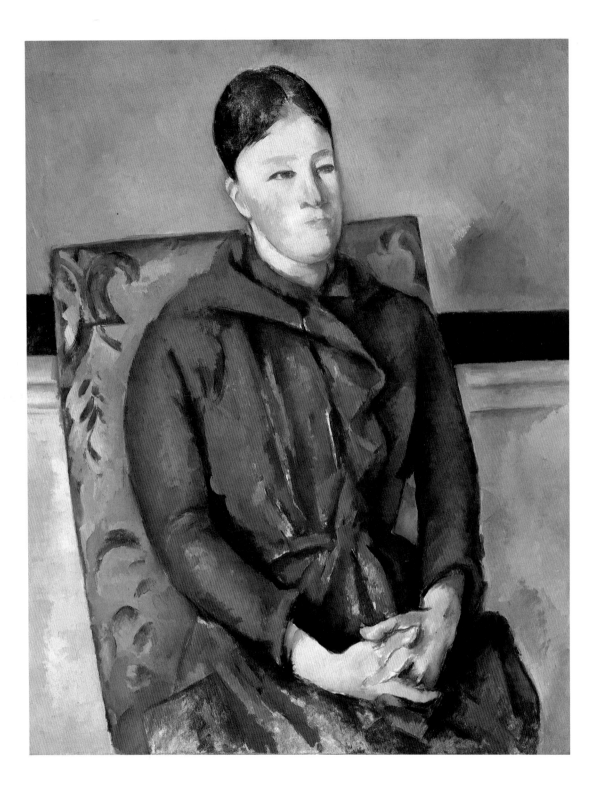

Paul Cézanne

French, 1839-1906
Madame Cézanne in a Yellow Armchair,
1893-95.
Oil on canvas.
31 13/16 x 25 9/16 in. /80.9 x 64.9 cm.
Wilson L. Mead Fund, 1948.54.

Paul Cézanne is generally hailed today as the father of modern painting, but recognition of the magnitude of his contribution to the history of art came only after his death. In part, this was a result of how he chose to live and work. As a student in Paris, he joined the Impressionists and even exhibited with them in 1874 and 1877. Unable to cope, however, with the public ridicule of his art, Cézanne withdrew from the group and opted for a reclusive existence, painting in solitude, mostly in Provence, especially in and around his native Aix-en-Provence.

Although hermitlike by nature, Cézanne did marry. The union seems not to have been very satisfactory for either the artist or his wife. Our greatest insight into the character of Madame Cézanne comes from his many depictions of her. The Art Institute's *Madame Cézanne in a Yellow Armchair* is one of three portraits of her in the same chair and pose from the same period. The simplicity of the portrait is at once apparent: a three-quarter-length figure sits in a three-quarter-turn view; the sitter's dress is red, the chair is yellow, the background is blue. The presentation is honest, straightforward, and unadorned, much like the woman herself. Her masklike face and tightly sealed lips reveal nothing. Her hands, though somewhat twisted, lie dormant, completing the serene oval of her arms. Madame Cézanne presents herself as solid and composed, with the same deliberation manifested by the artist in composing the image itself.

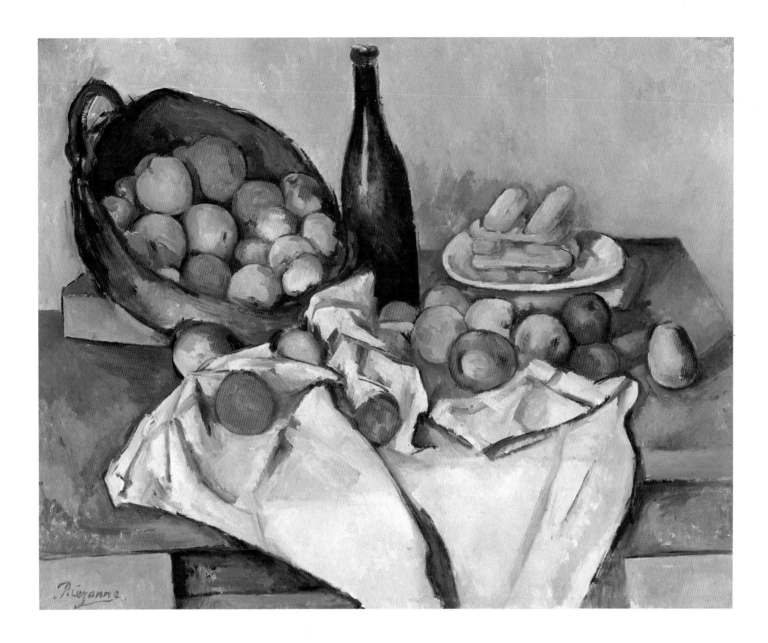

Paul Cézanne

French, 1839-1906
Basket of Apples, c. 1895.
Oil on canvas.
25 7/16 x 31 1/2 in. /65 x 80 cm.
Helen Birch Bartlett Memorial Collection,
1926.252.

Although Paul Cézanne withdrew from avant-garde art circles in Paris to paint in virtual isolation in Provence, his work was known by a few and known of by many more. Thus, when Cézanne was finally convinced by the Parisian art dealer Ambroise Vollard to exhibit in Paris in 1895, the occasion was a very important event.

Basket of Apples, one of Cézanne's so-called "baroque" still lifes (because it was inspired by seventeenth-century Dutch prototypes) was included in the exhibition. Like other paintings on display, it was signed by the artist, a rare concession probably made to satisfy Vollard.

By its very name, the term "still life" suggests an array of inert, or dead, objects; this association is even more clear in the French term *nature morte* (dead nature). Yet, Cézanne interpreted still life in a way that actually animates the objects. On one of his characteristic tilted tables — an impossible rectangle in which none of the corners lines up with the others — are placed a cloth, apples, a plate of neatly interlaced cookies, a bottle, and a basket of

apples. The basket careens forward from a slab-like base that appears to upset rather than support it. The apparent precariousness of the objects on the table is tempered by their heavy modeling, which gives them great density and weight. Even the white tablecloth possesses sculptural folds that seem to arrest the movement and contribute to the sense of permanence and inevitability with which Cézanne imbued his compositions.

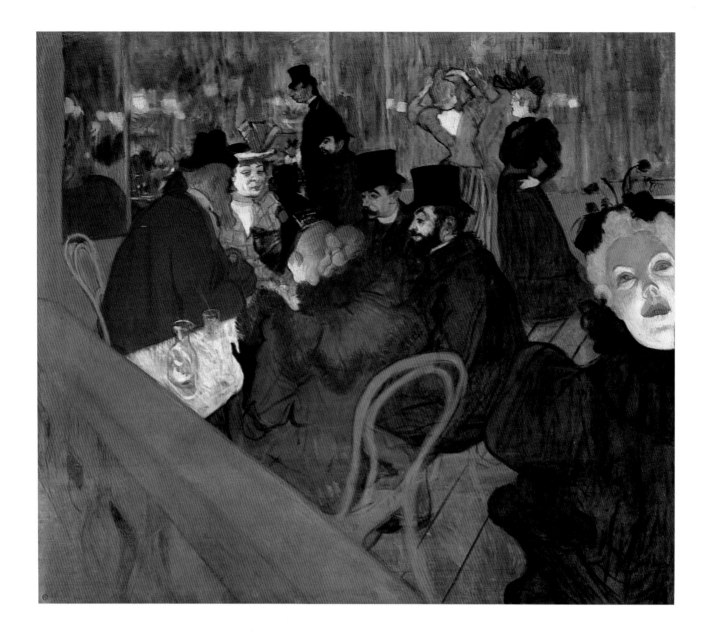

Henri de Toulouse-Lautrec

French, 1864 - 1901

At the Moulin Rouge, 1894 - 95.

Oil on canvas.

48⁷⁄₁₆ x 55½ in. /123 x 141 cm.

Helen Birch Bartlett Memorial Collection, 1928.610.

The "café-concert" was a popular institution in late nineteenth-century Paris; the performers and audience alike attracted the attention of artists such as Edgar Degas (see pp. 57, 60) and Henri de Toulouse-Lautrec. The Moulin Rouge was the most famous such establishment in Paris during the 1890s. Toulouse-Lautrec's painting *In the Circus Fernando: The Ringmaster* (p. 65) was displayed in its lobby.

In *At the Moulin Rouge,* Toulouse-Lautrec turned his acute powers of observation on the audience. These are not anonymous figures, such as one generally sees in the work of Degas. Rather, they are portraits of those habitués of late-night Paris — customers and entertainers — whom Toulouse-Lautrec counted among his friends and companions. The central group seated around the table includes a photographer, a poet, an owner of a vineyard, and two female entertainers. A third entertainer, whose greenish face looms eerily at the right edge of the canvas, has just departed. In the upper right, adjusting her coiffure, is a dancer,

accompanied by a friend. The latter seems to stare toward the far left, at two men in the process of leaving: the dwarfish figure of Toulouse-Lautrec himself and his very tall cousin.

At the Moulin Rouge has suffered considerable alteration. Apparently cut down along the right and bottom after the artist's death, presumably to make it less radical in composition and more attractive to buyers, the painting was restored sometime before 1924, when it was shown in its present state in a special Toulouse-Lautrec exhibition at the Art Institute.

Paul Gauguin

French, 1848 - 1903
Ancestors of Tehamana, 1893.
Oil on canvas.
30¹/₁₆ x 21³/₈ in. /76.3 x 54.3 cm.
Anonymous gift, 1980.613.

Paul Gauguin was a restless man, attracted to exotic places. Before his famous sojourn in Tahiti, he had visited South and Central America and lived in Brittany. In all these places, he was attracted to cultures he considered more "primitive" and, therefore, more spiritually pure than his own.

Gauguin first arrived in the French colony of Tahiti in 1891; he remained until 1893, when he returned to France in poor health, financially broke, and sadly disillusioned by what he had believed would be paradise. *Ancestors of Tehamana* is a portrait of Gauguin's Tahitian wife, Tehura. This rather formal portrait presents the young woman fully clothed and seated frontally. Behind her is a frieze covered with what seems to be ancestor figures and undecipherable writings. The most clearly depicted figure is the partly clothed female at the left, her arms outspread but her hands hidden, thus obscuring the true nature of the gesture. This enigmatic figure provides a striking counterpoint to the vibrant young woman, suggesting a profound, mysterious connection between them. Perhaps the large, glowing fruits at Tehamana's side represent an offering, a mark of respect and appeasement from the living to the dead.

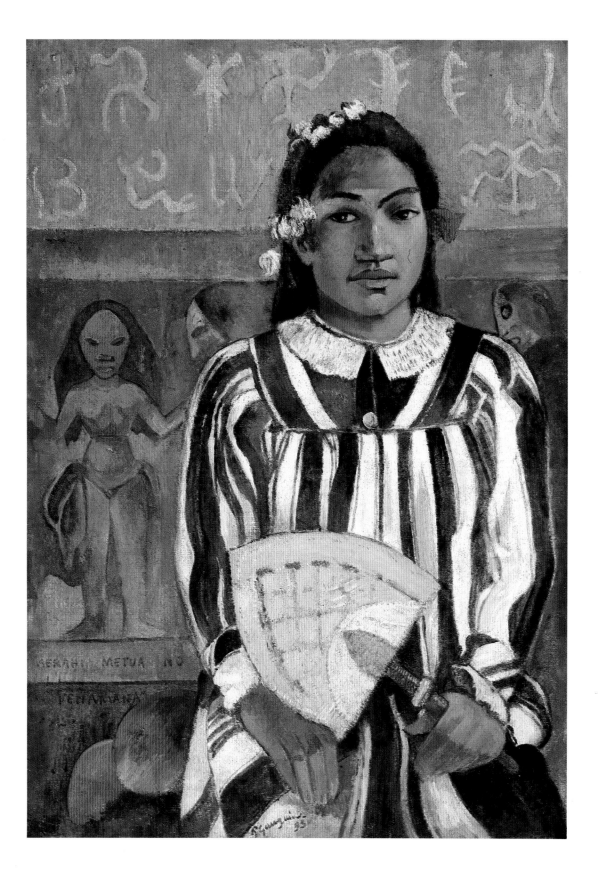

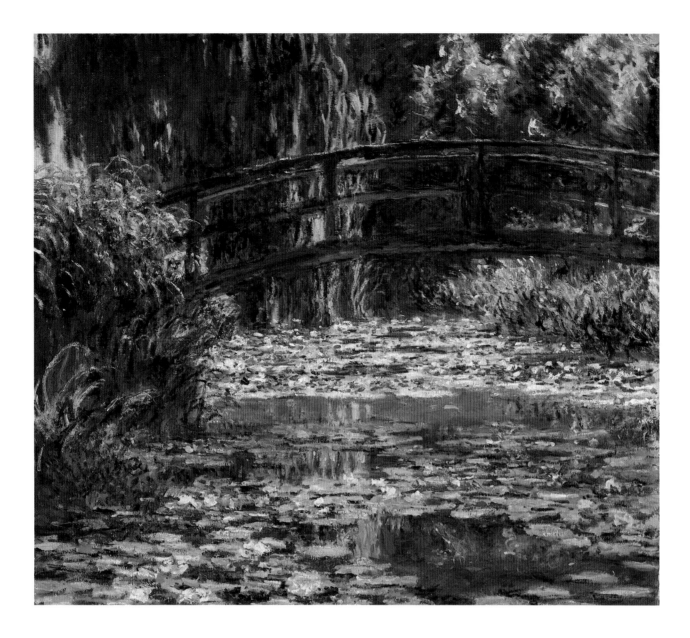

Claude Monet

French, 1840 - 1926
Japanese Bridge at Giverny, 1900.
Oil on canvas.
35⅜ x 39¾ in. /89.8 x 101 cm.
Mr. and Mrs. Lewis Larned Coburn Memorial
Collection, 1933.441.

Giverny, Claude Monet's home from 1883 until the end of his life, provided the artist not only with the subject matter for a quarter-century of paintings, but also gave him the opportunity to shape that very subject matter. Monet's garden was as much a passion with him as was his art, a place where he could devote himself to creating the ideal landscape. The magnificent flower garden he fashioned near his house featured a water garden spanned by a Japanese footbridge.

Monet did his first series of depictions of his water garden in 1899 and 1900. In this composition, the artist painted the footbridge as seen from the larger end of the pond, whose surface was practically covered with the water lilies that became the signature motif in Monet's later paintings. As in other works from this series, the space of *Japanese Bridge at Giverny* is clearly ordered: water relegated to the bottom half, bridge and trees above, with the whole neatly divided by the fixed horizon line.

As the years went by, Monet seems to have become increasingly drawn to the pond itself, approaching it ever more closely until he seems to have achieved complete immersion. In his last years, Monet became less and less interested in traditional descriptions of landscape. Fascinated with light and the color of the pond's flora, he merged the surface of the water with the surfaces of his canvases.

American Paintings

John Smibert

American, 1688 - 1751
Richard Bill, 1733.
Oil on canvas.
50¼ x 40¼ in. /127.6 x 102.2 cm.
Friends of American Art Collection, 1944.28.

Born in Edinburgh, Scotland, where he was apprenticed as a house plasterer, John Smibert moved in 1709 to London. After working as a draftsman and painter for several years, he set out on a Grand Tour of the European continent, studying from 1717 to 1720 in Italy, where he sketched from antique sculpture and copied paintings by Peter Paul Rubens (see pp. 28, 29), Anthonie van Dyck, Raphael, and Titian. Smibert returned to London but was unable to compete with London's best portraitists. He left for America in 1728 and landed in Newport, Rhode Island. Shortly thereafter, Smibert moved to Boston. His subsequent marriage to a woman from a distinguished Boston family assured him of the best patronage for his works. He also ran an artist's supply shop and organized America's first art exhibition, where, among other things, he displayed his Old Master copies and his fashionable portraits. Accustomed to the products of self-taught painters, viewers were fascinated by Smibert's polished style, skillfully rendered textures, and light effects.

Smibert, like many immigrant artists, modified his style in America, making it more simple and direct, in concert with the taste of his American clientele. The Art Institute's portrait of Richard Bill shows the Boston shipping merchant wearing a wig and ruffled shirt and standing next to a table that displays a letter addressed to him. To the right is an anchored ship referring to the family's wealth, probably copied by Smibert from European maritime prints available in his art shop. Despite his success, Richard Bill died insolvent in 1757.

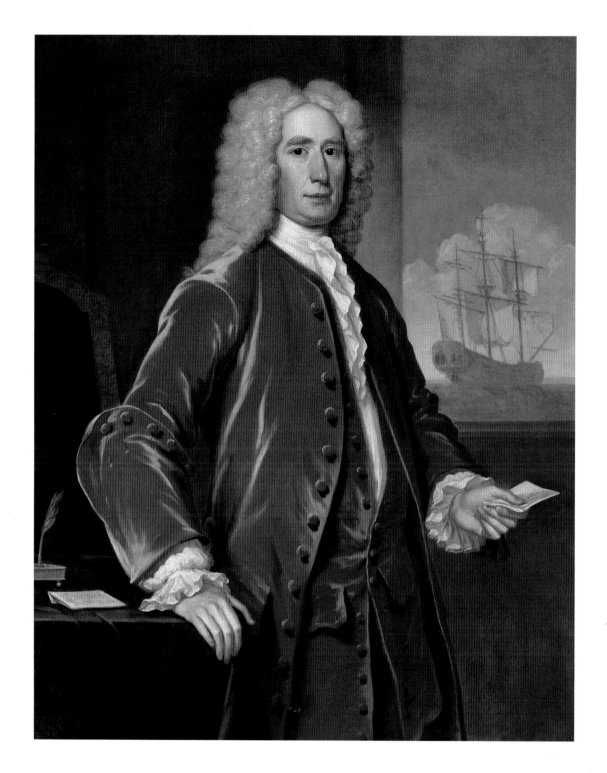

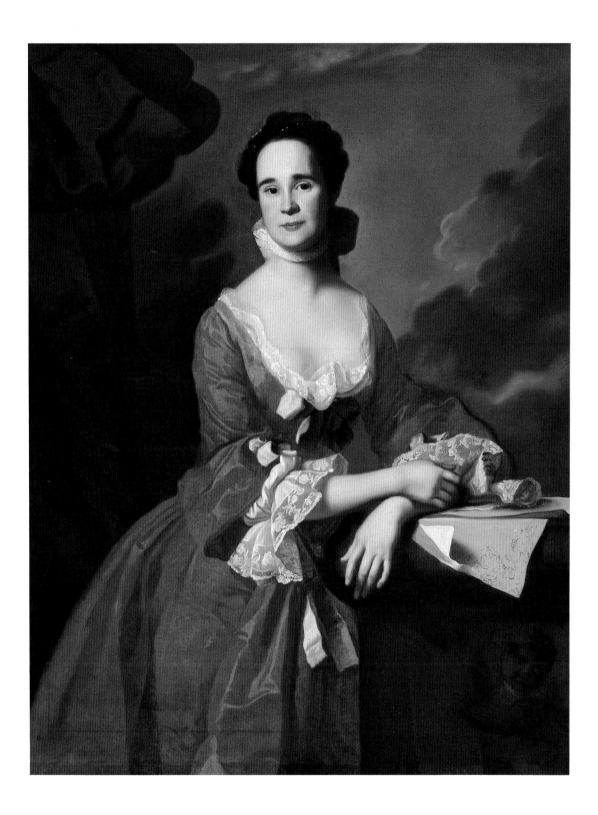

John Singleton Copley

American, c. 1738 - 1815
Mrs. Daniel Hubbard, 1764.
Oil on canvas.
50¼ x 39¾ in. /127.6 x 101 cm.
Art Institute Purchase Fund, 1947.28.

The most famous portrait painter in the American colonies before the Revolutionary War, John Singleton Copley was essentially self-taught. From the print collection of his stepfather (Peter Pelham, a mezzotint engraver), he learned the conventions of aristocratic portraiture — the poses, accessories, and backgrounds that constituted a likeness. These sources, however, did not instruct him about color, texture, and the application of oil paint, all of which he mastered on his own as well as by studying the work of other American painters of the time. Copley developed a sophisticated portrait style eagerly desired by New England's well-to-do merchant and professional classes. As his technical skill grew, so too did Copley's powers of observation, resulting in a large number of penetrating, precisely detailed portraits executed from the 1760s to the outbreak of the American Revolution in 1775, when the artist left Boston to settle in London.

Mrs. Daniel Hubbard was inspired by an oil portrait of an English noblewoman that Copley had seen copied in mezzotint. Standing on a balcony or terrace, Mrs. Hubbard leans informally on a pedestal on which have been placed several sheets of paper, including a sketch of floral designs. She looks at the spectator directly and candidly. A string of pearls, woven into her coiffure, adds pinpoints of light to her dark hair. Behind her, restless clouds seem to part, dramatically highlighting her head and shoulders against the blue of the clearing sky. A portrait of Mrs. Hubbard's husband, also in the Art Institute's collection, completed the pair.

Gilbert Stuart

American, 1755 - 1828

Major-General Henry Dearborn, 1812.

Oil on mahogany panel.

28³⁄₁₆ x 22½ in. /71.6 x 57.2 cm.

Friends of American Art Collection, 1913.793.

The American portrait painter Gilbert Stuart studied for many years in England with the American expatriate artist Benjamin West. Stuart described his approach to portraiture as slowly revealing his subject very much as the image of a face in a clouded mirror gradually becomes visible. He painted directly onto the canvas with assured brushstrokes and spirited color, maintaining conversation with his sitters to ensure in them a lively demeanor. Upon his return to the United States in 1793, he began to paint, among other subjects, a series of portraits of the young republic's military and political heroes, from which his many images of George Washington are most famous.

Henry Dearborn had been a distinguished soldier in the Revolutionary War; from 1801 to 1809, he served as President Thomas Jefferson's Secretary of War. As America expanded westward, several frontier posts were named after Dearborn, including Fort Dearborn, built in 1803, near where the Chicago River and Lake Michigan meet. Stuart chose to immortalize his subject not by heroic gestures but by concentrating on Dearborn's revealing physiognomy. Typical of Stuart's most expressive portraits, this likeness comes alive through the white highlights on the distinctive nose, forehead, and silvery hair, and the strong modeling beneath Dearborn's brow, nose, and chin. To emphasize the sitter's presence, Stuart provided a background of towering clouds with dramatically reddened edges.

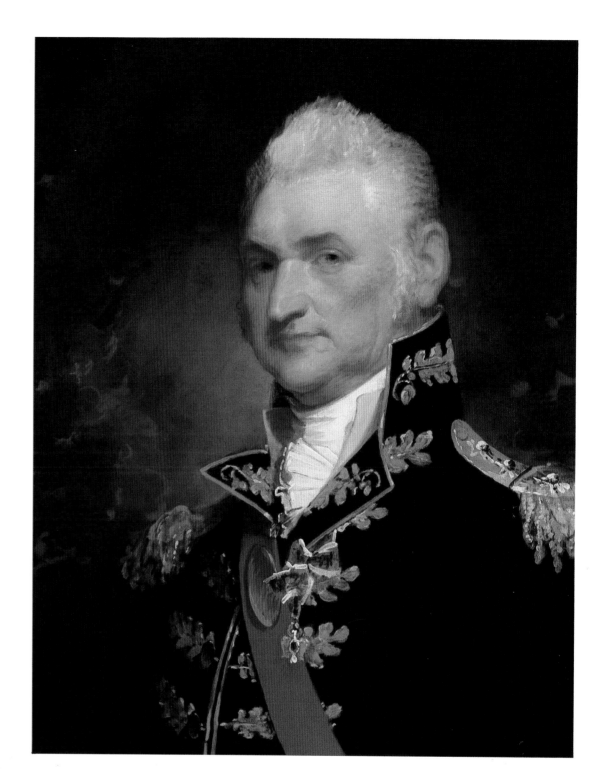

John Ritto Penniman

American, c.1782 - c.1830
*Meetinghouse Hill, Roxbury,
Massachusetts*, 1799.
Oil on canvas.
29 x 37 in. /73.7 x 94 cm.
Centennial Year Acquisitions Fund,
Centennial Fund for Major Acquisitions,
1979.1461.

John Ritto Penniman was only seventeen years old when he painted this tranquil vista of Roxbury, seen from a nearby hill as the sun sets over the town. His earliest known landscape, this expansive view is named for the distant clapboard town meetinghouse, with its steeple rising over the rolling terrain, farm buildings, and colonial houses. Lacking the sophisticated training and patronage of famous colonial portrait painters such as Gilbert Stuart (see p. 77), Penniman had collaborated with local craftsmen in the decoration of glass objects, frames, and clocks. *Meetinghouse Hill* exhibits the detailed manner of most ornamental painters: here, Penniman used carefully controlled brushstrokes; a bright, limited color range; sim-

ple, unmodeled forms; and sharp contrasts between light and dark tones.

The site of the summer and country houses of many Bostonians, Roxbury was famous for the role its citizens had played in the Revolutionary War and for its influential families, who had served as governors of Boston since the town's settlement in 1630. With its emphasis on Roxbury's meetinghouse, town common, and architecture, surrounded by an expansive, civilized landscape, the image reflects the Puritan ideal of a "Citty [sic] upon a Hill," and thus symbolizes a benevolent system that governs a citizenry bonded by homogeneous spiritual and civic goals and committed to free choice.

Ammi Phillips

American, 1788-1865
Cornelius Allerton, 1820-27.
Oil on canvas.
33 x 27½ in. / 83.8 x 69.9 cm.
Gift of Robert Allerton, 1946.394.

With no formal training, Ammi Phillips taught himself in his teens to be a limner — a painter of portraits. As the wealth and population of western New England increased, individuals often wished to record their success by preserving their own or their family members' likenesses for posterity. With this increased demand, talented decorative sign painters like Phillips became itinerant portrait painters. By 1811, Phillips had begun to use conventional poses adopted from popular European prints and had learned painting techniques from examples by Connecticut limners of the 1790s, who painted full-length, three-quarter, or bust portraits on canvas, wood, or glass. Until his death in 1865, Phillips succeeded as an inventive, prolific, and well-paid portrait painter of rural bankers, judges, doctors, farmers, and their families.

Phillips portrayed Dr. Cornelius Allerton seated in a painted country chair against a plain background with a tiny horse in the distance. The man's small head, with its flattened ear, is placed high on the canvas in a manner typical of Phillips's portraits. By hiding the doctor's fingers within a volume of *Parr's Medical Dictionary*, he avoided painting the sitter's hands, which probably challenged the artist's anatomical knowledge and skill. Phillips captured the sense of an individual in the detailed, but unmodeled, face. Itinerant painters were often commissioned to portray several members of a family; in addition to this portrait, Phillips completed one of Allerton's mother (also in the Art Institute) and mother-in-law (Connecticut Historical Society, Hartford).

John Quidor

American, 1800 - 1881

Rip Van Winkle, 1829.

Oil on canvas.

27½ x 34⅜ in. /69.9 x 87.3 cm.

George F. Harding Collection, 1982.765.

At the age of ten, John Quidor left his Tappan, New York, home to live in New York City. He was appreciated in his day more for his decorative panels than for his narrative paintings. In his narrative scenes, Quidor relied on his imagination to create fantastic images based on such popular literary sources as the work of James Fenimore Cooper and Washington Irving.

Quidor painted several scenes from Irving's famed *Rip Van Winkle* (1820), an adaptation of a German folk tale. The Art Institute's painting, first exhibited at the National Academy of Design, was praised for its dramatic lighting, complex space, and expressive figures. Quidor's characters act out the moment when Rip Van Winkle, bearded and ragged after his twenty-year sleep in the Catskills, responds in amazement to his surroundings and to the suspicious townspeople. Against a mysterious landscape, whose effects of color and atmosphere resemble French Rococo painting, Quidor arranged this burlesque of deliberately exaggerated figures, including Rip's son (who stands against a tree), satirizing the social customs and prejudices of his age.

William Sidney Mount

American, 1807 - 1868
Walking the Line, 1835.
Oil on canvas.
22⅝ x 27⁷⁄₁₆ in. /57.5 x 69.7 cm.
Goodman Fund, 1939.392.

In contrast to the panoramic, heroic landscapes of Thomas Cole and Frederic Edwin Church (see pp. 82, 83), the paintings of William Sidney Mount express the simple joys of everyday life in the age of Jacksonian democracy. Mount learned to paint signs and portraits from his brother in New York and then attended more formal art classes, copying prints and casts at the National Academy of Design. In the 1830s, prints of several of Mount's rural images were distributed throughout Europe and America, making Mount one of the few American artists known in Europe at that time.

Mount painted this 1835 tavern interior, *Walking the Line,* in Setauket, New York, in the house of a local military general. The sensitive tonal effects, crisp colors, and balanced composition of *Walking the Line* are typical of Mount's rural subjects at their best. A boisterous figure, drinking vessel raised over his head, stamps his feet along the floor line as others clap a beat or watch his feet. Mount skillfully rendered the varied details of clothing and furniture, captured expressive facial expressions and gestures, and conveyed the effects of light. Separating the young black man at the right from the more active, white participants, the artist — who was deeply sympathetic to black Americans — arranged the composition along the invisible lines that defined social relations in the United States in the 1830s.

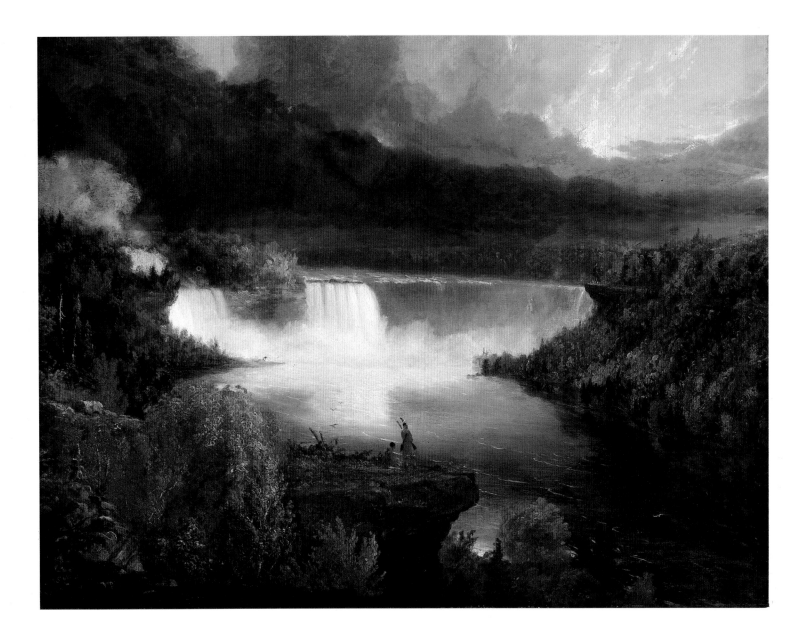

Thomas Cole

American, 1801 - 1848
Niagara Falls, 1830 - 31.
Oil on panel.
18⅞ x 23⅞ in. /47.9 x 60.6 cm.
Friends of American Art Collection, 1946.396.

In mid-nineteenth-century America, a love of the "sublime" landscape, inspiring in the viewer an almost religious sense of destiny, was nowhere felt more powerfully than at Niagara Falls, New York, by far the most frequently depicted and visited spectacle in the New World. Before he left the United States to study the countryside of England, France, and Italy, the Romantic landscape painter Thomas Cole visited Niagara Falls in April 1829 to gaze with wonder at America's untamed scenery. Cole stood in rapture before "the voice of the landscape," sketching and writing of the magnificent cataract in his diary. Cole even wrote a long poem describing the site's fearful, primordial power.

The Art Institute's painting expresses the untamed spirit described in Cole's poem. As was typical of his early methods, Cole did not execute this painting directly from nature; his letters indicate that he finished it in London in 1830 and 1831. Praising the spectacular beauty of the falls in his "Essay on American Scenery," published in 1836, Cole urged readers to cultivate their taste for American landscape, "an unfailing fountain of intellectual enjoyment," as a means to "purify thought." Even though Cole's later allegorical paintings were more satisfying to him than his landscapes, American viewers preferred his panoramic views of autumnal mountains, approaching thunderstorms, and untouched wilderness that celebrate the nation's extraordinary natural beauty.

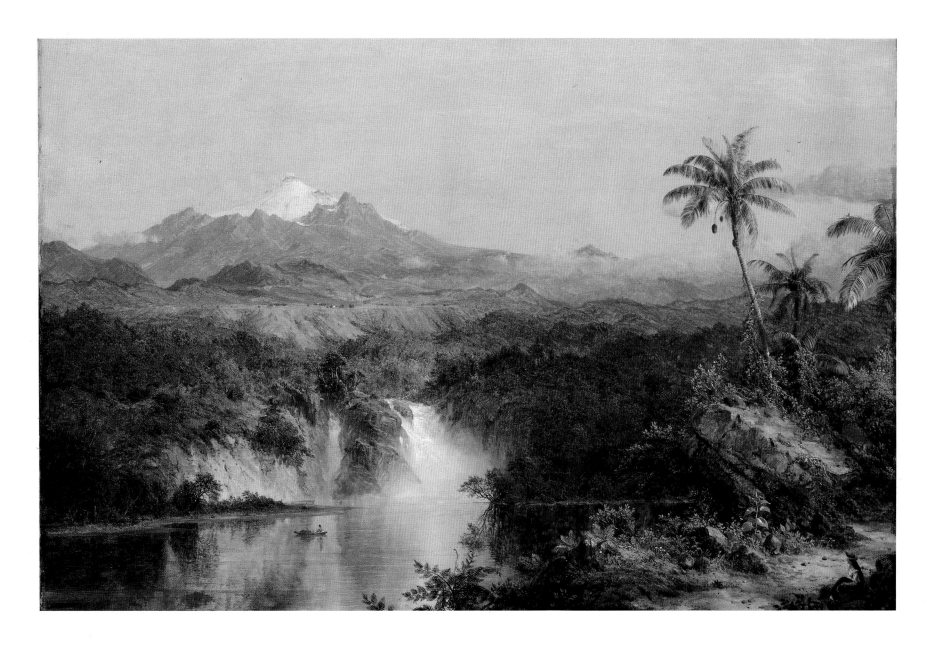

Frederic Edwin Church

American, 1826-1900

Cotopaxi, 1857.

Oil on canvas.

24½ x 36½ in. / 62.2 x 92.7 cm.

Gift of Jennette Hamlin in memory of
Mr. and Mrs. Louis Dana Webster, 1919.753.

A leading American landscape painter of the mid-nineteenth century, Frederic Edwin Church studied for four years with Thomas Cole (see p. 82), absorbing his descriptive, Romantic landscape style. Unlike Cole, Church was not drawn to the historic landscapes of Europe, but rather became deeply committed to capturing the natural beauty of the New World. Significantly, his first trip abroad in 1853 was to the mountainous terrain of South America. The voyage was inspired by the writings of the German natural historian Alexander von Humboldt. Humboldt had visited South America and had described his scientific explorations in his book *Cosmos* (published in English in 1849). He encouraged painters and explorers to turn their gaze to the untamed New World as a symbol of primordial nature and as a source for spiritual renewal.

Church painted this view of the Ecuadorian volcano Cotopaxi in 1857, just before he departed on his second trip to South America. Here, Church depicted lush flora, a waterfall, and the hills leading to the distant peak in a brightly lit, realistic style. An elevated vantage point permits us to witness an awesome vista filled with contrasts — of lush, green foliage and rugged, barren slopes; of water that is calm (the lake), explosive (the cascades), and frozen (the peak); of great warmth and extreme cold. In this panoramic view, Church combined the precise definition of scientific exploration with a symbolic and evocative view of the vast New World.

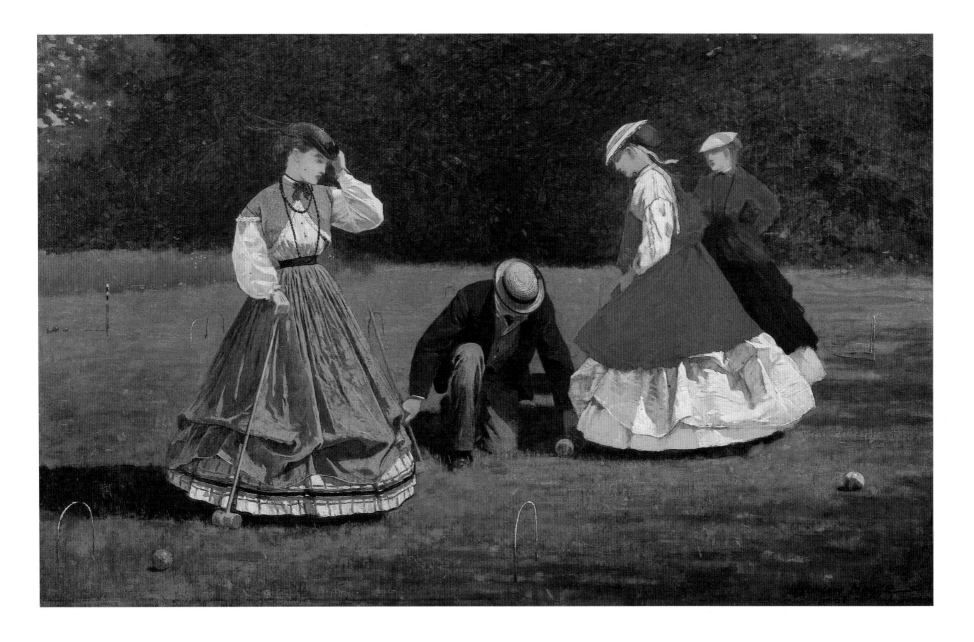

Winslow Homer

American, 1836-1910
Croquet Scene, 1866.
Oil on canvas.
15⅞ x 26¹⁄₁₆ in. /40.3 x 66.2 cm.
Friends of American Art Collection, 1942.35.

Employed as an illustrator during the Civil War, Winslow Homer began to work in oil paint in 1862, and, for the most part, was self-taught. His early paintings demonstrate how his graphic skills informed his art: broad, simple planes and carefully constructed spatial organization are qualities of his illustrations that appear in works like *Croquet Scene*. After the war, Homer became interested in country life, depicting farmers and their families, and the upper middle-class vacationing at summer resorts. In oil paintings, watercolors, and woodcuts, he portrayed these aspects of contemporary American life with acute observational and technical skills, never exaggerating or sentimentalizing his subjects.

The game of croquet was introduced to America at mid-century from Ireland and England. Serious competitors played on special surfaces, following precise rules and distinct ways of holding the mallet. However, those in pursuit of a more leisurely sport played on unprepared lawns, as Homer recorded in a group of paintings, of which the Art Institute's is an outstanding example. Despite the attention given to the players' clothing, in the bright sunlight the forms of the four figures seem to flatten out against the lawn and trees behind them. The gesture of the woman in blue to shield her eyes and the crisply defined figures and their shadows suggest the brilliance of the afternoon light and demonstrate Homer's consummate observational abilities.

John La Farge

American, 1835 - 1910
Snow Field, Morning, Roxbury, 1864.
Oil on beveled mahogany panel.
12 x 9⅞ in. /30.5 x 25.1 cm.
Gift of Mrs. Frank L. Sulzberger in memory
of Frank L. Sulzberger, 1981.287.

John La Farge was born in New York City to wealthy French émigré parents. After graduation from St. Mary's College in Maryland, he studied law briefly. In 1856, he traveled to Paris and then to London, where he became intrigued by the symbolic and carefully crafted work of a group of English artists known as the Pre-Raphaelites. A period of study with American artist William Morris Hunt convinced La Farge to become an artist. He was awarded an important commission in 1876 for a mural and stained-glass designs for Trinity Church in Boston, and eventually became renowned for his domestic and ecclesiastical decorative projects. A close friend of many cultivated Americans such as Henry Adams, with whom he traveled, La Farge was considered one of the leading American artists of his time.

Among his first paintings, executed in the 1860s, were numerous landscapes and floral still lifes. Painted at Roxbury, Massachusetts, *Snow Field, Morning* reveals La Farge as a sensitive landscapist. The barren, snow-covered field and downward-sloping horizon line are counterbalanced by the precise placement of the small cluster of evergreens at the right. Under the line of gray, threatening clouds in the background, a sliver of blue-green sky signals the promise of dawn.

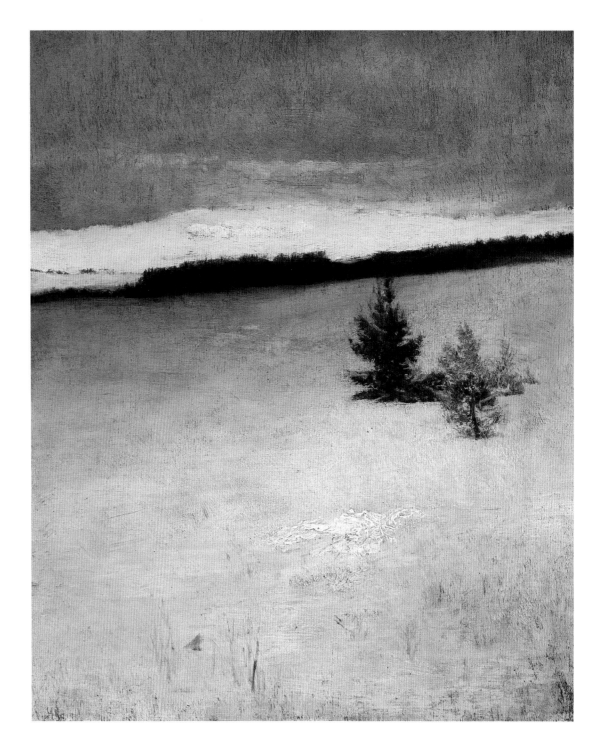

William Bradford

American, 1823 - 1892

The Coast of Labrador, 1866.

Oil on canvas.

28⅜ x 44⅝ in. /72.1 x 113.4 cm.

Ada Turnbull Hertle Fund, 1983.529.

William Bradford's early works are documentary "portraits" of ships in harbors. He went on to study the coast of New England, eventually following the shoreline as far north as Labrador. From 1861 to 1867, he made annual trips to Labrador to sketch and photograph icebergs and ice fields. Celebrated not only in America but also in England, the artist included Queen Victoria among his collectors.

Bradford is linked with several American painters of the 1850s and '60s who shared a fascination for poetic qualities of light. Along with artists such as John Frederick Kensett and Martin Johnson Heade (see pp. 87, 92), Bradford was interested not only in transcribing the radiance of light, but also in conveying its power to create mood, express emotion, and unify a diverse natural world.

In *The Coast of Labrador,* Bradford recorded, in meticulous detail, a stretch of shore where large boulders and jutting cliffs dominate the coast. In the foreground, a fisherman tends to his nets, while in the far distance two tiny figures walk along the beach. Yet, despite these closely observed elements, it is the pale sun centered in a hazy sky and its suffused, glowing light that establish the meditative mood of the scene. Through delicate atmospheric effects achieved by subtle tonal gradations, Bradford unified sky, sea, and land into a harmonious whole.

John Frederick Kensett

American, 1816 - 1872

Coast at Newport, 1869.

Oil on canvas.

11⅝ x 24¼ in. /29.5 x 61.6 cm.

Friends of American Art Collection, 1944.686.

John Kensett was part of the second generation of realistic landscape painters of the Hudson River School. Like Thomas Cole (see p. 82) and other leaders of the group, John Kensett began his career as an engraver. He settled in New York and routinely spent his summers outdoors sketching and his winters indoors painting. Although he traveled widely, he preferred to depict with straightforward details and careful gradations of tone tranquil scenes of New England coasts bathed in a distinctively clarified light. His unpopulated, almost timeless landscapes express the beliefs of Ralph Waldo Emerson and other Transcendentalists that the perfection of nature can best be experienced in solitude.

Kensett painted *Coast at Newport* fifteen years after his first visit to this summer resort and several decades before its shoreline was decked out with its now-famous inns and mansions. Typical of Kensett's coastal views, this horizontal painting conveys a profound sense of silence and eternity through its long, low horizon and the distinctions between the minutely detailed shoreline, crisply painted sea, and expanse of sky. At the same time, Kensett captured the specific quality of light and time of day, transcribing in detail everything from blades of grass, visitors to the beach, and tiny sails that notch the distant horizon line. This landscape, so very different in spirit from the heroic compositions of Cole and Frederic Edwin Church (see p. 83), embodies the qualities that earned Kensett great respect and popularity during his lifetime.

Winslow Homer

American, 1836-1910

Mount Washington, 1869.

Oil on canvas.

16¼ x 24⁵⁄₁₆ in. /41.3 x 61.8 cm.

Gift of Mrs. Richard E. Danielson,

Mrs. Chauncey McCormick, 1951.313.

Because of his feeling for tone, brushwork, and light, Winslow Homer's work has been compared to that of the French Impressionists. But he developed his style on his own and did not travel to Europe until he was thirty, in 1867. In that year, he visited the Exposition Universelle in Paris, where he may have seen paintings by artists who would become known as Impressionists.

Two years later, in 1869, Homer painted Mount Washington, the highest peak of New Hampshire's White Mountains and a favorite spectacle for tourists and landscape painters for many years. While the solidity of form and monumentality of the composition recall the style of Hudson River School artists, the overall blue tonality and lightened palette may indicate Homer's exposure in Paris to paintings by Edouard Manet, Claude Monet, and others. Homer recorded the effect of bright sunlight on the figures and horses, which tends to flatten them out slightly even as they retain their solidity and three-dimensionality. Homer's interest in strong design and tangible form distinguishes his work from that of the Impressionists. Whereas Monet allowed effects of light and atmosphere to partially disintegrate his forms, Homer refused to compromise the material presence of distant figures, landscape elements, or even of clouds.

Winslow Homer

American, 1836-1910

The Herring Net, 1885.

Oil on canvas.

30⅛ x 48⅜ in. /76.5 x 122.9 cm.

Mr. and Mrs. Martin A. Ryerson Collection,

1937.1039.

During the 1870s, Winslow Homer often represented the hard life of fishermen and their families when he visited Gloucester, Massachusetts, and other small fishing villages along the New England coast. While these summer excursions encouraged his interest in the sea and related subjects on the theme of survival, a trip in 1881-82 to Tynemouth, England, fundamentally changed his work and way of life. In most of his paintings from this date forward, he attempted to capture the continuous struggle of men and women caught in conflict with the enormous forces of nature.

The year after Homer returned from the rugged shores of England, he moved to an isolated cottage overlooking the Atlantic at Prout's Neck, Maine. From there, he could confront and observe the ocean's forces and the heroic efforts of those who depended on it for their livelihood. In 1885, after spending hours at sea sketching fishermen, Homer painted *The Herring Net*. In a small boat that hovers precariously between high waves, two anonymous, statuesque figures — a man and a boy — loom large against the horizon dotted with the forms of distant ships. Their haul, the netted herring, glistens in the sun and misty atmosphere. Like so many of Homer's paintings on this theme, this image lasts in our mind, a powerful poem about the heroism and strength of men who live outdoors, conveyed in a manner that is appropriately broad and masterful.

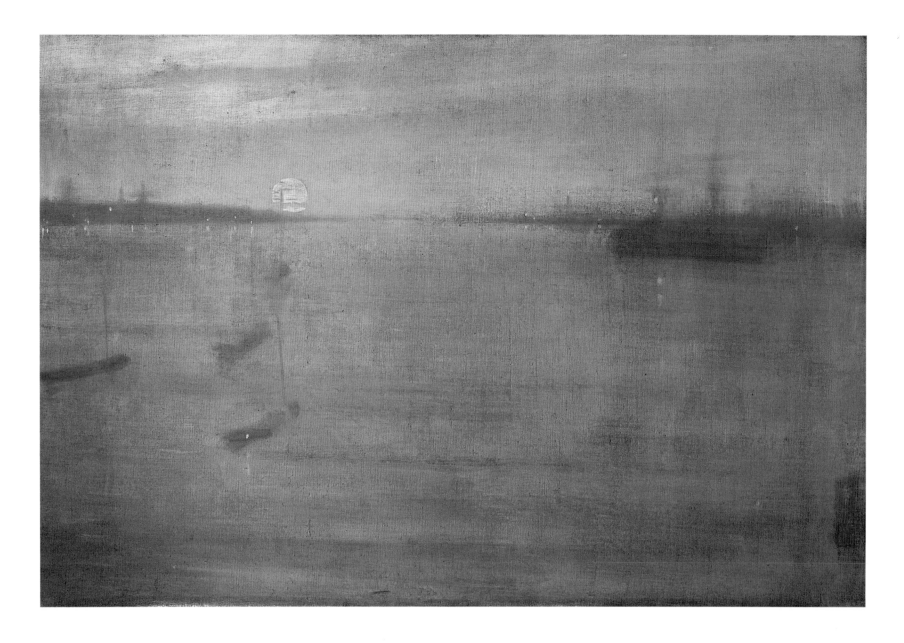

James Abbott McNeill Whistler

American, 1834 - 1903
Nocturne in Gray and Gold, 1872.
Oil on canvas.
19⅞ x 29¹⁵⁄₁₆ in. /50.5 x 76 cm.
Stickney Fund, 1900.52.

Although he was born in Massachusetts, James Abbott McNeill Whistler spent most of his life in Europe, studying in Paris before settling in London in 1859. A celebrated spokesman in the late nineteenth century for the "aesthetic" movement in art, Whistler insisted that the primary task of the artist is to present a harmonious arrangement of color and shape on a flat surface rather than to depict a familiar or narrative subject. To underscore this approach as well as the close relationship he believed exists between art and music, he shocked the public by titling his paintings "Arrangements," "Symphonies," and "Nocturnes."

Nocturne in Gray and Gold is one of the first paintings to which Whistler gave such an appellation. Writing to thank his patron Frederick Weyland for suggesting this term to him, Whistler enthused: "I say I can't thank you too much for the name 'Nocturne' as a title for my moonlights! You have no idea what an irritation it proves to the critics and consequent pleasure to me — besides, it is really so charming and does so poetically say all I want to say and *no more* than I wish." Thus, rather than emphasizing the ships one can discern here in a harbor, Whistler was more interested in the mood created by a specific time of day (a moonlit night) and the dominant color harmony (gray and gold). In fact, he relegated the ships to either side of the composition, creating a kind of visual frame for the tranquil expanse of water and sky at the painting's center. A homely piling at the lower right anchors the scene and suggests a nearby bank or prospect from which water, sky, and moon are viewed.

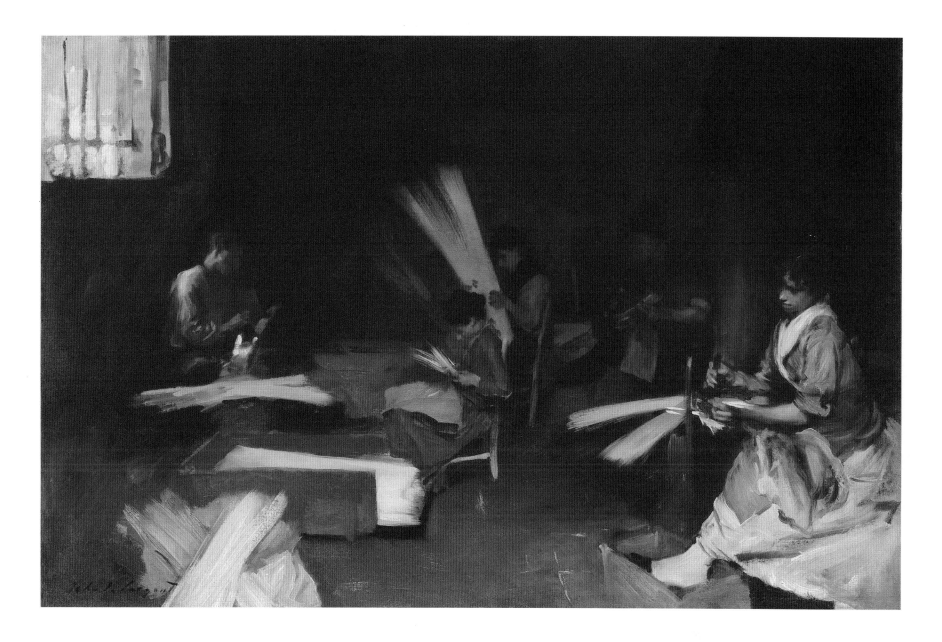

John Singer Sargent

American, 1856-1925
Venetian Glass Workers, 1880 or 1882.
Oil on canvas.
22¼ x 33¼ in. /56.5 x 84.5 cm.
Mr. and Mrs. Martin A. Ryerson Collection,
1933.1217.

The gifted artist John Singer Sargent spent most of his career in Europe. Born to American parents in Florence, Italy, he joined the studio of French painter Emile Auguste Carolus-Duran at age eighteen. Carolus-Duran urged his students to learn the virtuoso brushwork techniques of such Old Master painters as the Spaniard Diego Velázquez and the Dutchman Frans Hals. By the time he was twenty-three, Sargent was exhibiting paintings at the official French Salon.

Sargent painted *Venetian Glass Workers* while in Venice during one of two summer visits in 1880 or 1882. Sargent's debt to Velázquez is apparent in the compositional verve and tonal effects of this canvas. Illuminated in brilliant patches against the dark background, bundles of thin glass rods used in making beads are sorted by two men and three women who work in a hall that had been converted into a glassworks. The painting is noteworthy for its unusual composition, in which the lightest forms are grouped along the edges, and for its masterful brushwork. The glass rods have become nearly abstract dashes of color, suggesting the effects of Venice's intense light as it penetrates the space. During his many subsequent visits to Venice, Sargent completed over 100 paintings and watercolors of the city. Like many from this group, this work remained with the artist for several years. Devoted to music and a fine pianist, Sargent traded it and another Venetian work in 1886 to a piano maker for a piano.

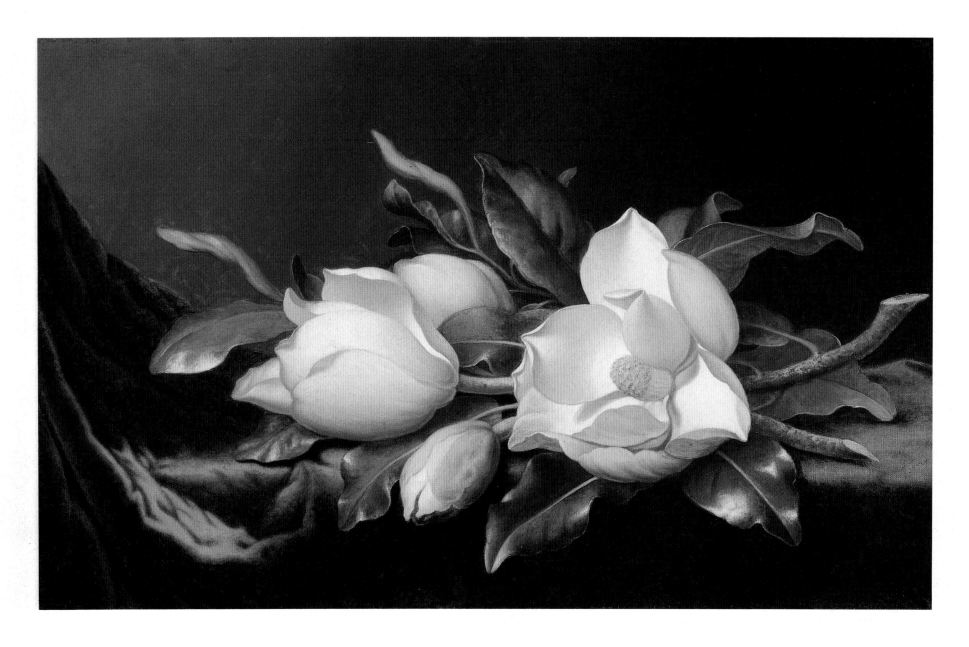

Martin Johnson Heade

American, 1819-1904

Magnolias, 1885-90.

Oil on canvas.

15¼ x 24⅜ in. /38.7 x 61.9 cm.

Restricted gift of Gloria and Richard Manney;

Harold L. Stewart Fund, 1983.791.

Never settling in one place long enough to pursue formal training, Martin Johnson Heade lived in New York, Philadelphia, Saint Louis, Chicago, Trenton, Providence, Boston, and, finally, in Saint Augustine, Florida. In addition to trips to England and the Continent, Heade traveled to study exotic flora and fauna, making three trips to Brazil. Over his very long career, he painted a wide range of subjects, including pristine, sensitive views of East Coast salt marshes, romantic images of South American forests, and still lifes of native or exotic flowers and of Brazilian orchids and hummingbirds.

Late in his career, at a time when highly realistic rendering was relatively unpopular, Heade completed several groups of flower paintings. In 1883, he moved to Saint Augustine, where he painted arrangements of local flowers, including roses, orange blossoms, water lilies, and lotus blossoms, mostly in a vertical format. Heade selected a horizontal format, however, for his wonderfully sensuous and decorative images of magnolia blossoms. The Art Institute's *Magnolias* is one of several compositions featuring this lemon-scented flower. Here, Heade evoked the steamy atmosphere and bright light in which the plant flourishes, and the pungent, heady aroma of its blossoms. Like his spectacular paintings of orchids, Heade's depiction of magnolias captures the curvaceous flower's delicate texture and subtle, pale hues in painstaking detail.

Elihu Vedder

American, 1836-1923
Fates Gathering in the Stars, 1887.
Oil on canvas.
44½ x 32½ in. /113 x 82.6 cm.
Friends of American Art Collection, 1919.1.

An artist who lived in Rome during the late nineteenth and early twentieth centuries, Elihu Vedder was more appreciated in America than in Italy for his visionary paintings, book illustrations, and stained-glass designs. He developed an elongated, classical figural style inspired by the art of antiquity and the Renaissance he saw in Italy and by the dreamy images of the Pre-Raphaelite painters in England. The symbolic content of Vedder's art also derives from the Pre-Raphaelite movement's preference for serious, literary subject matter. Vedder's sensitivity to symbol and design made his work particularly appealing to contemporary American architects, sculptors, and decorators, such as Stanford White, Augustus Saint-Gaudens, and Louis Comfort Tiffany.

After producing elegant covers for *The Studio* and *Century* magazines, Vedder designed illustrations for an 1884 edition of *The Rubáiyát of Omar Khayyám,* a commission that brought him wide fame and financial security. Painted after an image done for this publication, *Fates Gathering in the Stars* represents the partially draped Fates, standing upon swirling clouds, as they sweep in nets full of stars (a scene corresponding to quatrains 72-74). The three sinuous figures, their twisting drapery, and whirling nets are arranged in a linear manner that conveys a sense of motion across the entire surface. Vedder's refined, ethereal style was well suited to the popular *Rubáiyát,* which doubted divine providence, ridiculed timeless human glory, and, instead, focused on momentary, evanescent pleasure.

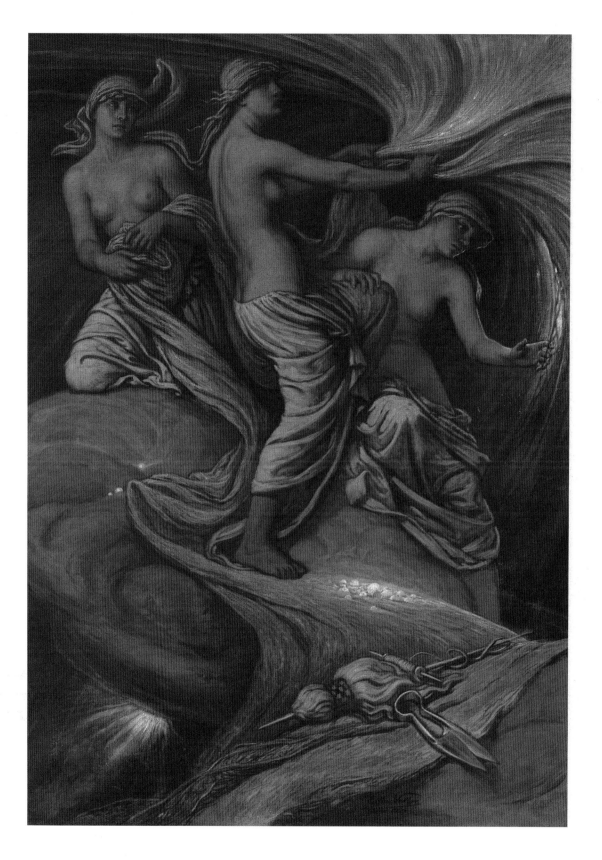

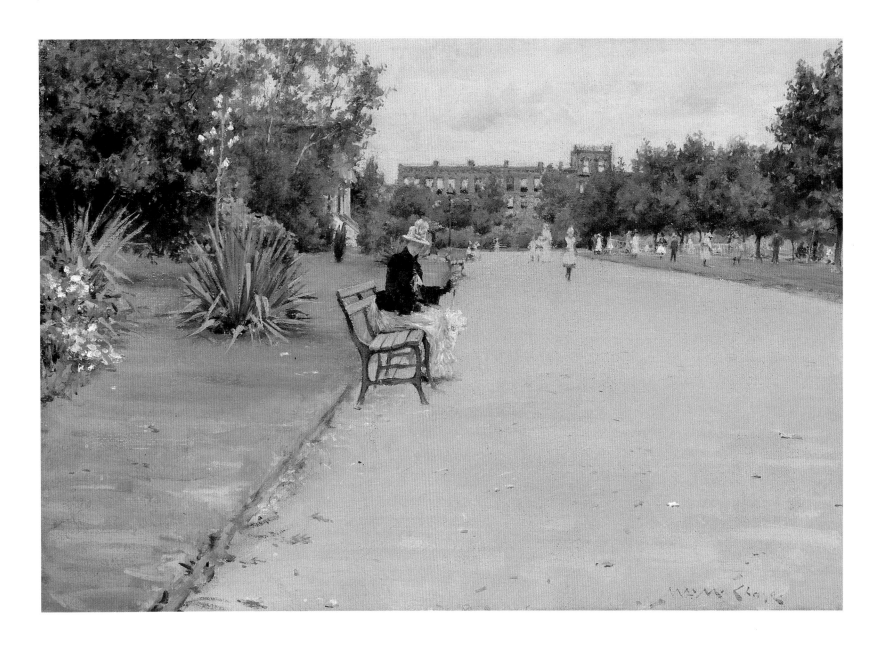

William Merritt Chase

American, 1849-1916
The Park, c. 1888.
Oil on canvas.
13⅝ x 19⅝ in. /34.6 x 49.9 cm.
Bequest of Dr. John J. Ireland, 1968.88.

Indiana-born William Merritt Chase was one of the most influential painters in America at the turn of this century. After an extended stay in Europe, which ended upon the establishment of his studio in New York City in 1878, Chase demonstrated his extraordinary versatility, painting portraits, landscapes, still lifes, and everyday scenes. His vigor as a painter was equaled by his long and successful career as a teacher: his classes in New York, Philadelphia, and Europe attracted many students.

In the mid-1880s, Chase embarked on a group of paintings inspired by the parks of New York. Influenced by the unorthodox compositional formats of the Impressionists, he often countered a broad, empty foreground with a detailed background. In the Art Institute's painting, almost half of the canvas is filled by the broad, empty walkway which, with its strong diagonal borders, carries the eye into the background. The swift movement into space is slowed by the woman on the bench who appears to gaze expectantly toward someone approaching along the path. Dressed fashionably in pink and black, the seated figure is probably Chase's wife, Alice. To the left, colorful flowers provide a contrast to the bare, dun-colored walk at the right. Such informal, seemingly spontaneous works, capturing the sparkle, light, and activity of a summer's day, testify to the freshness and vitality Chase brought to the painting of such scenes.

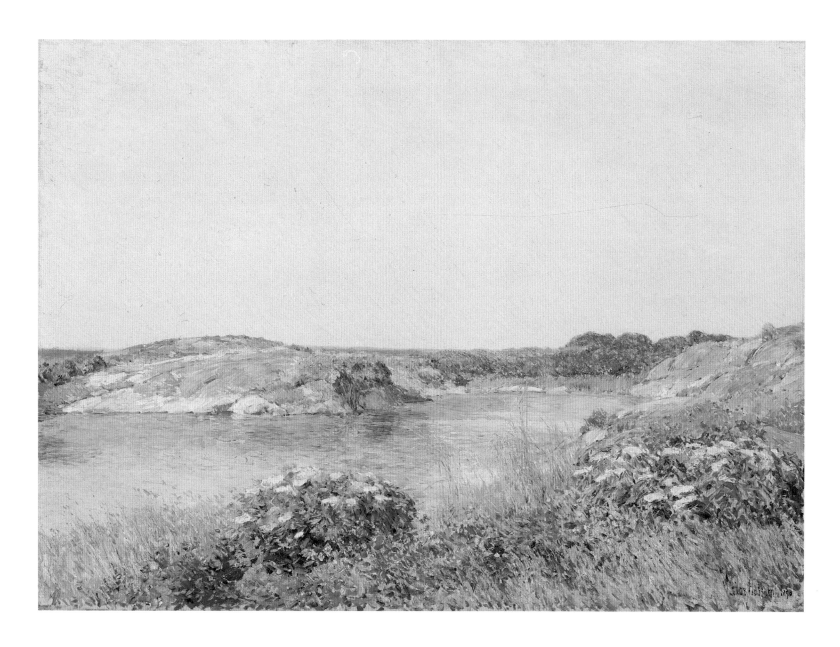

Frederick Childe Hassam

American, 1859 - 1935

The Little Pond, Appledore, 1890.

Oil on canvas.

16 x 22 in. / 40.6 x 55.9 cm.

Friends of American Art Collection; Walter M. Schulze Memorial Collection by exchange, 1986.421.

In Paris at the peak of the French Impressionists' success and influence, Childe Hassam mastered the painting techniques of Claude Monet (see pp. 54, 59, 72), most importantly, his spontaneous brushstroke and atmospheric effects of light and color. In New York City, where he settled, he expanded his Impressionist palette, handling, and sense of composition, painting spacious views of sunny, tree-lined boulevards and parks.

To vary his subjects and refine his eye, Hassam frequently traveled outside New York. Among the New England resorts he visited was Appledore, which was very popular among late-nineteenth-century American literary figures, musicians, and artists. *The Little Pond, Appledore* depicts a quiet, rippling body of water surrounded by breeze-blown grasses and colorful flowers. Beyond the rocks and trees that surround the pond, Hassam sketched the ocean, barely visible on the distant horizon beneath an expansive sky. With its inviting openness and shimmering summer light, this painting represents Hassam's deliberate efforts, after his experiences in Paris with the Impressionists, to brighten his colors, to capture fleeting effects of movement, and to achieve a fresher and more painterly technique. While different in theme from his urban vistas, this unpopulated landscape also demonstrates the mastery that made Hassam a leader among American Impressionist painters.

William Michael Harnett

American, 1848 - 1892
For Sunday's Dinner, 1888.
Oil on canvas.
37⅛ x 21⅛ in. /94.3 x 53.7 cm.
Wilson L. Mead Fund, 1958.296.

Since the ancient Roman historian Pliny reported birds mistaking painted grapes for real grapes, technically skilled artists have attempted to deceive viewers with highly realistic surfaces, foreshortening, and perspective to make images that appear identical with objects in the natural world. In nineteenth-century America, where imitative still-life painting was not as highly regarded as anecdotal scenes or landscapes, William Harnett became a very adept painter of deceptively real paintings, called trompe l'oeil (or "fool the eye").

Seeking a living in Europe from 1880 to 1886, Harnett spent an extended time in Munich, where he sold small, increasingly lavish trompe l'oeil paintings to tourists. By the time Harnett returned to America, collectors had learned to appreciate — and to pay higher prices for — fastidious still lifes they associated with Old Master paintings they could not afford.

In 1888, when his reputation was at its peak, Harnett painted *For Sunday's Dinner*. In contrast to the many paintings he did filled with carefully arranged objects, this work represents a single plucked chicken, waiting to be cooked. The chicken, shown life-sized, hangs against a plank door, its remaining feathers catching the light and appearing to float off into the air. The weathered door, with its chipped and cracked boards and brass hinges, is depicted parallel to the picture plane with emphatic presence and clarity, complicating the viewer's ability to separate illusion and reality.

Frederic Remington

American, 1861 - 1909
The Advance Guard, or
The Military Sacrifice, 1890.
Oil on canvas.
34⅜ x 48½ in. / 87.3 x 123.2 cm.
George F. Harding Collection, 1982.802.

Although he was born in Canton, New York, and later attended classes at the Yale Art School, New Haven, Connecticut, and the Art Students League in New York City, Frederic Remington gained widespread distinction for his heroic vision of life on the western plains. For health reasons, Remington moved to Mon-

tana and later to Kansas, worked as a ranch hand in the early 1880s, and traveled across the West and Southwest, observing Indian customs, ranch life, cowboys and cattle, the railroads, and soldiers on horseback patrolling America's expanding frontier. Capturing the individuality and self-determination of this population with a superb sense of drama, Remington romanticized the vanishing life of the Old West in magazine illustrations, etchings, oil paintings, and bronze sculptures.

During the late 1880s, Remington worked as an illustrator for *Harper's Weekly* and accompanied the U. S. Sixth Cavalry as it pursued Northern Plains Sioux Indians across the canyons of the Badlands. To protect the regiment

from Indian ambush, commanders sent single cavalrymen far ahead to draw Indian fire. *The Advance Guard* depicts the moment when the regiment's vedette, the forward-most sentinel, is shot by an Indian hidden in the surrounding rocky ravine. Remington meticulously represented the heroic cavalryman's sacrifice in the brightly lit foreground. The stricken soldier's distant companions retreat hastily to warn the regiment of the imminent danger.

John Henry Twachtman

American, 1853 - 1902

Icebound, c. 1889.

Oil on canvas.

25¼ x 30⅛ in. /64.1 x 76.5 cm.

Friends of American Art Collection, 1917.200.

The gentle and introspective vision of John Twachtman is revealed in the subtle nuances of his muted tonal harmonies. Like the French Impressionists, whose style deeply influenced Twachtman, he returned again and again to the same scene in order to explore its changing phases and his own emotional responses. During his lifetime, writers often compared his art to that of James Abbott McNeill Whistler (see pp. 90, 102, 103) and the effect of his paintings to the music of French composer Claude Debussy.

In 1889, Twachtman purchased a farm near Cos Cob, Connecticut, where he could concentrate on his study of nature. For the next decade, his home and the land surrounding it provided

him with an inexhaustible supply of subjects. *Icebound* depicts a tranquil winter scene in a limited range of whites and blues. Even though its title suggests a landscape that is frozen and still, movement is nonetheless implied: a stream descends from the rocks in the background, a descent accentuated by the sinuous arabesques of white snow against blue water; thick brush-strokes of white and streaks of violet amid the blue of the water enliven the picture's surface; and, finally, the vivid red-orange of the leaves stands out against the dominant white and serves as a reminder of the autumnal life that will not let go. These several enlivening notes, however, scarcely intrude upon the hushed tranquility of the scene.

Mary Cassatt

American, 1844 - 1926
The Bath, 1891 - 92.
Oil on canvas.
39½ x 26 in. /100.3 x 66 cm.
Robert A. Waller Fund, 1910.2.

Mary Cassatt grew up in a wealthy family and studied at the Pennsylvania Academy of the Fine Arts from 1861 to 1865. In 1866, she traveled to Europe to study in the museums of France, Italy, Spain, and the Netherlands. In 1872, she sent her first painting to the official French Salon and two years later settled in Paris, where she eventually established herself as one of America's foremost expatriate painters. In 1877, however, disenchanted with the conservatism of the official French Salon exhibitions, she accepted an invitation from Edgar Degas (see pp. 57, 60) to join the Impressionists, thus becoming the first American to exhibit with them. Significantly for her work, Cassatt chose Degas, the consummate draftsman, as her artistic mentor. Like Degas, she concentrated almost exclusively on the figure.

The Bath reflects Cassatt's interest in exploring unorthodox compositions. The wallpaper, painted chest, striped dress, and patterned carpet are daringly played off against one another. Even more boldly, the torso and bare, white legs of the child dramatically cut across the diagonal stripes of the woman's dress. Despite these striking effects, it is the tender rapport between woman and child — the woman assured, supportive, the child tentative, wary — that commands the viewer's attention. As a critic wrote of the 1893 one-person exhibition in Paris at which *The Bath* was first exhibited: "Here we find work of rare quality, which reveals an artist of lively sentiment, exquisite taste, and great talent."

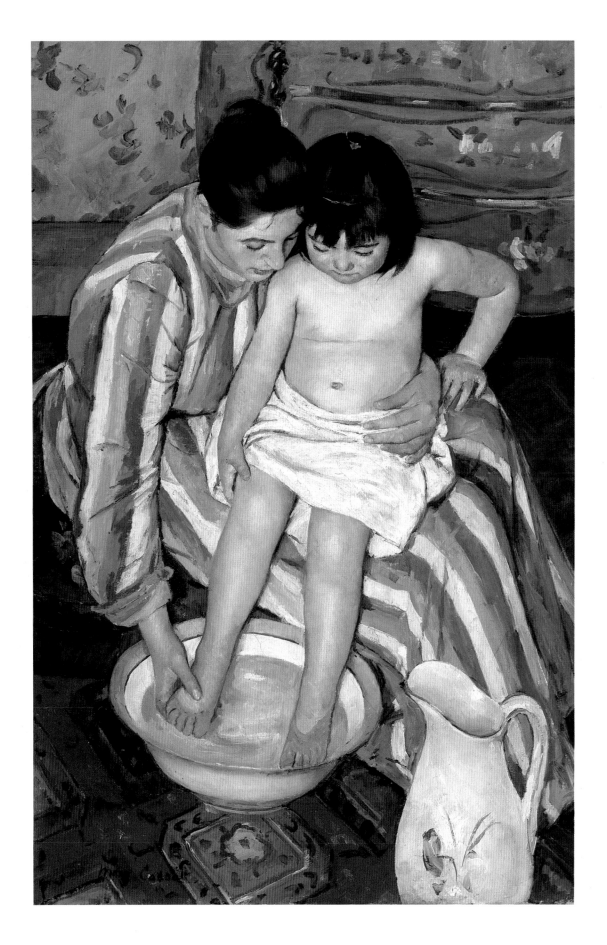

George Inness

American, 1825 - 1894
Early Morning, Tarpon Springs, 1892.
Oil on canvas.
42³⁄₁₆ x 32⅜ in. / 107.2 x 82.2 cm.
Edward B. Butler Collection, 1911.32.

In 1878, the painter George Inness wrote in *Harper's Magazine*, "Details in the pictures must be elaborated only enough fully to reproduce the impression that the artist wishes to reproduce. When [there are more details], the impression is weakened or lost, and we see simply an array of external things which may be very cleverly painted and may look very real, but which do not make an artistic painting. . . . The one is poetic truth, the other is scientific truth; the former is aesthetic, the latter is analytic."

In the last ten years of his life, the prolific painter eschewed precision of detail, conveying mood and emotion through richness of tone and broad handling. Inness first visited Florida about 1890, and subsequently established a house and studio in Tarpon Springs, where the Art Institute's painting was executed. In the pink and blue morning light, a solitary figure studies a cluster of buildings in the middle distance. Although a wooden bridge leads from foreground to figure, in fact, the pool of light that illuminates the central clearing quickly draws the eye of the spectator into the middle of the picture and, from there, to the cloudlike expanses of green foliage high atop the thin-trunked trees circling the clearing. Through blurred outlines and delicate, subtle tonalities, as well as the solitary presence of the figure, Inness masterfully evoked the brightening light and peaceful mood of early morning.

Robert William Vonnoh

American, 1858 - 1933

Spring in France, 1890.

Oil on canvas.

15³/₁₆ x 22 in. /38.5 x 55.9 cm.

Wirt D. Walker Fund, 1982.272.

Robert Vonnoh was among the first American artists to adopt the Impressionist techniques of separate, spontaneous brushstrokes, fragmentary images, and high-keyed colors. In 1881, after a period of study in Boston, he made the first of many trips to France, where he studied painting. By the late 1880s, he had begun to paint in the manner of Claude Monet

(see pp. 54, 59, 72). As he later recalled, "I gradually came to realize the value of first impression and the necessity of correct value, pure color, and higher key resulting in my soon becoming a devoted disciple of the new movement in painting."

Spring in France, a composition bursting with color, is one of the paintings Vonnoh executed in this style. Spontaneity is conveyed by the separate brushstrokes of lavender, violet, and green that represent the dense growth of grass and shrubbery. The brushstrokes also accentuate the diagonal sweep of the pathway in the foreground, a movement echoed by the sloping line of the two trees. The precipitous movement to the right and tremulous vibration

of glowing color is stabilized by the vertical fence posts and the horizontal mass of buildings at the center.

An exhibition of thirteen paintings by Vonnoh at the 1893 World's Columbian Exposition in Chicago inspired American author Hamlin Garland to write enthusiastically: "The impressionist is a buoyant and cheerful painter. He loves the open air, and the mid-day sun. He has little to say about the 'mystery' and 'sentiment' of nature. His landscapes quiver with virile color."

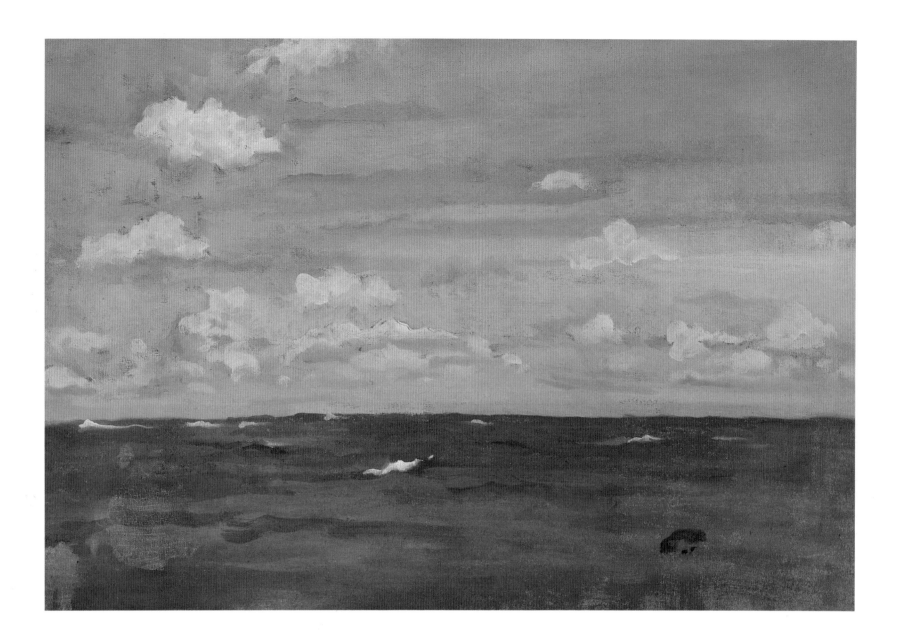

James Abbott McNeill Whistler

American, 1834 - 1903

Violet and Silver — The Deep Sea, 1893.

Oil on canvas.

19¾ x 28⅞ in. /50.2 x 73.3 cm.

Gift of Clara Margaret Lynch in memory
of John A. Lynch, 1955.743.

Throughout the 1870s, James Abbott McNeill Whistler challenged contemporary critics and the public with his belief in "art for art's sake." He championed art as a self-sufficient form meant to delight the eye of the viewer. His belief that art should not be judged by standards unrelated to the formal issues and qualities that concern the artist and that it is an artist's right to create his or her own standards of beauty eventually brought him into conflict with the conservative and powerful English critic John Ruskin, who accused Whistler of "flinging a pot of paint in the public's face." In 1877, Whistler successfully sued Ruskin for libel, but the artist won only a farthing in damages, leaving him bankrupt.

He nonetheless continued to work in many mediums, producing small landscapes, urban views, interiors, and seascapes. He painted *Violet and Silver — The Deep Sea* in 1893 and displayed the seascape in Paris in 1894. Apparently, this broadly painted view, with portions of the canvas left unpainted, was one of several related compositions Whistler executed while boating off the coast of Brittany. Deeply moved by the beauty of this place, Whistler made vivid the expanse of water, clouds, and sky, using harmonious colors and simple shapes. The painting's subtlety and sonorous tones are not too distant from his earlier Nocturnes (see p. 90).

James Abbott McNeill Whistler

American, 1834 - 1903
*An Arrangement in Flesh Color and
Brown (Arthur Jerome Eddy)*, 1894.
Oil on canvas.
82½ x 36½ in. /209.6 x 92.7 cm.
Arthur Jerome Eddy Memorial Collection,
1931.501.

By the early 1890s, James Abbott McNeill Whistler had begun to earn recognition for his art on both sides of the Atlantic. In the last decades of his life, he received many commissions to portray prominent Americans and Europeans. Sensitive and understated in their characterization of sitters, his portraits were nonetheless conceived as compositions of subtle tonalities and form, as the title of this portrait, *An Arrangement in Flesh Color and Brown*, demonstrates.

The Art Institute's portrait commemorates one of Chicago's early and most enthusiastic collectors of modern art. One year after he had seen Whistler's work in the World's Columbian Exposition, held in Chicago in 1893, lawyer, collector, critic, and writer Arthur Jerome Eddy asked the artist to paint his portrait. Eddy traveled to his Paris studio, where the two apparently formed a lasting friendship: the year after Whistler's death, Eddy wrote *Recollections and Impressions of James A. McNeill Whistler* as a memorial to the painter. In 1913, Eddy purchased many works from the famous Armory show, which introduced Americans (and enraged many of them) to revolutionary European art. This exhibition, whose showing in Chicago Eddy encouraged, prompted him to write the first book by an American on modern European art, *Cubists and Post-Impressionists*, first published in 1914. The Arthur Jerome Eddy Memorial Collection, including this portrait, was presented to the Art Institute in 1931.

Thomas Eakins

American, 1844 - 1916
Mary Adeline Williams, 1899.
Oil on canvas.
24 x 20 1/16 in. / 61 x 51 cm.
Friends of American Art Collection, 1939.548.

One of the great American artists of his time, Thomas Eakins studied art in his native Philadelphia before spending three years at the Ecole des Beaux-Arts in Paris. After his return to America in 1870, he lived, taught, and painted in Philadelphia until his death in 1916. Convinced that science — anatomy and perspective — was essential knowledge for an artist, Eakins insisted that all his students, female as well as male, practice drawing from the nude. This stand, revolutionary at the time, contributed to forcing his resignation as director of the Pennsylvania Academy of the Fine Arts in 1886.

Eakins's uncompromising realism is apparent in his portraiture. His portraits were not popular in his own day, which explains why many of them were really private in nature, depicting friends, relatives, or professional acquaintances. In this portrait of Mary Adeline Williams (a long-time friend of Mrs. Eakins who eventually moved into the Eakins's household), the dark background and severity of dress and coiffure throw into relief the sitter's plain features. Her erect posture, pursed lips, and furrowed brow are softened by the three-quarter pose that casts her left side in shadow, while the light that illumines her right side reveals a thoughtful, inward gaze and a reserved, but warm, demeanor. In such breathtakingly honest portraits as this one, Eakins showed his sensitivity to the subtleties of character and his constant need to contemplate through his sitters the nature of the human condition.

Twentieth-Century Paintings

William James Glackens

American, 1870-1938
Chez Mouquin, 1905.
Oil on canvas.
48³⁄₁₆ x 36¼ in. /122.4 x 92.1 cm.
Friends of American Art Collection, 1925.295.

Snails, bouillabaisse, and vintage wines dazzled New Yorkers who frequented Mouquin's restaurant, immortalized in William Glackens's 1905 painting. The restaurant was as fashionable and French as Glackens's technique, which was derived from the French Impressionists' exuberant and spontaneous method of directly observing and painting everyday life. In Mouquin's mirrored café (there was a formal dining room upstairs), Glackens portrayed his friend James Moore, a lawyer and man-about-town, with a woman, either an acquaintance of Moore's or a professional model. Another friend and Glackens's wife are among the figures glimpsed in the mirror. Despite the gaiety and glitter of the setting, the two principal figures seem preoccupied, even withdrawn. A similar note of detachment can be seen in the café scenes of Edouard Manet and Henri de Toulouse-Lautrec (see pp. 62, 70). In the late nineteenth century, artists often depicted aloofness and introspection in their figures, perhaps reflecting the psychological dislocation of a world in rapid change.

In this work, one of the major American paintings of the pre-World War I era, Glackens achieved a delicate balance of subject and technique that he was not able to sustain through his career. While he always remained faithful to the loose brushwork of Impressionism, his later paintings lacked the energy of his earlier works and took on a more distracted and dreamlike tone, heavily influenced by the late paintings of Auguste Renoir.

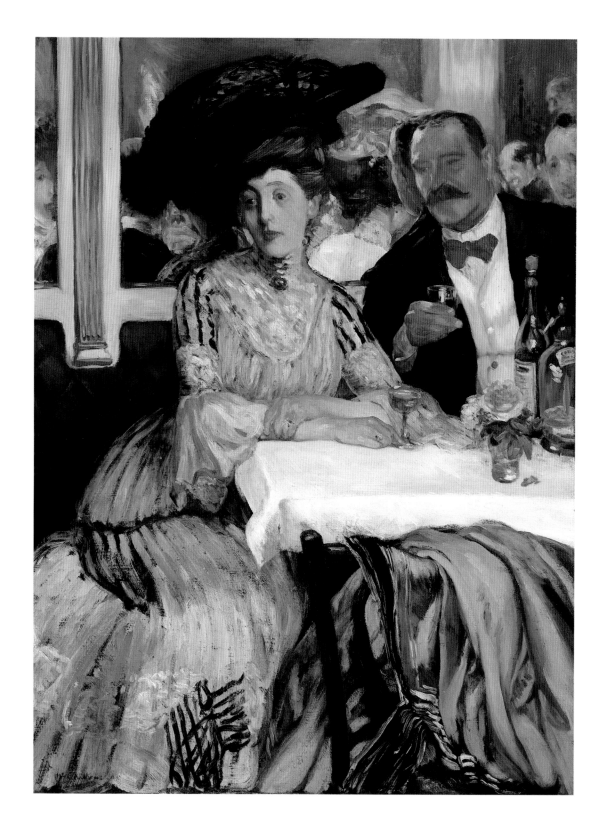

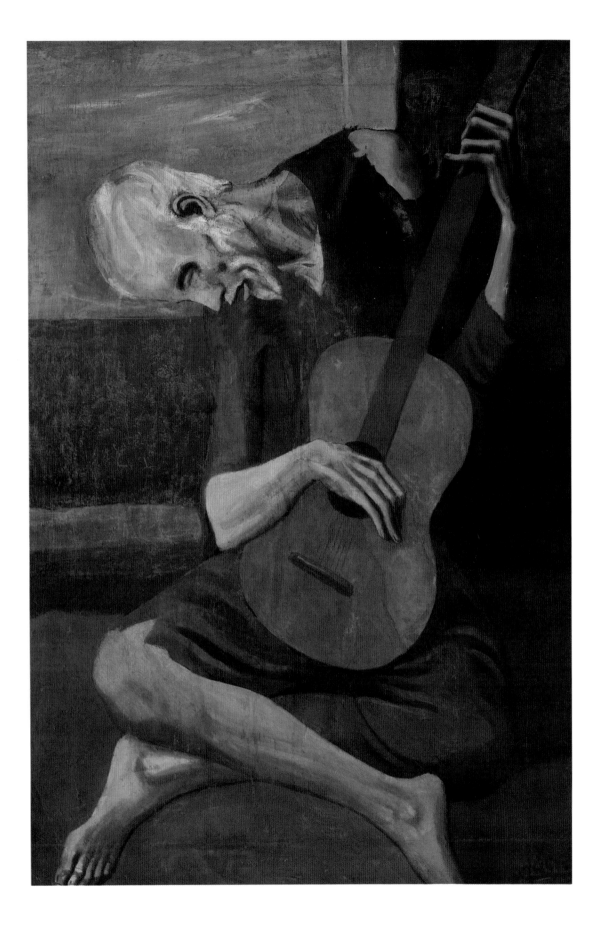

Pablo Picasso

Spanish, 1881 - 1973
The Old Guitarist, 1903/04.
Oil on panel.
48⅜ x 32½/122.9 x 82.6 cm.
Helen Birch Bartlett Memorial Collection,
1926.253.

Pablo Picasso painted *The Old Guitarist*, one of the most haunting images of this century, when he was twenty-two years old. In the paintings of his Blue Period (1901 to 1904), of which this is a prime example, Picasso worked with a monochromatic color palette, flattened forms, and pensive themes. There have been many attempts to explain Picasso's nearly exclusive use of blue during this time. He may have been too poor to buy other colors. He usually worked at night under lamplight, which could have contributed to his choice of one color. Not the least among the possibilities is the psychological impact of blue, which can convey a sense of mystery and sadness.

The emaciated figure of the blind musician reflects Picasso's artistic roots in Spain. The old man's elongated limbs and angular posture recall the figures of the great sixteenth-century artist El Greco (see p. 23). Also, Picasso was sympathetic to the plight of the downtrodden and painted many canvases at this time depicting the miseries of the poor, the ill, and the outcasts of society. He knew what it was like to be poor, having been nearly penniless during all of 1902.

With the simplest means, Picasso presented in *The Old Guitarist* a timeless expression of human suffering. The bent and sightless man holds close to him his large, round guitar — its brown body the painting's only shift in color. It fills, both physically and symbolically, the space around the solitary figure, who seems oblivious to his infirmity and poverty as he plays, totally absorbed in his music.

Henry Ossawa Tanner

American, 1859 - 1937
The Two Disciples at the Tomb, 1905.
Oil on canvas.
51 x 41 ⅝ in. /129.5 x 105.7 cm.
Robert Waller Fund, 1906.300.

The Two Disciples at the Tomb was acquired by
the Art Institute after being cited as "the most
impressive and distinguished work of the
season" at the museum's annual exhibition of
American painting and sculpture. At that time,
Henry Ossawa Tanner was at the height of his
reputation, enjoying international fame and
winning prizes on both sides of the Atlantic.
The son of a black American bishop, Tanner
was raised in Philadelphia, where he studied
with Thomas Eakins (see p. 104) before working
as an artist and photographer in Atlanta.
Repelled by the racial prejudice he encountered
in the United States, he chose to spend nearly
all of his adult life in France.

Tanner's early subjects included many
scenes of black life, but later he specialized in
religious paintings, of which *The Two Disciples
at the Tomb* is one of the most concentrated and
austere. The somber spirituality of the moment
when two of Jesus' followers realize that he has
risen from the dead is conveyed by Tanner's
dark tones, compressed space, and lack of
superfluous incident. Although Tanner painted
in a relatively conservative representational
manner throughout his life, the sinuous lines
and simplified, harsh modeling here suggest his
awareness of Art Nouveau and Expressionist
currents in contemporary European painting.
Likewise, his emphasis on psychological rather
than physical experience has many parallels in
advanced art of the same period, including
Pablo Picasso's early work, such as *The Old Gui-
tarist* (p. 108), painted nearly two years earlier.

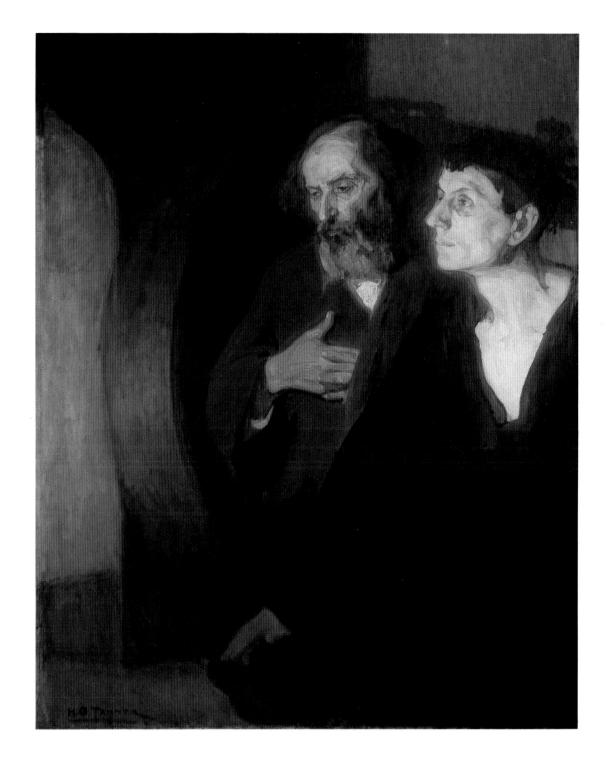

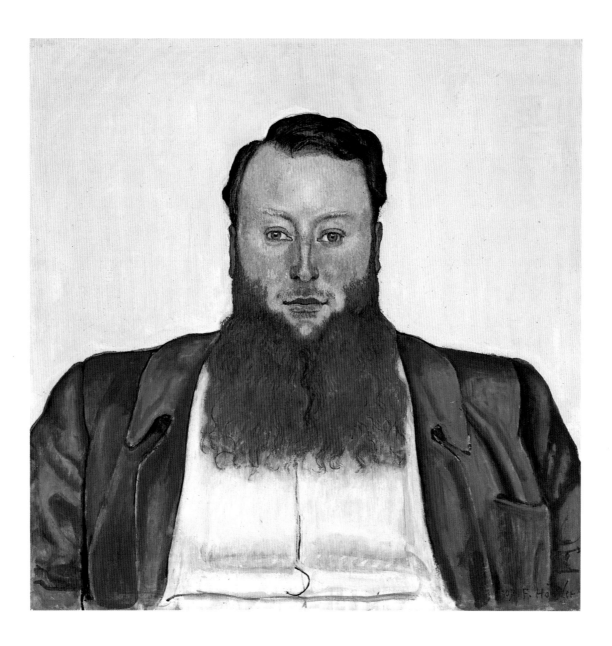

Ferdinand Hodler

Swiss, 1853 - 1918
James Vibert, Sculptor, 1907.
Oil on canvas.
25¾ x 26⅛ in. /65.4 x 66.4 cm.
Helen Birch Bartlett Memorial Collection,
1926.212.

Although Ferdinand Hodler enjoyed brief acclaim in Europe, his work is now little known outside of Switzerland, where, at the turn of the century, he was considered the nation's leading artist. Three paintings by Hodler in the Art Institute, including *James Vibert, Sculptor*, represent the greatest concentration of his work

in any American museum. Throughout his career, Hodler struggled to guide his art along philosophical principles. He developed a strict aesthetic theory he called Parallelism, according to which he relied heavily on laws of compositional organization, such as symmetry and repetition, to create a world of unity and stability.

As a portraitist, Hodler limited his portrayals to his friends and patrons. A Swiss sculptor who had studied with Auguste Rodin, James Vibert was one of Hodler's closest friends. The Art Institute's portrait is the earliest of nine pictures of the sculptor painted by Hodler. With his square-cut red beard and blue eyes, Vibert cuts a striking figure against the pale yellow background. Hodler's Parallelism can be seen

in the painting's rigid symmetry: the line from the nose to the mouth and chin down through the shirt divides the portrait vertically into two nearly identical halves. Hodler's skills as a portraitist and his adherence to his aesthetic and philosophical principles combined to produce an image that is both unique and universal. As he wrote, "We differ one from the other, but we are like each other even more. What unifies us is greater and more powerful than what divides us."

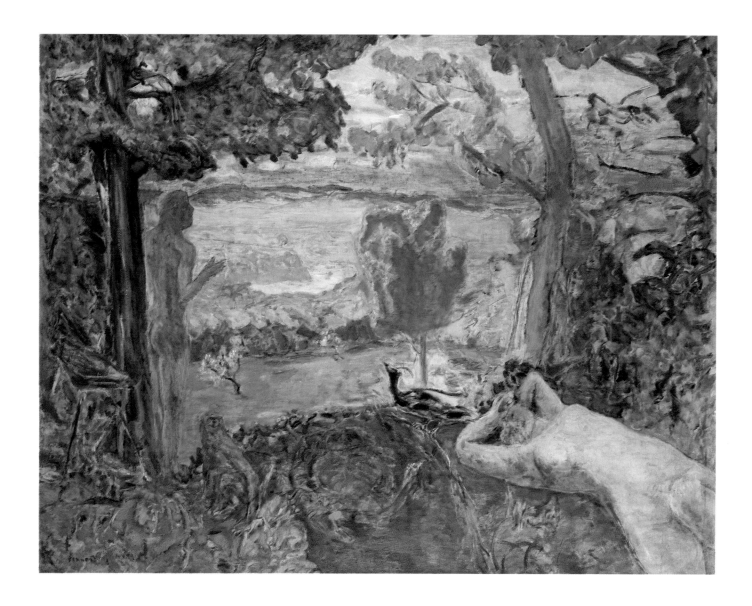

Pierre Bonnard

French, 1867–1947

Earthly Paradise, 1916–20.

Oil on canvas.

51¼ x 63 in. / 130 x 160 cm.

Estate of Joanne Toor Cummings; Bette and Neison Harris and Searle Family Trust endowments; through prior gifts of Mrs. Henry Woods, 1996.47.

Following a period of producing lithographs, paintings, and posters of Parisian scenes in the style of Edouard Vuillard and Henri de Toulouse-Lautrec, Pierre Bonnard virtually reinvented his art, around 1905. The artist's new emphasis on large-scale, expansive compositions; bold forms; and, above all, brilliant colors shows his awareness of the work of modernist masters Henri Matisse and Pablo Picasso, as does his focus on a theme he had not previously explored, Arcadian landscapes.

Earthly Paradise exhibits Bonnard's new, daring investigations of light, color, and space. Here, the artist used foliage to create a prosceniumlike arch for a drama involving a rigid, brooding Adam and a recumbent, languorous Eve. The contrast Bonnard set up here seems to follow a tradition according to which the female, who is essentially sensuous, is connected with nature, while the male, essentially intellectual, is able to transcend the earthly. Heightening the ambiguity of the image is an unusual panoply of animals, including various kinds of birds, a monkey, rabbits, and of course, a serpent—here reduced to a garden snake. The melancholic scene, presented as a paradise that is less than Edenic, may reflect the artist's response to the destruction of Europe during World War I, when he executed the painting.

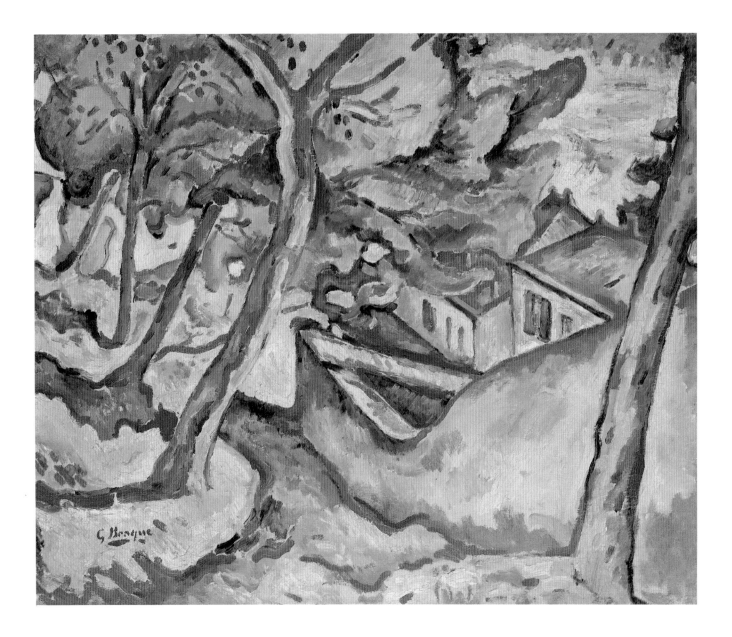

Georges Braque

French, 1882 - 1963

Landscape at La Ciotat, 1907.

Oil on canvas.

23⅝ x 28½ in. /60 x 72.5 cm.

Walter Aitken Fund Income, Major
Acquisition Centennial Fund Income,
Martha E. Leverone Fund; restricted gift of
Friends of The Art Institute of Chicago in
honor of Mrs. Leigh B. Block, 1981.65.

Although Georges Braque's name is mainly associated with Cubism, *Landscape at La Ciotat* is an example of the period when he was counted among the Fauve painters. Fauvism, a short-lived but potent artistic movement, gained recognition in 1905 when a group of artists who painted with brilliant colors and freedom of line caused a sensation in Paris. The group was labeled by a critic *les fauves*, or "wild beasts."

In the summer of 1906, instead of continuing to paint in a manner close to Impressionism, the young Braque began to work in the bright hues and curvilinear forms of the Fauves. In the spring of 1907, Braque went to the small port and summer resort town of La Ciotat, east of Marseilles, where he painted the Art Institute's landscape. Because of the clarity of light and expanse of sky and water, the Mediterranean coast in the south of France was a favorite site for artists interested in outdoor scenes. In this painting, a steep, tree-lined road winds by a wall enclosing a group of houses, rendered in improbable tones of yellow, pink, green, lavender, and orange. Among the last and the youngest to join the Fauves, Braque painted about forty pictures in that style in 1906 and 1907. These paintings show an individual approach to his subjects, in which Braque used more subdued color and less densely applied paint and created more lyrical compositions than did the other Fauves. By the end of 1907, Braque's interest in Fauve methods had diminished, and the movement itself had come to an end.

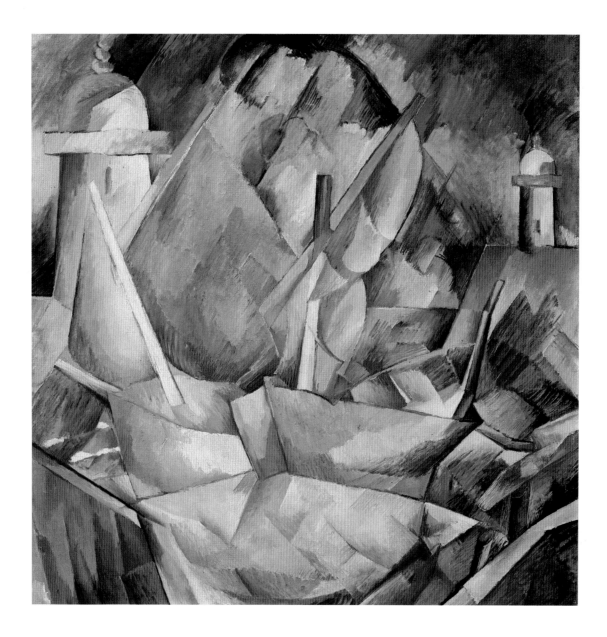

Georges Braque

French, 1882 - 1963
Harbor in Normandy, 1909.
Oil on canvas.
31 15/16 x 31 11/16 in. /81.1 x 80.5 cm.
Samuel A. Marx Purchase Fund, 1970.98.

Georges Braque's introduction to the paintings of Paul Cézanne at his 1907 memorial exhibition and the influence of Pablo Picasso's revolutionary painting *Les Demoiselles d'Avignon* (Museum of Modern Art, New York), seen by Braque in the same year, inspired him to turn away from his Fauve style (see p. 112) in favor of more subdued and considered studies of shape and volume. Over the next several years, Braque worked closely with Picasso to develop the style that came to be known as Cubism.

While many of his Fauve works were done out-of-doors, *Harbor in Normandy* was painted from memory in his Paris studio. Between a pair of lighthouse structures, two sailboats, with their strongly defined hulls and swelling sails punctuated by spars and masts, enter the harbor and approach the wharf. Braque's compressed treatment of space seems to propel the sailboats forward to the front edge of the picture. A turbulent steel-blue sea with a fringe of whitecaps and a stormy blue sky with dashes of white clouds energize the powerful composition. *Harbor in Normandy* may have been exhibited in Paris in March 1909 at the Salon des Indépendants. If so, this painting was the first major Cubist work to have appeared in an official salon and the last to be submitted by Braque to a public exhibition in Paris for ten years.

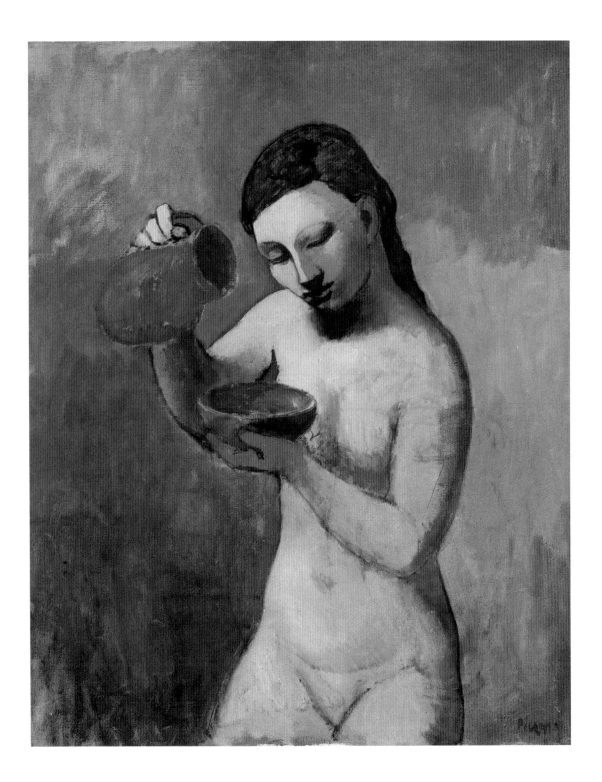

Pablo Picasso

Spanish, 1881 - 1973
Girl with Pitcher, 1906.
Oil on canvas.
39⅜ x 32 in. /100.8 x 81.9 cm.
Gift of Mary and Leigh B. Block, 1981.14.

From 1904 through 1906, Pablo Picasso shifted from the melancholic subjects of his Blue Period (see p. 108) to the more cheerful themes of his Rose Period, painting acrobats and clowns in pinks, grays, and ochers. By 1905, his living conditions had improved. In February of that year, he exhibited his first Rose Period paintings, most of which were purchased by his dealer Ambroise Vollard. A short trip Picasso made to Holland seems to have reawakened his interest in the nude, and he began to paint figures with a classical and sculptural feeling.

Girl with Pitcher probably dates from the summer of 1906, which Picasso and his mistress, Fernande Olivier, spent in the Catalan village of Gosol in the Spanish Pyrenees. In a neutral space, the artist depicted a young girl whose rounded forms are echoed in the ceramic Gosol pitcher and bowl she holds. Picasso's treatment of the girl's face is significant. Her blocky features reveal the artist's growing interest at this time in the powerful and simple forms of ancient Iberian sculpture and primitive art; the somewhat angular, masklike face anticipates the vocabulary of Cubism, which would appear in his famous composition of the following year, *Les Demoiselles d'Avignon* (Museum of Modern Art, New York).

Pablo Picasso

Spanish, 1881 - 1973

Daniel-Henry Kahnweiler, 1910.

Oil on canvas.

39¹³⁄₁₆ x 28⅞ in. /101.1 x 73.3 cm.

Gift of Mrs. Gilbert W. Chapman in memory of Charles B. Goodspeed, 1948.561.

It may be difficult at first to see the subject of this painting. Despite its highly abstract character, Pablo Picasso provided clues to direct the eye and focus the mind: a wave of hair, the knot of a tie, a watch chain. From flickering, partially transparent planes of brown, gray, black, and white emerges the upper torso of a seated man, hands clasped in his lap. To the left is an elongated sculpture similar to a figure from New Caledonia that hung in Picasso's studio, and below this is a small still life.

The process by which we discover and read these details is an important part of the experience of Cubist paintings. No longer seeking to create the illusion of appearances, Picasso invited the viewer to probe the many aspects of forms that he broke down and recombined in totally new ways. In this work, we are presented with objects whose volumes have been fractured into various planes, shapes, and contours, and presented from several points of view. The term Analytical Cubism has been given to this most complex phase of the movement. The portrait's subject, Daniel-Henry Kahnweiler, was a dealer who championed the radical new style. Two years before this portrait was done, he had introduced Picasso to Georges Braque (see pp. 112, 113), and the two artists worked closely together to create Cubism. Kahnweiler purchased the majority of their paintings produced between 1908 and 1915 and wrote an influential book which provided a theoretical framework for the movement.

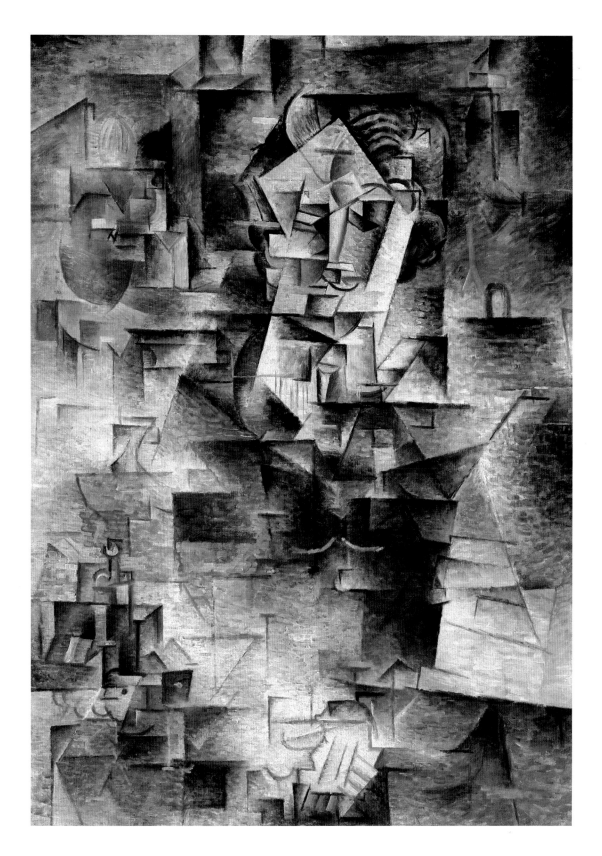

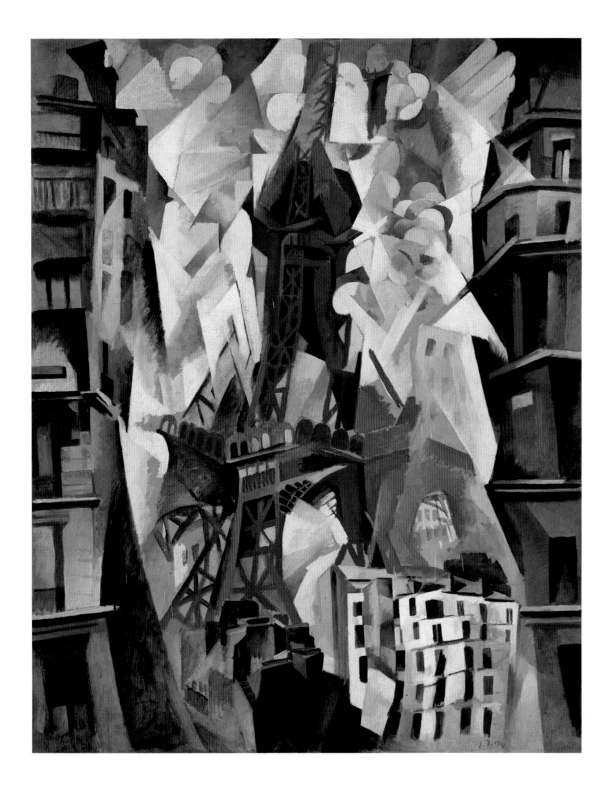

Robert Delaunay

French, 1885 - 1941

Champs de Mars, the Red Tower, 1911.

Oil on canvas.

63¼ x 50⅝ in. /160.7 x 128.6 cm.

Joseph Winterbotham Collection, 1959.1.

Robert Delaunay was four years old when the Eiffel Tower was erected in Paris. This engineering triumph became a symbol for that city, as well as for the modern age. One of the first of many artists to focus on the landmark, Delaunay did a series of paintings about the tower between 1909 and 1913, of which the Art Institute's example is among the most important. Using a visual language that he called Simultaneity, largely adapted from Cubism and influenced by nineteenth-century color theory, he attempted to infuse the dynamism of modern life into this image of the monument by means of multiple viewpoints, extreme fragmentation of form, and strong color contrasts.

Tall, dark buildings on the sides of the picture frame the red tower, which fronts on the gardens of the Champs de Mars. An illusion of height and distance is created by the smaller, lower buildings at the foot of the structure, which are seen from a high vantage point. The tower's red girders are broken and interrupted by planes of blue and white: clouds, walls of buildings, patches of sky. Its top and struts seem to lean, tumble down, and soar at the same time. The vigor and strength of the steel structure, which totally commands the city over which it stands, seems to have affected the surrounding buildings and park, whose fragmented forms appear to dance and merge before our eyes.

Juan Gris

Spanish, 1887 - 1927
Portrait of Picasso, 1912.
Oil on canvas.
29³⁄₁₆ x 36⁵⁄₈ in. /74.1 x 93 cm.
Gift of Mr. and Mrs. Leigh B. Block, 1958.525.

Juan Gris's *Portrait of Picasso* is among the most important portraits of the Cubist movement. In an inscription, *"Hommage à Pablo Picasso,"* added at the bottom of the painting, Gris indicated his admiration for the cofounder of Cubism, a fellow Spaniard six years his senior. Born in Madrid, Gris went to Paris in 1906 and moved into the Bateau-Lavoir, the famous gathering place for the avant-garde where Picasso lived. By 1912, Gris had evolved a significant Cubist style of his own. The portrait of Picasso was exhibited at the Salon des Indépendants in Paris that year.

Gris's early Cubist method depends greatly on systematic patterns of planes carefully delineated through light and shadow. Picasso is portrayed here half-length, seated, holding his palette. Although his facial features have been reorganized into many parts, a resemblance remains. Colors have been limited to cool tones: blues, browns, and grays. The almost monochromatic colors of Gris's early pictures perhaps relate to the name the artist chose as a pseudonym. In 1906, José Vittoriano González renamed himself Juan Gris; *gris* translates to "gray" in both Spanish and French. In many of his later paintings, however, Gris restored light and color to Cubism, creating faceted surfaces that are at times almost jewel-like in their intense coloration.

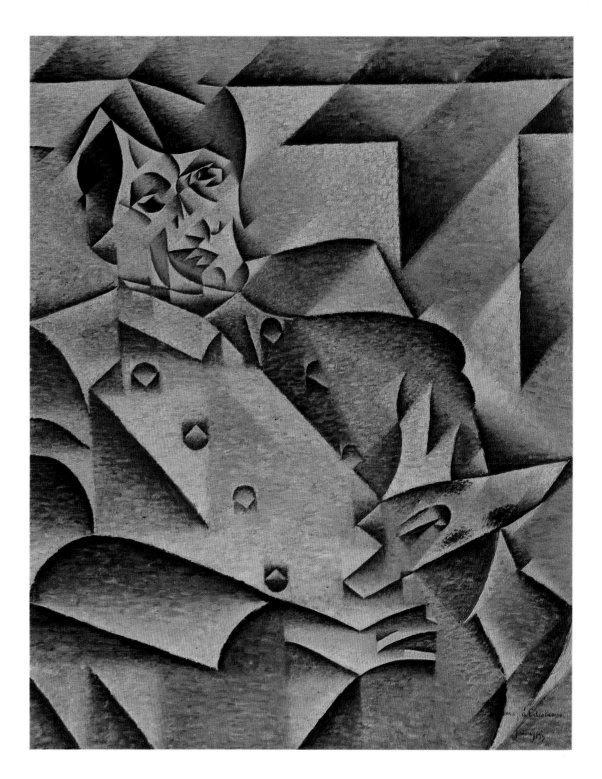

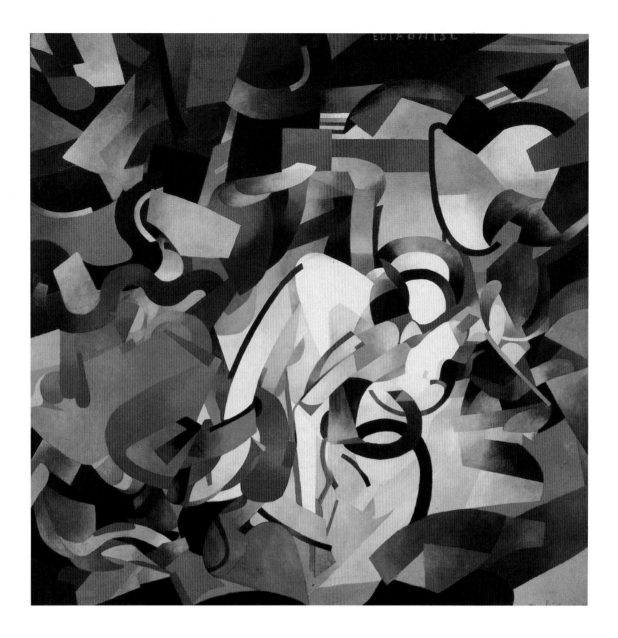

Francis Picabia

French, 1879 - 1953
Edtaonisl (Ecclésiastique), 1913.
Oil on canvas.
118¼ x 118⅜ in. /300.4 x 300.7 cm.
Gift of Mr. and Mrs. Armand Phillip Bartos,
1953.622.

Francis Picabia, the son of a Cuban father and a French mother, was one of the most versatile artists of this century, working in a variety of styles. The riddle posed by the title of the Art Institute's painting *Edtaonisl* relates to an experience Picabia had aboard a transatlantic ship in 1913, on his way to the opening in New York of the famous exhibition of modern art, the Armory Show. Two of his fellow passengers fascinated the artist. One, Stasia Napierskowska, was an exotic dancer well-known in Paris. The title of the museum's painting is an acronym made by alternating the letters of the French words *danseuse étoile,* or "star dancer." To Picabia's amusement, another passenger captivated by the dancer's shipboard

rehearsals was a Dominican priest. This probably led to his giving the painting the subtitle *Ecclésiastique,* thereby juxtaposing the sensual with the spiritual.

Only the cryptic title hints at the inspiration of this painting. Purely abstract shapes float rhythmically in a profusion of colors across the canvas. The sense of perpetual motion that their fragmentation and overlapping creates reflects Picabia's indebtedness to Italian Futurism and the related French movement, Orphism. While one cannot be too literal in interpreting the meaning of a work such as *Edtaonisl,* the intended theme of the painting probably relates to the excitement of the clergyman as he watched the dancer and her troupe.

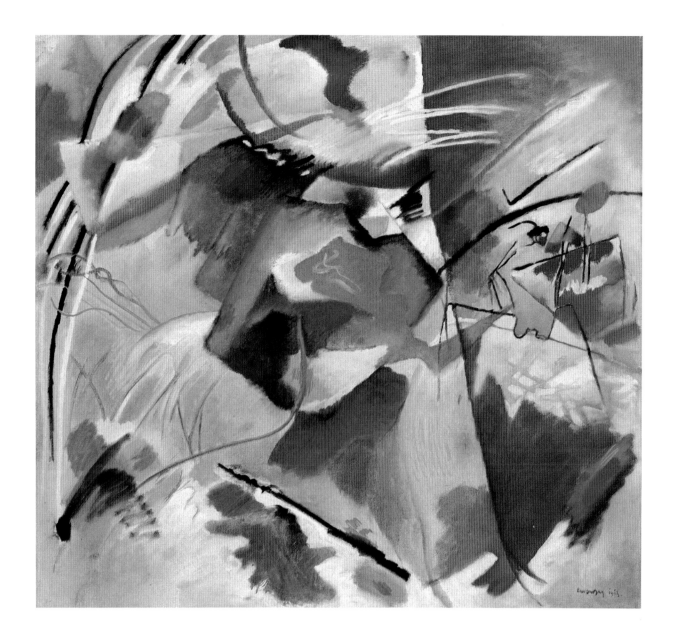

Wassily Kandinsky
Russian, 1866-1944
Improvisation with
Green Center (No. 176), 1913.
Oil on canvas.
42⅞ x 46⅝ in. /108.9 x 118.4 cm.
Arthur Jerome Eddy Memorial Collection,
1931.510.

Influenced by theosophy, which promoted spiritual fulfillment through a direct relationship with divine forces, Wassily Kandinsky published an important book, *Concerning the Spiritual in Art*, in 1912. Between 1910 and 1914, he painted his first wholly nonobjective works, believing his abstract compositions to be closer to the purity of music and more spiritual than images based on rational thinking and the representation of appearances.

It was Kandinsky's mysticism, his sense of the connection between inner creative urges and higher forces, that enabled him to create paintings whose subject is the relationship between colors, lines, and forms. Unlike James Abbott McNeill Whistler's deliberate series of Arrangements and Nocturnes (see pp. 90, 103), Kandinsky's Improvisations were, as he described them, "largely unconscious, spontaneous expressions of inner character, nonmaterial in nature." Kandinsky allowed his colors and forms to flow onto his canvas, giving free rein to his imagination and subconscious feelings. Nonetheless, he tried to retain some reference to nature, out of a concern that his work might become too decorative. Thus, the associations one has with the forms and colors in *Improvisation with Green Center* — a suggestion of landscape, of the movement and energy of living things — were probably intended. Kandinsky's influence was considerable in Europe and America on artists as different as Marsden Hartley (see p. 120) and Jackson Pollock (see p. 149).

Marsden Hartley

American, 1877 - 1943

Movements, 1913.

Oil on canvas.

47⅛ x 47¼ in. /119.7 x 120 cm.

Alfred Stieglitz Collection, 1949.544.

Marsden Hartley was among the most talented and restless of the avant-garde American artists exhibited by the photographer and dealer Alfred Stieglitz in his 291 Gallery in New York. Hartley's work underwent frequent changes in style and subject. His life was one of continual physical displacement and frustrated attempts to participate in hospitable communities — either of artists or of friends. Perhaps this is why he turned so often to nature for solace and to art for transcendental experience. *Movements* was painted in 1913 in Germany, where Hartley was influenced by the abstract and highly spiritual art of Wassily Kandinsky (see p. 119) and others.

Movements suggests a musical analogy for its nearly abstract forms, which are rhythmically orchestrated around the central red circle and black triangle. The triangle suggests a mountain, around which other shapes may be read as aspects or symbols of a natural scene: sun, sky, lightning, water, vegetation. Hartley's brilliant, intense color is not naturalistic, nor is the heavy outline that weaves the whole together. The effect would be something like stained glass, were it not for the active brushstrokes that call attention to the rich, painterly surface. The charged, romantic energy of this work remained constant in his subsequent work, even when he turned to a less abstract manner.

Frantisek Kupka

Czech, 1871 - 1957
Reminiscence of a Cathedral, 1913 - 23.
Oil on canvas.
59 x 37 in. / 149.9 x 94 cm.
Gift of Mr. and Mrs. Joseph Randall Shapiro,
1984.6.

One of the pioneers of abstract art, Frantisek Kupka was born in Czechoslovakia. His family was quite poor, and he received only an elementary-school education before being apprenticed to a saddler. At this time, the young man was introduced to spiritualism, which became a life-long interest. In fact, later, when he was an art student, Kupka supported himself as a medium at séances.

Kupka immigrated to Paris in 1896, where he lived until his death in 1957. He became a champion of Orphism, a French movement in which color was used to create a visual equivalent to poetry or music. Combining his interests in spiritualism, Slavic folk art, and the purely decorative art of Islam, Kupka developed a unique path to pure abstraction. He had thoroughly studied the stained-glass windows of the cathedrals of Notre-Dame in Paris and Chartres. His desire to capture the feeling of light passing through colored glass led to a number of compositions on this theme, including *Reminiscence of a Cathedral.* The painting appears to glow with its luminous prisms of light. The vertical forms suggest the monumental and uplifting architecture of Gothic cathedrals. Yet, these associations are just that — associations. This fully abstract work creates a powerful and mysterious mood through its deeply sonorous colors and evocative shapes.

Giorgio de Chirico
Italian, 1888 - 1978
The Philosopher's Conquest, 1914.
Oil on canvas.
49¼ x 39 in. /125.1 x 99.1 cm.
Joseph Winterbotham Collection, 1939.405.

The strangeness of this image, with its over-sized, isolated objects set around a plaza empty of everything but shadows, creates in us a psychic unease, triggering memories and associations. What are we to make of the lush artichokes beneath the green barrel, their spherical shapes echoing the cold cannon balls? What does the clock signify, the cold sunlight, the menacing shadows? Giorgio de Chirico meant these objects to be elements of a puzzle, a dream, which the viewer must solve, an enigma for the reflective mind to ponder. His matter-of-fact rendering, flat application of bright colors without nuance or personal touch, and clarity of the treatment of the parts only serve to render the mysteriousness of the whole more bizarre. De Chirico referred to this quality as metaphysical: "art that in certain aspects resembles...the restlessness of myth."

De Chirico intended his paintings to express a momentary spatial and temporal dislocation akin to madness, but a divine madness that yields moments of clairvoyance and wholeness of vision, and that he believed to be the basis of artistic creativity. De Chirico's works, somewhat outside the mainstream movements and styles of his time, profoundly affected the Surrealists, who attempted to portray dreams and images of the subconscious (see pp. 139, 140). His reputation was established by his early works, painted in his twenties and thirties, such as *The Philosopher's Conquest.*

Amedeo Modigliani

Italian, 1884 - 1920
Jacques and Berthe Lipchitz, 1916.
Oil on canvas.
31¾ x 21¼ in. / 80.7 x 54 cm.
Helen Birch Bartlett Memorial Collection,
1926.221.

In a short life marked by alcoholism, drug abuse, carousing, and sexual excess, Amedeo Modigliani managed to create an accomplished body of work. He matured first as a sculptor, but his eventual shift to painting is not surprising. He was above all an elegant draftsman, with a particular feeling for the human figure.

Modigliani's art was mildly influenced by Cubism, from which he derived a simplicity of shape and contour and a freedom with anatomical detail. While his favorite subject was the female nude, he also painted many portraits. The portrait of the sculptor Jacques Lipchitz and his bride Berthe Kitrosser was commissioned by Lipchitz on the occasion of their wedding as a way of helping the troubled Modigliani financially. While Modigliani and Lipchitz were not close friends, the Lithuanian-born sculptor and Italian artist shared their Jewish backgrounds and émigré status in Paris.

The double portrait, according to Lipchitz, took two days. During the first, Modigliani made about twenty drawings, of which nine have been identified. And during the second, he executed the painting. While Modigliani's portrayal of Berthe is graceful, gentle, and warm, his depiction of her husband is more complex, his face tight and pinched. Perhaps because he was unhappy with his likeness, Lipchitz traded the portrait to his dealer after Modigliani died in 1920.

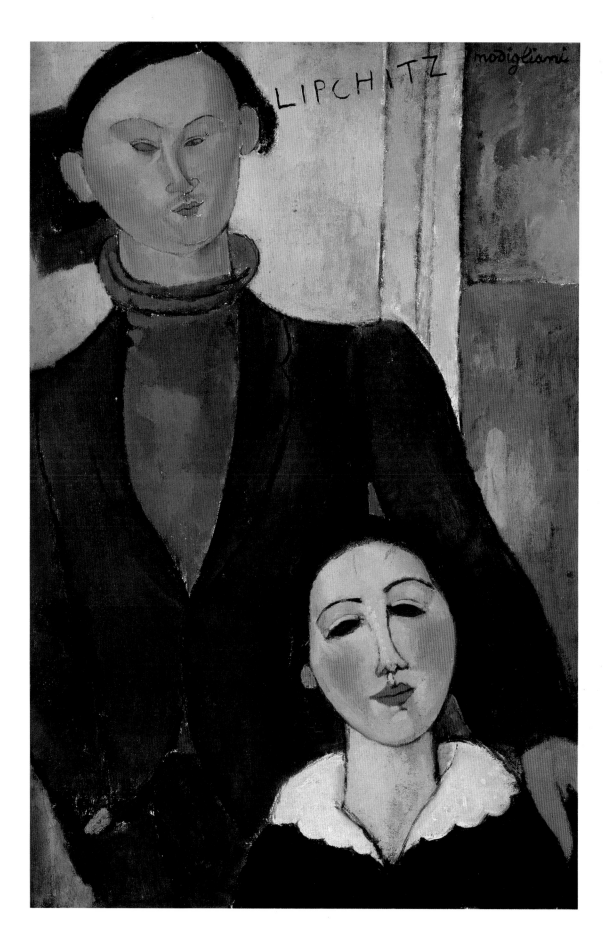

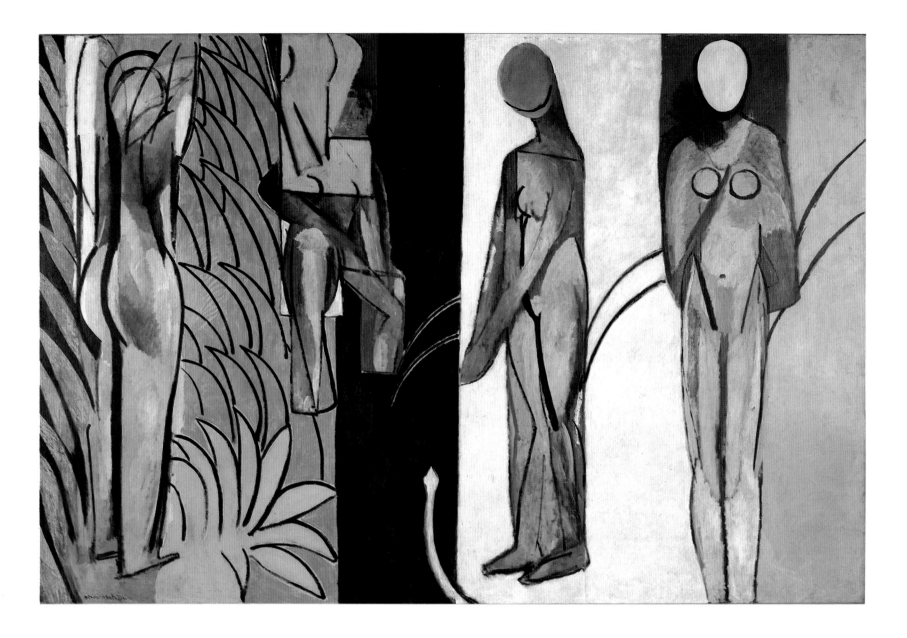

Henri Matisse

French, 1869-1954

Bathers by a River, c. 1916-17.

Oil on canvas.

102¼ x 153½ in. /259.7 x 389.9 cm.

Charles H. and Mary F. Worcester Collection,

1953.158.

Henri Matisse portrayed the subject of nude female bathers in an idyllic outdoor setting in some of his most significant early works. Conveying an atmosphere of sensual freedom, abandonment, and harmony with nature, his paintings on this theme reflect a tradition that was explored by such nineteenth-century artists as Ingres, Renoir, Gauguin, and Cézanne.

In this monumental painting, the artist investigated the structural methods of Cubism, subordinating his usual reliance on color to ordered form. The regular division of the canvas into vertical planes creates a calm, rhythmically regular background for the figures, which, with their grayish flesh tones and strong black outlines, seem almost embedded, like low-relief sculptures, in the surface. Behind them, the landscape is reduced to simplified areas of earth and sky (the luxuriant burst of lime-green foliage at the left and the blue panel at the right), and to light and shadow (the white and black panels).

The gravity, even solemnity, of *Bathers by a River* may be attributed to its having been completed during World War I. The Art Institute's painting is one of a number of severe, monumental canvases Matisse painted during the war years that are considered among the finest of his career.

Joan Miró

Spanish, 1893 - 1983
*Portrait of a Woman
(Juanita Obrador),* 1918.
Oil on canvas.
27⅜ x 24⅜ in. /69.5 x 62 cm.
Joseph Winterbotham Collection, 1957.78.

Born in Barcelona, Joan Miró had a conventional art training in Barcelona's art schools until his dealer R. J. Dalmau introduced him to the work of the Fauves, Pablo Picasso, and Juan Gris (see pp. 112, 108, 114, 115, 117). His work quickly reflected his discovery of these vanguard artists. *Portrait of a Woman (Juanita Obrador)* is one of several portraits Miró painted in 1917 - 18. Juanita Obrador, the daughter of the landlord of an artist friend, agreed to pose for Miró. As time went on, she became disturbed by the artist's silent, intense manner and by the image he was creating and left him to finish the portrait from memory.

In Cubist fashion, Obrador's features are slightly distorted, emphasizing every peculiarity of her face. Contributing to the vigor and intensity of the image are the greenish gray shadows on her neck, chin, and forehead and the purple-red that accentuates the hollows of her cheeks and tip of her nose. Her black-and-white dress creates a striking pattern, echoed in the curls of her hair. The dress's insistent design is set off against the salmon-pink wallpaper, broadly painted with diamond shapes and flowers outlined in black. Reflecting the floral decor is a red flower and green leaf, held in unseen hands or pinned in a buttonhole. The primitive energy and uncompromising stylization of this expressive early painting characterize the later Surrealist fantasies for which Miró was to become so justly famous (see p. 139).

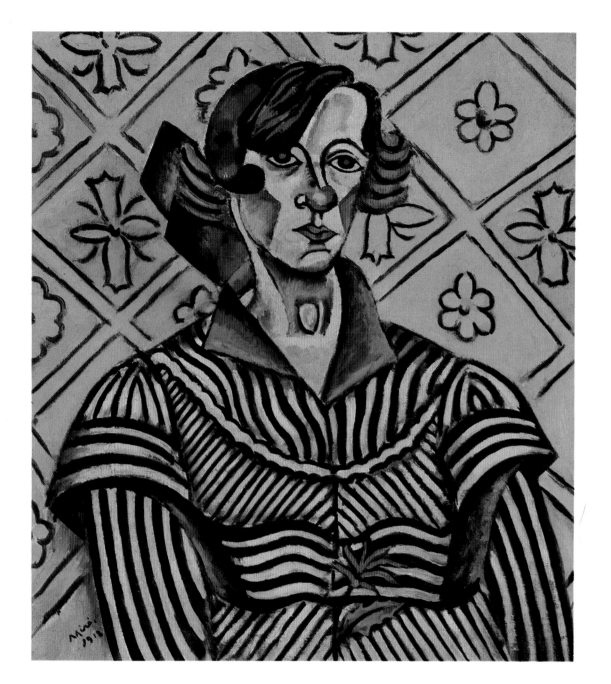

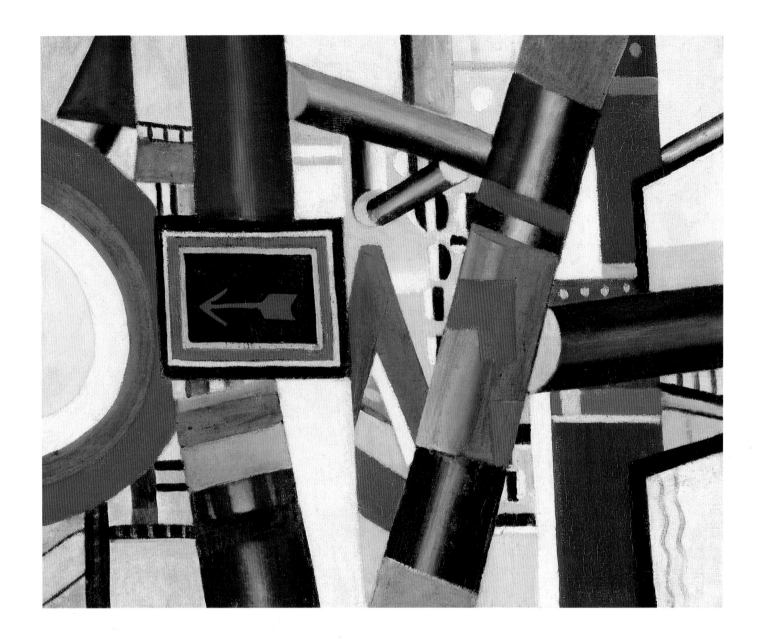

Fernand Léger

French, 1881 - 1955
Follow the Arrow
(study for *The Level Crossing*), 1919.
Oil on canvas.
21⁵⁄₁₆ x 25⁷⁄₈ in. /54.1 x 65.7 cm.
Joseph Winterbotham Collection; gift of Mrs.
Patrick Hill in memory of Rue Winterbotham
Carpenter, 1953.341.

Fernand Léger first saw the work of Pablo Picasso and Georges Braque at the Paris gallery of Daniel-Henry Kahnweiler (see pp. 108, 112, 113, 114) and, about 1909, began to paint in a Cubist style. His Cubist abstractions are more colorful and curvilinear than the angular forms and subdued tones of Picasso and Braque. An artist with far-ranging interests and talents, Léger later became a designer for theater, opera and ballet, as well as a book illustrator, filmmaker, muralist, ceramist, and teacher.

Typically, Léger would develop a major composition by preparing studies in a variety of mediums. *Follow the Arrow* is an oil study for his painting of 1919 titled *The Level Crossing* (private collection, Basel, Switzerland), a refer-

ence to a railroad or street safety barrier. Like many of his contemporaries, Léger was fascinated by the machine age. He maintained that machines and objects were as important as figures in his compositions. References to mechanical and industrial elements pervade works such as *Follow the Arrow.* In the midst of a complex scaffolding of cylinders and beams, an arrow appears on a brightly outlined signboard. A network of solid volumes and flat forms seems to circulate within the shallow space, just as pistons move within a motor. The precise definition of his forms and brilliance of his colors express Léger's belief that the machine, and the age it created, is one of the triumphs of modern civilization.

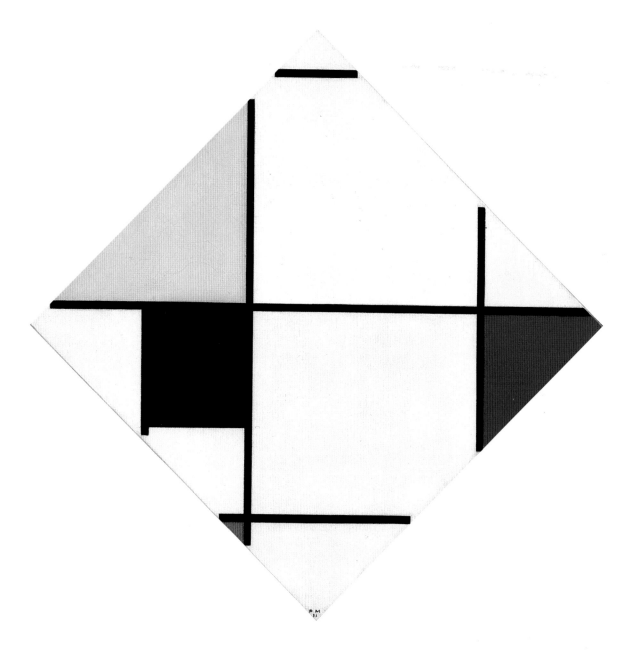

Piet Mondrian

Dutch, 1872 - 1944
Diagonal Composition, 1921.
Oil on canvas.
23⅝ x 23⅝ in. /60.1 x 60.1 cm.
Gift of Edgar Kaufmann, Jr., 1957.307.

Although Piet Mondrian's abstractions may seem far removed from nature, his basic vision is rooted in landscape, especially the flat geography of Holland, divided into a linear network of roads, fields, and canals. The artist evolved an abstract style of extreme purity to express the unity and order of nature. Beginning with realistic landscapes, over time he reduced natural forms to their simplest linear and colored equivalents. Finally, he eliminated natural forms altogether, developing a visual language of verticals, horizontals, and primary colors that he believed expressed universal forces.

In *Diagonal Composition,* Mondrian turned the rectangular canvas on edge to create a dynamic relationship between the rectilinear composition and the diagonals of the edges. Deceptively simple, his paintings reveal an exacting attention to the subtle relations between lines, shapes, and colors. Mondrian hoped that his art would point the way to a utopian future in which the principles of universal harmony would be embodied in all facets of life and that art, as we know it, separate from our environment, would become unnecessary. This goal was first formulated in Holland around 1916 - 17 by Mondrian and a small group of like-minded artists and architects. Their ideas, collectively referred to as the De Stijl movement, have been extraordinarily influential on all aspects of modern design from architecture and fashion to household objects.

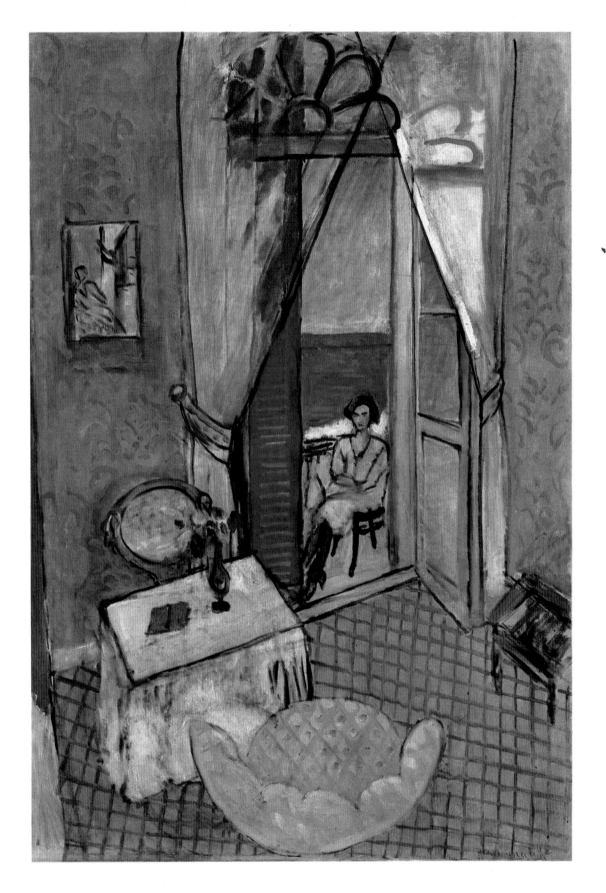

Henri Matisse

French, 1869 - 1954
Interior at Nice, 1921.
Oil on canvas.
52 x 35 in. /132.2 x 88.9 cm.
Gift of Mrs. Gilbert W. Chapman, 1956.339.

Henri Matisse painted *Interior at Nice* in the Hôtel Méditerranée, a Rococo-inspired building he later fondly termed "faked, absurd, delicious!" It was the scene of many images he did of young women seen in the warm, silvery Mediterranean light that fascinated the painter. Present in many of these paintings are pink-tiled floors, a skirted dressing table with an oval mirror, a shuttered French window and its balcony, and patterned wallpaper. The Art Institute's variation on this theme is large and intricately composed, with a high viewpoint and plunging, wide-angle perspective. The empty shell-shaped chair in the foreground echoes the oval mirror, the flowers, and the scalloped motif at the top of the window. The picture on the wall duplicates the form of the woman on the balcony. All attention converges on this woman, who, her back to the sea, returns the observer's gaze.

Pinks, honeyed grays, silvery blues, smoky coral all serve the illusion of a gently pulsating atmosphere of light and radiant warmth. The hesitations, overpaintings, loose and fluid brushstrokes make the artist's process, his painterly choices, palpable to the viewer. These visible marks fix the momentary act of painting, just as the painting fixes on canvas the fugitive atmosphere of an afternoon in Nice. Matisse attempted here a kind of deliberate impressionism in which spontaneity is staged, atmospheric effects are carefully plotted, and a dramatic moment is knowingly enacted. The effect is deliciously fresh, yet formally perfect.

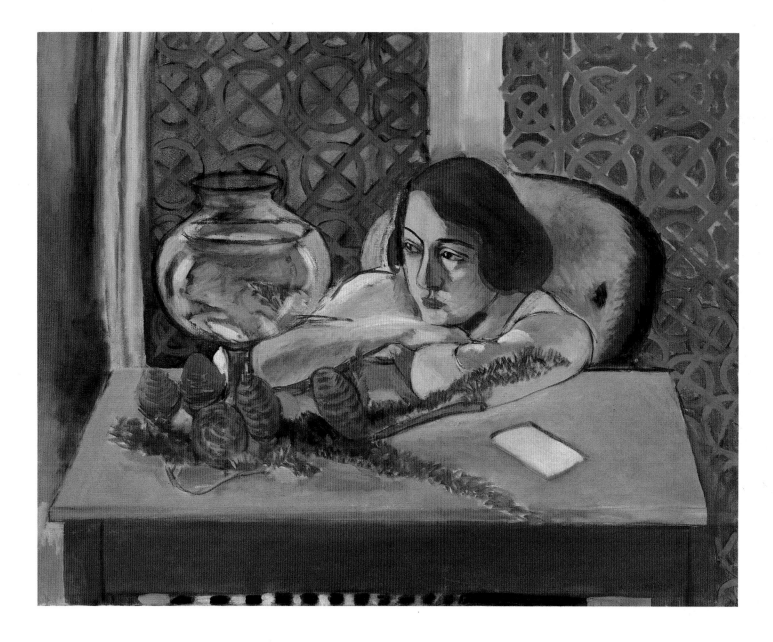

Henri Matisse

French, 1869-1954
Woman before an Aquarium, 1921-23.
Oil on canvas.
31¾ x 39⅜ in. /80.7 x 100 cm.
Helen Birch Bartlett Memorial Collection,
1926.200.

This subdued treatment of a model in an interior is one of the most ambitious from the early years of Henri Matisse's stay in Nice (1917-23). Painted about the time of the marriage of his daughter, Marguerite, this painting may well represent her and allude to her reflective character as she contemplated her forthcoming wedding. The goldfish, an Oriental symbol of happiness, and the evergreen branches with their cones, suggesting long life and perpetual freshness, are both appropriate tokens of marital good wishes.

Matisse treated this subject in the realistic style to which he had returned around 1917. A supreme colorist, he orchestrated his palette here toward muted browns, grays, and blues, relieved by pervasive touches of fluorescent pink. Only the yellow and orange flash of the goldfish and the vivid blue-green vertical stripe above the woman's head challenge the calm tonality of the work. In these years, Matisse was to paint many other versions of young women at leisure in hotel rooms or studios (and many more with the model in exotic middle-eastern harem costumes), but he was rarely able to capture the dreamy, introspective sense of enclosure that *Woman before an Aquarium* conveys. The decorative screen behind her, with its iridescent pattern of circles, creates an ambience parallel to the watery confines of the aquarium. Matisse presented this young woman to our view just as the goldfish are presented to her knowing and appreciative gaze.

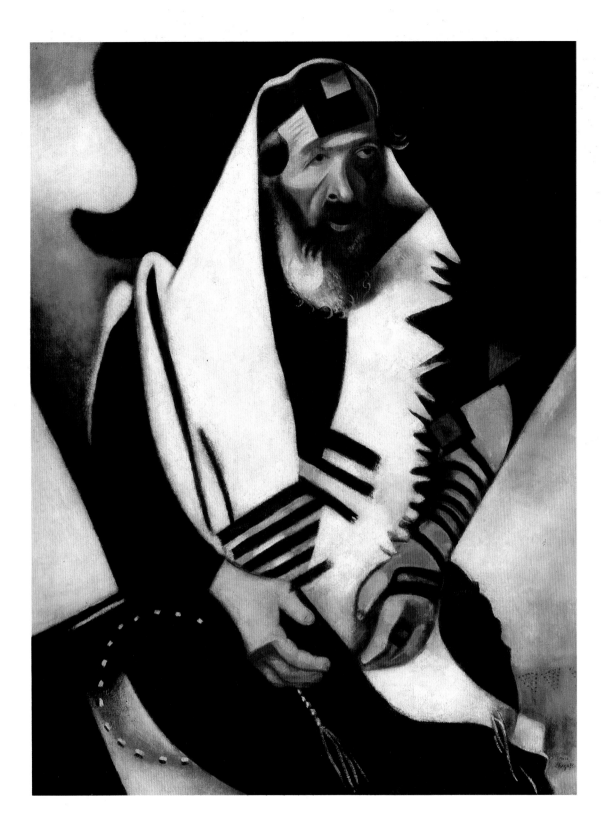

Marc Chagall

Born Russia, 1887 - 1985
The Praying Jew (Rabbi of Vitebsk), 1923.
Oil on canvas.
46 x 35³⁄₁₆ in. /116.8 x 84.9 cm.
Joseph Winterbotham Collection, 1937.188.

Living into his nineties, Russian-born Marc Chagall had a prolific career that spanned more than eight decades of the twentieth century. At different times, his work reflected influences of the movements he encountered in France and Germany: Fauvism, Cubism, Expressionism, and Surrealism. Yet, his style was always distinctly his own. His fantastic and often whimsical subjects and decorative lyricism reflect his love of Russian folk art and his roots in the Hasidic Judaism into which he was born.

It was not unusual for Chagall to paint variants or replicas of paintings he loved. The Art Institute's *Praying Jew* is one of three versions of this composition (the first version is in a private Swiss collection; a second is in the Museo d'Arte Moderna, Venice). He painted the original canvas in 1914 in his native Vitebsk. It accompanied him when he returned to Paris in 1923 and, before it left his possession, he painted the two other versions, which differ only in small details. In his autobiography, Chagall relates how he paid an old beggar to put on his father's prayer clothes and pose for him. He limited his palette to black and white, befitting the solemnity of the subject. The striking patterns, abstract background, and slightly distorted features of the old man show Chagall's absorption of modern tendencies, especially of Cubism. This moving portrayal stands out among Chagall's works for the simplicity of its execution and its particularly personal origins.

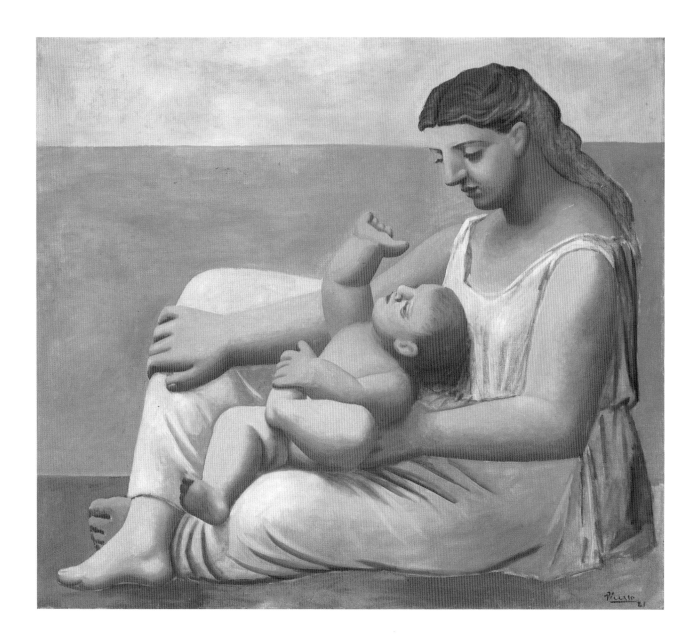

Pablo Picasso

Spanish, 1881 - 1973

Mother and Child, 1921.

Oil on canvas.

56¼ x 68 in. /142.9 x 172.7 cm.

Gift of Mary and Leigh B. Block Charitable
Fund, Inc., Mr. and Mrs. Edwin E. Hokin,
Maymar Corporation, Mr. and Mrs. Chauncey
McCormick, Mrs. Maurice L. Rothschild;
Ada Turnbull Hertle Fund, 1954.270.

The extraordinary energy and genius of Pablo
Picasso could not be contained by one style. In
1917, he was asked to go to Rome to design sets
and costumes for a ballet troupe. Deeply
impressed by the ancient and Renaissance art
of that city, he entered what is called his Clas-
sical Period, during which he experimented
with the forms and styles of ancient art, from
Etruscan painting and Greek vases to Roman
sculpture.

Between 1921 and 1923, Picasso returned to
a subject of his Blue Period, painting at least
twelve variations on the mother-and-child
theme. This group of works features images of
women that are majestic in proportion and feel-
ing. In the Art Institute's *Mother and Child,* an
infant reclines on his mother's lap and reaches
up to touch her. The mother, dressed in a sim-
ple gown with Grecian folds, gazes intently at
her child. Behind them stretches a simplified
background of sand, water, and sky. Picasso's
first child, Paolo, was born in 1918 and became
a frequent subject in his art. Picasso's treatment
of the mother and child is not sentimental, but
the relationship of the figures expresses a
serenity and stability that characterized
Picasso's life at this time.

Arthur Dove

American, 1880 - 1946

Silver Sun, 1929.

Oil and metal paint on canvas.

21¾ x 29½ in. /55.2 x 74.9 cm.

Alfred Stieglitz Collection, 1949.531.

In 1912, Arthur Dove made news in New York and Chicago when he exhibited ten pastels that were the first abstract works by an American to be seen by the public. Beginning with themes from nature, Dove had simplified and rearranged them, creating patterns, rhythms, and color harmonies to demonstrate that artists could dispense with illusionistic subjects in order to communicate through form and color alone. From then on, Dove dedicated himself to exploring how he might depart from illusionism without abandoning nature.

Silver Sun reveals with particular clarity Dove's method of recasting nature into art. The artist's sense of wonder at the force and beauty of nature is apparent, but so is his control over his artistic means and, ultimately, over our aesthetic experience. Dove imparted a metaphysical radiance through expanding rings of blue and green, and through his use of glowing metallic-silver paint. He simplified, adjusted, and accented until the pulsating image no longer represented the thing seen but rather conveyed feeling, impact, meaning.

Dove remained committed to a personal vision. Nevertheless, he was well informed about modern art, and a web of interconnections link his work to other artists. For example, *Silver Sun* relates to the art of two of Dove's friends, painter Georgia O'Keeffe (see p. 133) and photographer Alfred Stieglitz: they, like Dove, sometimes depicted transcendent skies to communicate a vision of man's wholeness in nature.

Georgia O'Keeffe

American, 1887 - 1986
Black Cross, New Mexico, 1929.
Oil on canvas.
39 x 30¹/₁₆ in. /99.2 x 76.3 cm.
The Art Institute of Chicago Purchase Fund,
1943.95.

Georgia O'Keeffe differed from other American pioneers of modernism in that she was trained entirely in the United States (including a brief period at The School of The Art Institute of Chicago). O'Keeffe first exhibited her work in 1916 at 291, the New York gallery established by photographer Alfred Stieglitz that was a forum for avant-garde European and American art. O'Keeffe soon joined the roster of American artists who became known as the Stieglitz Circle. O'Keeffe and Stieglitz were married in 1924. O'Keeffe lived to the age of ninety-eight, and, in spite of failing eyesight, worked almost until the end of her life. She is best known for her paintings of flowers and plants, enlarged beyond life-size and precisely painted with bold colors, as well as for spare and dramatic images inspired by the landscape of the Southwest.

Black Cross, New Mexico dates from O'Keeffe's first visit to Taos, New Mexico, in the summer of 1929. She said that she saw such crosses often, spread "like a thin, dark veil of the Catholic Church...over the New Mexico landscape." The large black cross in this canvas is probably one of the Penitente crosses, "large enough to crucify a man," that O'Keeffe described as having encountered late one night during a walk in the hills. She painted the cross against the Taos mountains, with a vivid sunset below the object's horizontal arm. The power of an image such as this lies in the way O'Keeffe's abstracted forms demonstrate their deep connection to nature and in the way she infused her natural forms with abstract and spiritual qualities.

José Clemente Orozco

Mexican, 1883 - 1949
Zapata, 1926.
Oil on canvas.
70¼ x 48¼ in. /178.4 x 122.6 cm.
Gift of Joseph Winterbotham Collection,
1941.35.

José Clemente Orozco was a leader of the Mexican mural movement of the 1920s and '30s, which was inspired by the Mexican Revolution of 1910-20. After an uproar over murals depicting mass slaughter and upheaval that he did for the National Preparatory College in Mexico City, Orozco decided to seek work in the United States. It was during this self-imposed exile that he painted *Zapata*.

Emiliano Zapata was a revolutionary leader who struggled to return the enormous land holdings of the wealthy to Mexico's peasant population. After his death by ambush in 1919, he became a national hero. Framed here against a patch of bright sky glimpsed through the open doorway of a peasant hut, the specterlike figure of Zapata appears. Solemn and unmoved, he seems to stare beyond the drama before him of the two kneeling figures who, with outstretched arms, implore Zapata's soldiers for their lives. Such menacing details as the exaggerated peaks of the sombreros, the ammunition, and the weapons — especially the knife aimed at the eye of Zapata — symbolize the danger of the fight in which the revolutionaries engaged and the eventual deadly outcome for Zapata himself. The painting's dark reds, browns, and blacks evoke both the land that is being fought over and the bloodletting of the Mexican people. Orozco was ambivalent about the revolution; his vision of class struggle as inevitable, eternal, and hopeless explains the compassion, defiance, and despair expressed in this painting.

Ivan Albright

American, 1897 - 1983

*Into the World There Came a Soul Called Ida
(The Lord in His Heaven and I in My Room Below)*, 1929 - 30

Oil on canvas.

56¼ x 46¹⁵/₁₆ in. /142.9 x 119.2 cm.

Gift of the artist, 1977.34.

Ivan Albright was born and lived most of his life in Chicago. The Art Institute holds the largest collection of paintings by this artist of any museum. While Albright's unique style has been called Magic Realism, it defies categorization. His painstaking creative process, driven by his need to meticulously record detail, involved designing sets and creating studies of models and props in his studio, even making diagrammatic plans for colors. Albright's desire to present the minutest subtleties of human flesh or the tiniest elements of a still life often required that he spend years on a single painting. His experience as a medical illustrator during World War I is often cited as a determinant of his later, haunting portrayals of aging and decay.

Into the World There Came a Soul Called Ida was begun in 1929 after Ida Rogers, then about twenty years old, answered Albright's advertisement for a model. Ida was an attractive young wife and mother whom Albright transformed into a sorrowful older woman sitting in her dressing room, her flesh drooping and the objects surrounding her worn and bare. With Albright's characteristic precision, even the single hairs in the comb on the dressing table have been delineated. The material lightness and precarious placement of her possessions on the dressing table and floor seem to symbolize the vulnerability of the sitter. Ida gazes poignantly into the mirror and, with all the dignity she can muster, powders her aging flesh in vain.

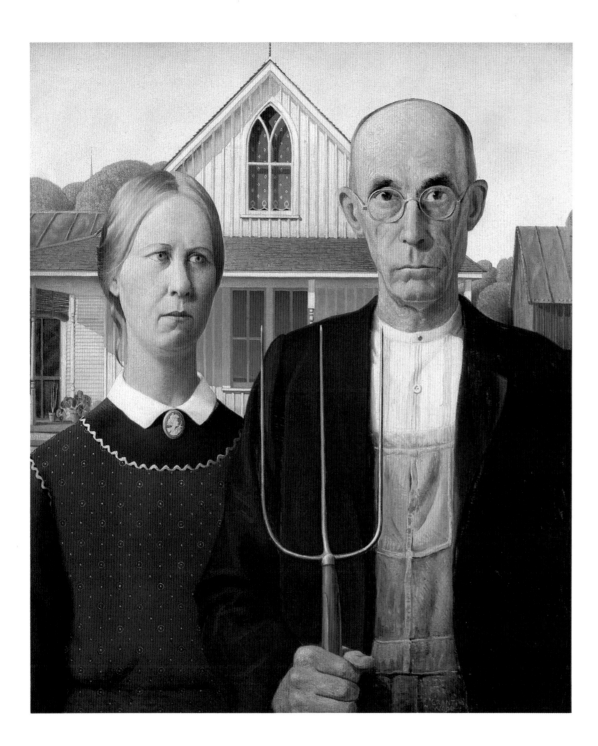

Grant Wood

American, 1892 - 1942
American Gothic, 1930.
Oil on beaverboard.
29¼ x 24⁹⁄₁₆ in. /74.3 x 62.4 cm.
Friends of American Art Collection, 1930.934.

Grant Wood's *American Gothic* caused a sensation in 1930 when it was exhibited for the first time at The Art Institute of Chicago and awarded a prize of three hundred dollars. Newspapers across the country carried the story, and the picture of the farm couple posed with a pitchfork before a white house brought instant fame to the artist. The Iowa native, then in his late thirties, had been enchanted by a simple Gothic Revival cottage he had seen in the small southern Iowa town of Eldon. Wood envisioned a painting in which, as he put it, "American Gothic people...stand in front of a house of this type." He asked his dentist and sister to pose as a farmer and his spinster daughter. The highly detailed, polished style and rigid, frontal arrangement of the two figures were inspired by Flemish Renaissance art, which Wood was able to study during three trips to Europe between 1920 and 1926. After settling in Iowa, he became increasingly appreciative of the traditions and culture of the Midwest, which he chose to celebrate in such works as this.

One of the most famous American paintings, *American Gothic* has become part of our popular culture, with the couple having been the subject of endless parodies. Wood was accused of creating in this work a satire on the intolerance and rigidity that the insular nature of rural life can produce — an accusation he denied. Instead, he created in *American Gothic* an image that epitomizes the Puritan ethic and virtues that he believed dignified the Midwestern character.

Charles Demuth

American, 1883 - 1935
And the Home of the Brave, 1931.
Oil on composition board.
29⁷/₁₆ x 23½ in. /74.8 x 59.7 cm.
Gift of Georgia O'Keeffe, 1948.650.

Charles Demuth's series of still lifes and architectural studies display astonishing technical skill and testify to the refined intelligence with which he manipulated abstract design and sensuous response to reality. In his paintings of the early 1930s, Demuth often interpreted the architecture in his hometown of Lancaster, Pennsylvania. Obviously not a literal representation of Lancaster, this painting, with its compressed and discontinuous space, emphasis on two-dimensional design, and rearrangement of observed facts into a new pictorial reality, is derived from Cubism. The accent on American urban and commercial forms acknowledges Demuth's native land: specifically, the double water towers at the apex of the composition are adapted from those atop a Lancaster cigar factory, while the number seventy-two at the lower edge of the painting refers to a state highway — the Manheim Pike — running north from town.

The ambiguous title of the work, *And the Home of the Brave*, is characteristic of Demuth's ironic temperament. Like other American artists and intellectuals of the early twentieth century, Demuth was simultaneously attracted to the vitality of American civilization and repelled by its utilitarian coarseness.

Paul Klee

Swiss, 1879-1940
Sunset, 1930.
Oil on canvas.
18³/₁₆ x 27⁵/₈ in. /46.2 x 70.2 cm.
Gift of Mary and Leigh B. Block, 1981.13.

The imaginative and prolific Paul Klee worked in many mediums and styles, each of which he made unmistakably his own. After World War I, he was invited to join the faculty of the Bauhaus, the famed art school in Dessau, Germany. Klee resigned his position in 1931 and left Germany for good in 1933 after the Nazis came to power. He spent his remaining years in his native Switzerland, struggling against a disease that took his life in 1940. Klee's art — inventive, mystical, and technically masterful — and his great teaching skills made him one of this century's most important artists.

Sunset, like much of Klee's art, is small in scale and deceptively simple. Klee acknowledged his interest in primitive art and in the art of children, which he believed to be closer to the sources of creativity and to truthful expression than the conventional art of adults. Over a neutral, loosely painted background, Klee applied small dots of pigment to create an overall pattern loosely organized into abstract shapes. An odd, schematic face in the upper left balances the small, red sun in the lower right; a quirky little arrow (a favorite device of Klee's to indicate lines of force) traces the sun's descent in the sky. Though hardly a conventional depiction of a sunset, Klee's composition evokes the necessary landscape elements — sky, water, the horizon. As in all his work, using understatement, brevity, and wit, Klee created a microcosm that almost magically embodies life's great forces.

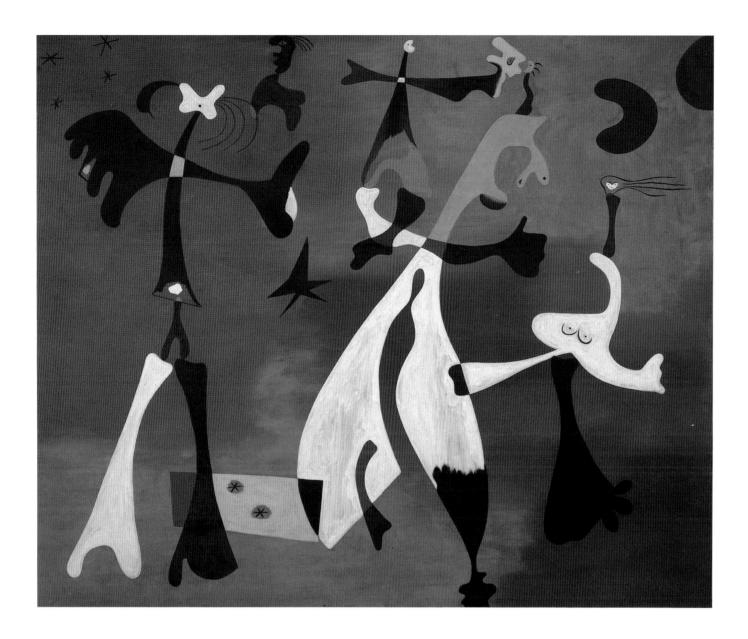

Joan Miró

Spanish, 1893 - 1983

Personages with Star, 1933.

Oil on canvas.

78 x 97 in. /198.1 x 246.4 cm.

Gift of Mr. and Mrs. Maurice E. Culberg,
1952.512.

Gentle and poetic by nature, Joan Miró pursued his own course throughout all the phases of his long career, from its early Cubist beginnings through the Surrealism and abstraction that are the hallmarks of his mature style. Miró's particular brand of fantasy is often lighthearted, even whimsical; his dreamlike images attempt to capture expressions of the subconscious, rather than perceptions of the objective world. Miró rejected the notion that he ever painted an abstraction, maintaining instead that every element in his art is a sign of something that truly exists. Thus, one can "read" or decipher the artist's iconography, since certain symbols, such as the stars seen here, are frequently repeated and have constant referents.

Personages with Star is one of four cartoons for tapestries commissioned by the Paris collector Marie Cuttoli in 1933 to be fabricated at the famous French Aubusson tapestry works. At least one and possibly two tapestries were actually manufactured. In the Art Institute's painting, three large, basically black-and-white figures gesture boldly, precariously supporting two smaller figures as they all cavort among the stars. Playful and joyous, the figures seem to celebrate life on a cosmic plane.

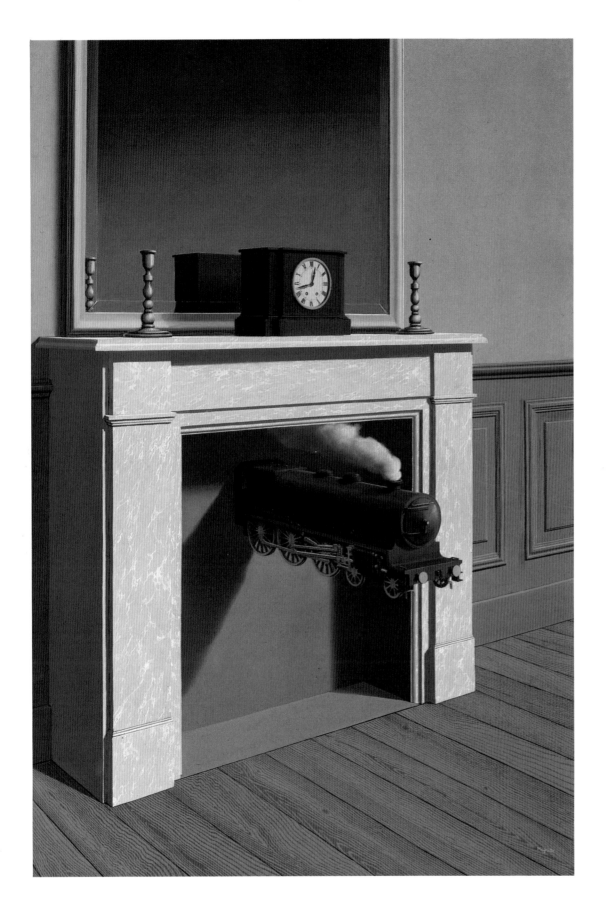

René Magritte

Belgian, 1898 - 1967

Time Transfixed, 1938.

Oil on canvas.

57⅞ x 37⅞ /147 x 98.7 cm.

Joseph Winterbotham Collection, 1970.426.

Although conservative, even conventional in his lifestyle, René Magritte developed an individual and eccentric style of painting that evokes the world of the supernatural. Magritte eschewed the trance state sought by other members of the Surrealist group in their efforts to tap into the undercurrents of the subconscious mind. Rather, his precise, magical realism explored the poetry of shadows, the surprising affinities and disparities between people and things, and the profound absurdity of life. Magritte's personal brand of Surrealism was fashioned from commonplace objects whose altered sizes and surprising juxtapositions create an atmosphere of mystery and wonder.

In *Time Transfixed*, a metamorphosis has occurred: into the deep stillness of a sparsely furnished room, a tiny locomotive chugs incongruously out of the fireplace, emerging from the vent customarily used for a stovepipe. Small in scale, the engine — its smoke efficiently and neatly disappearing up the chimney — represents no physical threat. What it does present, however, is a threat to the viewer's sense of order and notion of reality. The spectator is arrested by the very unexpectedness of the vision, and time is indeed transfixed.

Max Beckmann

German, 1884 - 1950
Self-Portrait, 1937.
Oil on canvas.
75¾ x 34½ in. /192.4 x 87.6 cm.
Gift of Lotte Hess Ackerman and Philip
Ringer, 1955.822.

The German artist Max Beckmann had a pre-
dilection for portraits and, particularly, for self-
portraits. This *Self-Portrait* was painted in Ber-
lin in 1937, just before the artist and his wife
were forced to flee Nazi Germany. Beckmann
portrayed himself in evening dress on the stair-
case of a hotel lobby. His sense of isolation and
impending human disaster is expressed in
several ways: by his full size and position, filling
and pressing forward toward the edge of the
picture plane; by his pale, inscrutable face,
which is withdrawn from us in half shadow, and
by his hands, large and inert against his black
tuxedo; by his separation from the two figures
in animated conversation, discernible behind a
potted plant on the landing. Despite the ele-
gance of his dress and surroundings, the artist
appears trapped and helpless.

Among Beckmann's favorite subjects were
theatrical events, costume parties, carnivals,
masked balls, grotesque charades; he himself
wrote several plays in the early 1920s. It seems,
therefore, in character that he presented him-
self in this painting with so many aspects of the
stage — a masklike face, a dress costume, a
theatrical pose. And, having witnessed the rise
of Nazism, he had learned that even the artist,
as an observer of world events, is not immune
from them, and understood that his role as
onlooker and commentator led to a dangerous
destiny he could not avoid.

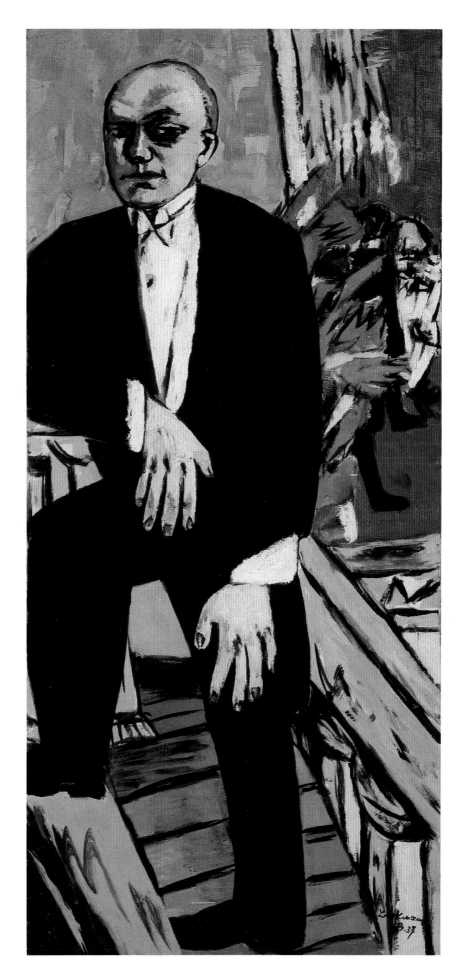

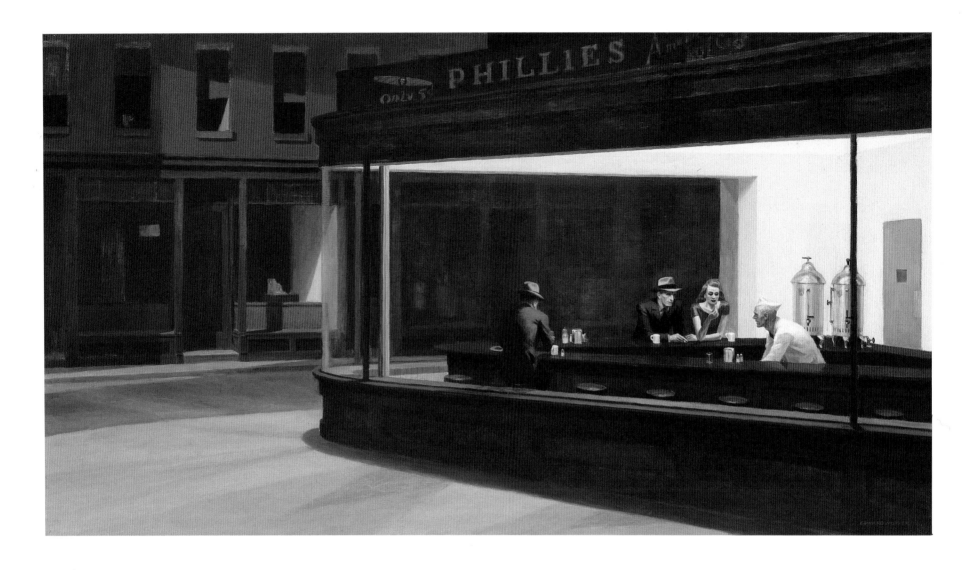

Edward Hopper
American, 1882 - 1967
Nighthawks, 1942.
Oil on canvas.
33⅛ x 60 in. / 84.1 x 152.4 cm.
Friends of American Art Collection, 1942.51.

In paintings of city streets, interiors and architectural exteriors, country roads, and the Atlantic coastline, Edward Hopper presented with clarity and forcefulness familiar aspects of American life, using a factual approach and dramatic lighting. The all-night diner in Hopper's *Nighthawks* has become one of the most famous images of twentieth-century American

art. Hopper said the work was inspired by a "restaurant on New York's Greenwich Avenue where two streets meet." As is true of most of his paintings, the image is a composite, not a literal translation of a place: he simplified the scene and enlarged the restaurant. The diner, an oasis of light on a dark corner, draws us toward it. By eliminating any reference to an entrance, Hopper forced the viewer to observe the three customers and cook through the window. Sealed off from us by a seamless wedge of glass and lit by an eerie glow, the four anonymous, uncommunicative figures seem as separate from one another as they are from us, evoking myriad questions about their lives that cannot be answered.

Hopper always maintained that he did not infuse his paintings with symbols of human isolation and urban emptiness. By leaving interpretation up to the viewer, however, he invited such speculation. He summed up the essential ambiguity of his urban images when he said, *"Nighthawks* seems to be the way I think of a night street. I didn't see it as particularly lonely. . . . Unconsciously, probably, I was painting the loneliness of a large city."

Charles Sheeler

American, 1883 - 1965
The Artist Looks at Nature, 1943
Oil on canvas.
21 x 18 in. /53.3. x 45.7 cm.
Gift of the Society for Contemporary Art,
1944.32.

A photographer as well as a painter, Charles Sheeler considered the purposes of art as carefully as anyone of his generation of early twentieth-century modernists. In both media, his subjects were usually drawn from the world of man-made objects: urban architecture, factories, barns, and interiors that were often furnished with the spare and elegant Shaker furniture he admired. These subjects were rendered (or, in the case of the most abstract paintings, suggested) in a hard-edged, controlled technique indicative of the artist's restrained and intellectual point of view and interest in formal values.

For the usually objective Sheeler, *The Artist Looks at Nature* is a peculiar work because it represents an imaginary scene. Here, we see the artist working outdoors on a painting, but the scene before him is not what he paints. The unfinished work on his easel reproduces *Interior with Stove* (private collection), a much earlier painting based on an even earlier photograph by the artist. Thus, in the Art Institute's painting, we see Sheeler almost playfully reconstructing his own past over a period of more than twenty-five years, emphasizing the self-referential nature of his art, and suggesting the interchange between the representational arts of photography and painting. One of Sheeler's most complex, yet charming, works, *The Artist Looks at Nature* implies much about the ironies and ambiguities of art in our century.

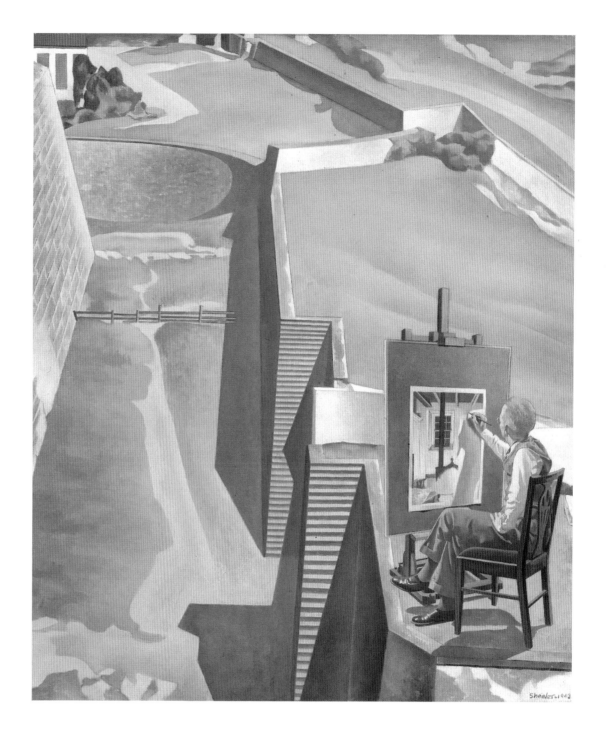

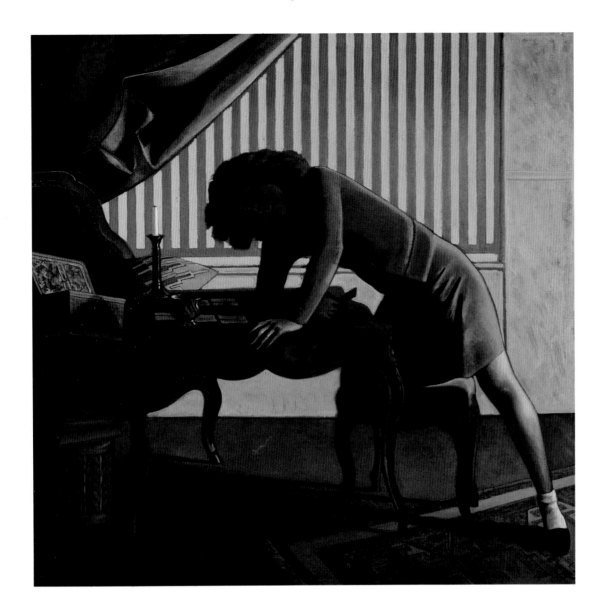

Balthus
(Balthasar Klossowski de Rola)

French, born 1908
Patience, 1943.
Oil on canvas.
63½ x 64⅜ in. /161.3 x 163.5 cm.
Joseph Winterbotham Collection, 1964.177.

A reclusive artist who is rarely photographed or interviewed, Balthus was born into an educated, artistic family of Polish aristocrats who had fled political and economic turmoil to settle in Paris. For financial reasons, he received little formal schooling; this permitted him to develop a deeply personal vision, aided by copying Old Master paintings in museums in Paris and in churches in Italy. In 1933, Balthus began producing work in his characteristic style. His erotically charged paintings — with their solidly modeled figures, especially young girls lost in reveries, placed in modestly decorated interior spaces — caused a scandal when first exhibited.

Balthus spent most of World War II in Switzerland, where, in 1943, he painted one of his masterpieces, *Patience.* The painting shows an adolescent girl playing the card game Solitaire (also called Patience). The striking posture of the girl — taut and contemplative as she bends over the table — is one Balthus had used in a number of earlier works. The counterpoint created by the insistent verticals of the patterned wallpaper against the feline curves of the girl's back; the mysterious expression of her darkened face in contrast to the strong, raking light that defines her delicate, long fingers and outthrust leg produce an unsettling emotional tenor. A master at capturing psychological states and at suspending time, Balthus presented here a complex and enigmatic moment of private thought.

Jean Dubuffet

French, 1901 - 1985
*Supervielle Grand Portrait
Bannière,* 1947.
Oil and mixed media on canvas.
51¼ x 38¼ in. /130.2 x 97.2 cm.
Gift of Mr. and Mrs. Maurice E. Culberg,
1950.1367.

In 1923, Jean Dubuffet encountered the book
of Swiss physician Hans Prinzhorn, *The Art of
the Insane,* with its descriptions of the artwork
of mental patients. Prinzhorn pointed out the
connections between primitive art, the drawings
of children, and art produced by the mentally
ill, suggesting an underlying creative impulse
in man that can be easily destroyed by the
refinement and demands of "high culture." Art
Brut (or "raw art"), as Dubuffet called this kind
of work, had a great impact on the young artist
and became a lifelong interest.

In his early works, he painted with simple,
childish scrawls, with no hint of perspective or
modeling. As his work continued, he built
coarse surfaces from such unorthodox materials
as gravel, sand, chalk, and string. After scanda-
lizing the Paris art world with his deliberately
ugly images, in the 1940s Dubuffet did a num-
ber of portraits of his friends. Jules Supervielle,
a poet and playwright from South America, is
the subject of the Art Institute's portrait.
Worked into a thick, impasto background that
resembles scorched earth, the image is most
unflattering. The outline of the head is achieved
with a whitish paint that has been ladled on
and scraped off. Supervielle's jowly chin and
withered cheeks have been sketched in with
crude black lines. In this series of portraits,
Dubuffet accentuated certain physical fea-
tures, such as Supervielle's long, pointed nose
and, at the same time, used these exaggerations
to convey a sense of the human personality
and spirit.

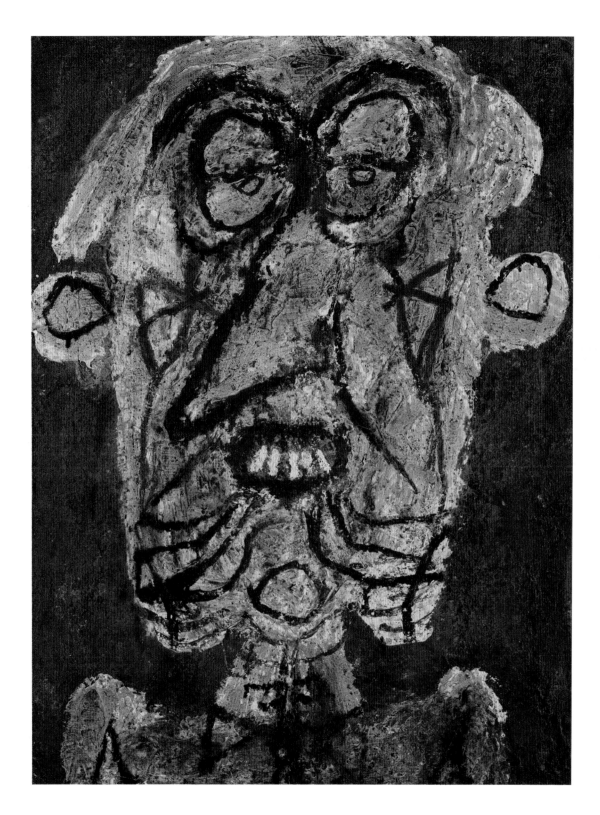

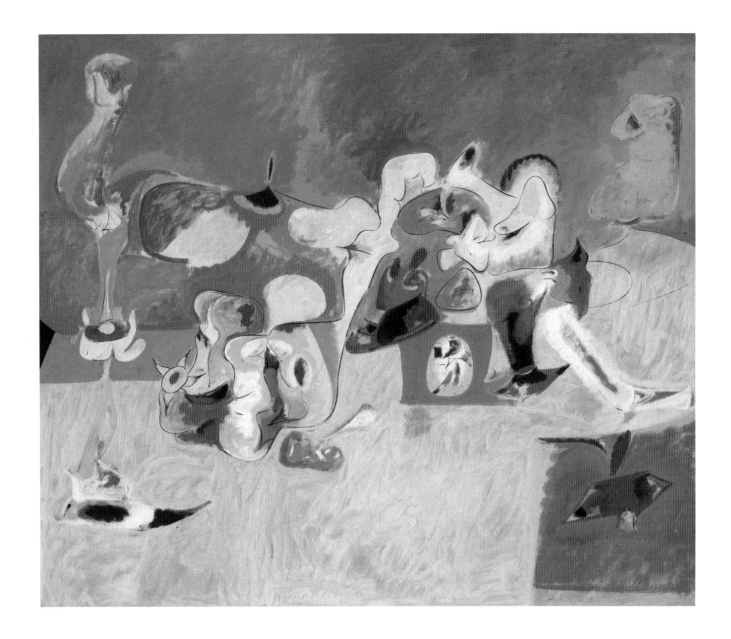

Arshile Gorky

American, born Armenia, c. 1904-1948
The Plow and the Song II, 1946.
Oil on canvas.
50¾ x 60¼ in. /128.9 x 153 cm.
Mr. and Mrs. Lewis Larned Coburn Fund,
1963.208.

Arshile Gorky's life was not happy. His un-settled childhood in Armenia (he moved to the United States in 1920) was followed by tragedy in later years. A fire in 1946 destroyed much of the work in his Connecticut studio. He sur-vived a serious cancer operation only to suffer an automobile accident in 1948 that left his painting arm paralyzed. In that same year, the artist took his life.

Always interested in avant-garde European art, Gorky experimented with a variety of styles until he found his mature expression in the 1930s. At that time, young artists such as Gorky working in New York City became particularly stimulated by the European Surrealists, many of whom moved to New York before and during

World War II and whose circle Gorky joined. The 1940s, especially the years 1944-47, marked the creation of Gorky's most important work, in a kind of stream-of-consciousness, or "automatic" manner of painting. *The Plow and the Song II* reflects the artist's indebtedness to the lyrical Surrealism of Joan Miró (see p. 139), but the sketchy handling of paint, translucent color, and tumbling pile of forms are charac-teristic of Gorky. A delicate line darts like a needle, stitching together the fragments of the image into a cohesive whole. Deeply earth-bound and yet lyrical and poetic, the painting is at once a still life, a landscape, and a fantasy.

Peter Blume

American, born Russia 1906

The Rock, 1948.

Oil on canvas.

57⅝ x 74⅜ in. /146.4 x 188.9 cm.

Gift of Edgar Kaufmann, Jr., 1956.338.

Unlike the Surrealism practiced by the Europeans, with its preponderance of sexual motifs and dreamlike images, the unique brand of Surrealism of Peter Blume, one of the first American artists to embrace the movement, was based on the juxtaposition of disjunctive and unrelated objects and figures, all rendered in an accomplished and painstaking technique that echoes northern European painting of the fifteenth and sixteenth centuries. Blume typically labored tirelessly over his paintings, creating many sketches, which explains the relative rarity of large-scale works by the artist.

Although Blume's deeply personal iconography eludes clear interpretation, images of decay and rebirth occur again and again. *The Rock,* painted in the aftermath of World War II, is a clear and powerful evocation of this theme. In the painting, a group of men and women, perhaps representing mankind, is shown here in the process of rebuilding civilization out of its own destruction. Figures labor at the task of cutting stone for the new buildings that are to be raised on the rubble of the old. Looming above the figures is a monumental rock, scarred, blasted, yet enduring, itself a symbol of humanity's tenacity and capacity to survive. At the left rises a scaffold, a clear indication of hope in the future.

Willem de Kooning

American, born the Netherlands 1904
Excavation, 1950.
Oil on canvas.
81³⁄₁₆ x 101⁵⁄₁₆ in. /206.2 x 257.3 cm.
Gift of Mr. and Mrs. Noah Goldowsky,
Edgar Kaufmann, Jr.; Mr. and Mrs. Frank G.
Logan Fund, 1952.1.

Willem de Kooning belonged to a group of artists in New York City whose work took shape in the 1940s and 1950s with such vitality and originality that, for the first time, the United States was looked upon as a major source of modern art. Each member of the group, called the Abstract Expressionists or the New York School, had his own characteristic imagery, but all shared an interest in the nature of the creative process and in the role of the subconscious in that process.

By 1950, when he executed this painting, the Dutch-born de Kooning had developed his personal style, with its expressive brushwork and distinctive organization of space into loose, sliding planes with open contours. In *Excava-*

tion, coarse and wispy black lines seem to define anatomical parts — bird and fish shapes, human noses, eyes, teeth, jaws, necks. The forms seem to writhe in a joyous, almost orgiastic, dance across the surface. Originally worked in white, the pigment has yellowed somewhat over the years so that the flashes of red, blue, yellow, and pink that punctuate the composition are not as clear and as invigorating as they once were. Aptly named, *Excavation* acknowledges the months de Kooning spent building up and scraping down its paint layers. The title also refers to the challenge it poses to the viewer, requiring probing examination of its complex, layered surface.

Jackson Pollock

American, 1912 - 1956
Grayed Rainbow, 1953.
Oil on canvas.
72 x 96⅛ in. /182.9 x 244.2 cm.
Gift of the Society for Contemporary
American Art, 1955.494.

Jackson Pollock created in his short life a body of work that helped change the course of modern painting. Following the lead of the Surrealists, many of whom were living in New York City during World War II, Pollock began to experiment with automatic painting, allowing accident and intuition a role in determining his compositions. The network of drips, splatters, and lines that animates the surfaces of his paintings was meant to reveal the artist's subconscious mood and led to the term Action Painting. Pollock's work emphasized the expressive power of the artist's gestures, materials, and tools (he often used sticks, trowels, and palette knives instead of brushes). He challenged the concept of easel painting by working on large canvases placed either on the floor or fixed to a wall. The paintings that resulted, with no apparent beginning or end, top or bottom, imply an extension beyond the edges of the canvas and are no longer separate and self-contained objects. Rather, they engulf the viewer and his or her space.

In *Grayed Rainbow*, a painting from Pollock's last years, the viewer is swept into the illusion of a shallow space in which splashes of black and white coil and intertwine, retract and expand in a dizzying fashion. From this turmoil, delicate colors emerge in the lower third of the composition, much as a rainbow peeks through storm clouds, contributing to this painting's particularly lyrical feeling.

Francis Bacon

British, born 1909
Head Surrounded by Sides of Beef, 1954.
Oil on canvas.
51 ⅛ x 48 in. /129.9 x 121.9 cm.
Harriott A. Fox Fund, 1956.1201.

Surrealism was an early influence on the self-taught painter Francis Bacon, but philosophical and literary sources provided more significant stimuli, especially the bleak visions of Friedrich Nietzsche and T.S. Eliot. Like many of the generation that lived through the rise of Fascism and World War II, Bacon came to believe that life is meaningless, that each person must confront that void of meaning in order to wrest any significance out of existence. In his powerful, nihilistic works, tortured and deformed figures become players in dark dramas for which there appear to be no solutions.

Bacon has often referred in his work to the history of art, interpreting borrowed images through his own tormented vision. *Head Surrounded by Sides of Beef* is part of a series Bacon devoted to Diego Velázquez's *Portrait of Pope Innocent X* (Galleria Doria-Pamphili, Rome). The Spanish Baroque artist's elegant portrayal has been transformed into a nightmarish image, in which the blurred figure of the pope, seen as if through a veil, seems trapped in a glass-box torture chamber, his mouth open as if in a scream. Instead of the noble drapery that frames Velázquez's pope, two sides of beef frame Bacon's figure, in a quotation from the work of Rembrandt van Rijn (see p. 30) and the Russian twentieth-century artist Chaim Soutine, both of whom painted haunting and brutal images of raw meat. Bacon avoided explaining the meaning of this and other compositions in the series. The painting's masterful execution and monumental concept add to its profoundly disturbing effect.

Pablo Picasso

Spanish, 1881 - 1973
Nude under a Pine Tree, 1959.
Oil on canvas.
76 x 109 in. /193 x 276.9 cm.
Bequest of Grant J. Pick, 1965.687.

Pablo Picasso was in his late seventies when he painted *Nude under a Pine Tree*. He had just purchased the historic chateau of Vauvenargues near Aix-en-Provence, situated on the north slope of Mont Sainte-Victoire. The surrounding Provençal countryside is rocky, arid land dotted with pine trees, a distinct contrast from the lush, almost tropical, settings of his resid-ences on the French Riviera. For Picasso, the 1950s seem to have been a period of re-examination, both personal and artistic. Even though he was to live into his nineties, his own mortality must have been on his mind, for in these years such colleagues as André Derain and Henri Matisse (see pp. 124, 128, 129) and his first wife, Olga, had died.

Picasso's prodigious energy continued, almost in defiance of age, and he produced an extraordinary body of work. In *Nude under a Pine Tree*, Picasso returned to a favorite motif, the reclining female figure. The scale of the canvas itself, over six by nine feet, accommo-dates a large nude who lies on her side, her body rendered in a playful and bold Cubist distortion. The slate-colored ground, lone, scrappy pine tree, and rolling mountains reflect the landscape around Vauvenargues. The mon-umental painting is a synthesis of earlier periods in Picasso's art: the coloring of the Rose Period, the volumes of the Classical Period, and the inventiveness of the 1930s and '40s. For a time, *Nude under a Pine Tree* hung in a place of honor behind the desk of Picasso's dealer Daniel-Henry Kahnweiler (see p. 115) in his Paris gal-lery before it was acquired in 1965 by the Art Institute.

Stuart Davis

American, 1894 - 1964

Ready-to-Wear, 1955.

Oil on canvas.

56⅛ x 42 in. /142.6 x 106.7 cm.

Mr. and Mrs. Sigmund W. Kundstadter;

Goodman Fund, 1956.137.

Stuart Davis was acquainted from an early age with such friends of his parents as John Sloan and Robert Henri. Both were leaders of the Ash Can School, a group of artists committed to depicting all aspects of modern urban life, including the most seamy. Davis studied at Henri's New York school, but he eventually came to disagree with his teacher's beliefs in the pre-eminence of subject matter over composition and form, and instead created a style in which he generalized and abstracted his shapes and the spaces between them.

Nonetheless, Davis's art is never totally abstract. Twentieth-century American life is reflected in the shapes and colors he chose and in the sheer vitality of his compositions. His style — big, bright, bold, and clear — is completely appropriate to his subject matter. Forms have been reduced to large colored planes; words or numbers are simplified and offered as elements of design. In *Ready-to-Wear*, the bright, unmixed colors recall those of French artist Fernand Léger (see p. 126). The way in which they intersect and interrupt one another, however, conveys a mood that is distinctly American — energetic, jazzy, mass-produced, all qualities summed up by the title. The planes, reminiscent of overlapping, pasted-down paper cutouts, even suggest the garment patterns from which ready-to-wear clothes are assembled.

Jean Dubuffet

French, 1901 - 1985
Genuflection of the Bishop, 1963.
Oil on canvas.
85¾ x 117½ in. /217.8 x 298.5 cm.
Joseph Winterbotham Collection, 1964.1087.

The formal density, animistic vision, and implied humor of Jean Dubuffet's early works (see p. 145) continued in his later paintings and sculptures. *Genuflection of the Bishop* is an early example of Dubuffet's *Hourloupe* series, a coined word sometimes identified as an imaginary character, but most often referring to an alternative, encompassing universe created by the artist. This cycle came into being in the 1960s as the result of the artist's doodles with ball-point pens and felt-tip markers producing free-form images outlined in black and filled in with lines and shading. These irregular shapes seem to constrict as they expand, and are at once familiar and exotic, organic and mechanistic.

In this painting, the artist's delight in his new vocabulary can be seen in the jigsaw profusion of disembodied forms, striped patterns, and bright colors. The image is a visual metaphor for the artist's concept of mental space, which, he said, "does not resemble three-dimensional space and has no use for notions such as above or below, in front of or behind, close or distant. Mental space presents itself as flowing, whirling, meandering water and therefore its transcription requires entirely different devices from those deemed appropriate for the perceived world." The picture's complex puzzle of interlocking, jostling shapes contains five figures, one of which is the genuflecting bishop referred to in the title. During the remainder of his career, Dubuffet extended the *Hourloupe* series beyond painting into sculpture, drawing, and animated events, creating a world that both rejects and reflects upon our own.

Mark Rothko
American, born Russia, 1903 - 1970
Purple, White, and Red, 1953.
Oil on canvas.
77¾ x 81¾ in. /197.5 x 207.6 cm.
Bequest of Sigmund E. Edelstone, 1983.509.

Like some other New York artists in the 1940s and '50s, Mark Rothko became deeply interested in ancient myths and various religious practices. His work was initially filled with figurative content influenced by Surrealism, but toward the end of the 1940s he had begun to dematerialize his canvases into the veils of shimmering color for which he was to become so well-known. By directly staining the fabric of the canvas with many thin washes of pigment and by paying particular attention to the edges where the fields of color interact, he achieved the effect of light radiating from the painting itself. This technique suited Rothko's metaphysical aim: to offer painting as a doorway into purely spiritual realms and to make it as immaterial and evocative as music.

Purple, White, and Red follows the characteristic format of Rothko's mature works in which three stacked rectangles of color seem to float within the boundaries of the canvas. Although Rothko limited his palette, he did not use color in any overt symbolic way. He meant to draw the viewer into a state where a multitude of associations and meanings can flourish. For many, the planes of color might suggest luminous mists hovering over a landscape; for others, the muted, mysterious atmosphere could lead to a state of spiritual reflection. The painting's large scale, sensuous color, and sense of limitless inward and outward spatial expansion suggested by the floating rectangles immerse the viewer in an all-encompassing visual experience.

Morris Louis

American, 1912 - 1962

Earth, 1958.

Acrylic on canvas.

92¹⁄₁₆ x 138¹³⁄₁₆ in. /233.8 x 352.6 cm.

Grant J. Pick Fund, 1969.246.

Aside from four years he spent in New York City, Morris Louis chose to live and work in and around Washington, D. C., relatively isolated from developments abounding in the New York art world. Louis worked in series, developing several pictorial types. Each type has a distinct and characteristic structure: the Veils (begun in 1954, resumed in 1957 - 59), the Florals (1959 - 60), the Unfurleds (1960 - 61), and the Stripes (1961 - 62). Despite the variations in the shapes, the "subject" of these canvases is the complete fusion of foreground and background, of hue and texture: color is both the vehicle and the content. Louis's saturated stripes and misty veils of color were achieved by a careful process of staining sheets of raw canvas, hung from vertical scaffolding, with thin washes of plastic-based paints. The artist allowed the paint to move over the canvas, guiding its flow by the curves in the loose canvas and with a cloth-covered stick.

Epic in size, *Earth* is one of a series of Bronze Veils, paintings Louis did in 1958, inverting them after they were completed so that the flow appears to go from bottom to top. A rich, bronze shape thrusts up from the bottom of the canvas, its forceful growth held in check only by a gracefully dripped, deeper hue which tops the main form like icing on a cake. His palette of deep greens and golds creates a mood of glowing, yet sedate, monumentality.

Hans Hofmann

German, 1880-1966

The Golden Wall, 1961.

Oil on canvas.

59½ x 71⅞ in. /151.1 x 182.6 cm.

Mr. and Mrs. Frank G. Logan Prize Fund,

1962.775.

The German-born painter Hans Hofmann was as much revered for his gifts as a teacher as for his brilliantly colored, richly painted canvases. In Munich during World War I, he operated his own art school. He came to the United States in 1930 to teach in California; in 1932, he settled in New York, where he opened another art school. Hofmann subsequently founded a summer program in Provincetown, Massachusetts, in 1934. Truly creative expression, Hofmann believed, emerges from the translation of subjective states into "pure" form. His teaching influenced a generation of American abstract painters.

The chief distinguishing characteristic of Hofmann's art is the richness of his painted surfaces. His work became increasingly abstract over his career, culminating in paintings that combine flat, floating rectangles with expressionistic brushwork. *The Golden Wall*, for example, unites various brightly hued rectangles against a ground that is primarily orange, red, and yellow. The rectangles emphasize the two-dimensionality or wall-like aspect of the canvas; the tangle of brushstrokes demonstrates the illusionistic, space-creating capabilities of painting. The true subject of *The Golden Wall* is the sensuousness of paint itself—thick or thin, opaque or scumbled, but always left in its purest, most color-saturated state.

Roy Lichtenstein

American, born 1923

Brushstroke with Spatter, 1966.

Oil on magna on canvas.

68 x 80 in. /172.7 x 203.2 cm.

Barbara Neff Smith and Solomon Byron Smith

Purchase Fund, 1966.3.

The irreverent style called Pop Art elevated commonplace, even vulgar, aspects of modern industrial society to the status of "high art," and interpreted them with wit, detachment, and objectivity (see also p. 161). One of the early leaders of the movement, which reached its zenith in the 1960s, Roy Lichtenstein has forged from the humble cartoon a powerful, graphic manner. Lichtenstein's paintings of comic-strip scenes on themes of love and war and his series on great works of art — from Greek temples to the art of Picasso — all express his fascination with the mass reproduction of images.

In *Brushstroke with Spatter* he parodied Abstract Expressionism, the movement with which he began his career. The individual brushstroke and accidental splatters of paint, honored by those artists as charged, like handwriting, with individual expression and content, are presented here as if they were magnified details from a commercial photographic reproduction of an Abstract Expressionist painting. By using a background of enlarged Ben Day dots (invented to add tone to a printed image) and outlining the smoothly rendered brushstrokes and splatters in black, the artist removed any record of his own hand from this work. Lichtenstein thereby withdrew any reference to his art as an expression of himself and called into question such issues as the meaning of the creative process, of reproduction, of the work of art itself.

David Hockney

British, born 1937
American Collectors, 1968.
Acrylic on canvas.
83⅞ x 120 in. /213 x 305 cm.
Restricted gift of Mr. and Mrs. Frederic G.
Pick, 1984.182.

As a painter, printmaker, set designer, and photographer, David Hockney is one of the most versatile and inventive artists of the postwar era. He was born and trained in art in England, and lived in London, Paris, and New York before settling in Los Angeles in 1964. For the last quarter century, his canvases have reflected the sun-washed flatness and bright colors of the southern California landscape.

In the late 1960s, Hockney painted a number of double portraits of friends and associates, including *American Collectors*. This not entirely flattering portrait depicts Los Angeles collectors Fred and Marcia Weisman, who amassed a significant collection of contemporary art. Standing straight and still in a stagelike pictorial space, the two figures and the objects around them are struck by a brilliant, raking light that flattens and abstracts them. While their placement in the composition seems stilted and arbitrary, it is actually quite revealing. The collectors are situated on a terrazzo deck on which some of their art collection is displayed.

Mr. Weisman's shadow falls possessively over an abstract stone work; the manner in which Mrs. Weisman holds her arms is similar to the sculpture between them on a pedestal, and the expression on her face is mirrored by the totem pole in the background. By depicting the Weismans almost as if they were sculptures themselves, Hockney asks us to consider the relationship not only between these two individuals, but also between the couple and the art with which they chose to surround themselves.

Richard Estes

American, born 1936
Drugstore, 1970.
Oil on canvas.
62⅜ x 46⅜ in. /158.4 x 117.8 cm.
Gift of Edgar Kaufmann, Jr.; Twentieth-
Century Purchase Fund, 1970.1100.

The Photo-Realist movement began in the late
1960s and was based on the use of photographs
in creating sharply focused, painted versions of
urban scenes. Photo-Realist works customarily
incorporate mirrors, glass storefronts, or other
reflective surfaces, thus presenting further illu-
sionistic complexities within a spatial setting
already filled with visual incident.

Richard Estes is the acknowledged leader
of the Photo-Realists. Unlike a number of other
painters who project a photograph directly onto
the canvas and then trace the image, Estes
draws from his photographs without any
mechanical assistance. Although his paintings
appear to be exacting, objective replications of
existing sites, they are, in fact, the artist's care-
fully edited interpretations of these views.
Sometimes he combines scenes, dramatically
condensing the space. In *Drugstore*, urban litter
has mysteriously vanished, and what remains is
a pristine, rigidly controlled, almost sterile
world. Human figures are altogether absent.
Instead, the artist has painted a portrait of a
corner drugstore, which he has idealized in its
central, frontal placement and made timeless
by the lack of distracting trivia.

Georg Baselitz

German, born 1938
Woodman, 1969.
Oil on canvas.
98½ x 78¾ in./250 x 200 cm.
Restricted gift of Mrs. Frederic G. Pick;
Walter Aitken Fund, 1987.14.

Born in 1938 in what is now East Germany, Georg Baselitz changed his name to that of the town of his birth, Deutschbaselitz, at age eighteen, when he began to study art in East Berlin. An active student with anarchist leanings, especially in his views on the social value of art, Baselitz was expelled from school; in the late 1950s and early '60s, he continued his studies in West Berlin. While the prevailing international style during this period was Abstract Expressionism, Baselitz, like his compatriot Anselm Kiefer (see p. 165), has insisted on turning to Germany's artistic heritage for his subjects and stylistic models.

A relatively early painting, *Woodman* is one of many works Baselitz executed in the 1960s of rustic figures such as shepherds and wanderers. A figure in green overalls hangs sideways before a tree, his body torn apart above the waist. Other details, such as the shoe prints on the ground, the absence of feet on the figure, and the figure's animallike ears, add to the disturbing and mysterious quality of the work. This composition was completed just before the artist began to turn his images upside down, making even more emphatic the sense of physical and artistic dislocation expressed in *Woodman*. The painting's implied, and unexplained, violence is also evoked by Baselitz's gestural, almost muscular, paint application and strong colors. Painted not long after he had left the divided city of Berlin to reside in a small village, *Woodman* may reflect Baselitz's torment at the division of that city and of Germany itself.

Andy Warhol

American, 1930-1987
Mao, 1973.
Acrylic and silkscreen on canvas.
176½ x 136½ in. /448.3 x 346.7 cm.
Mr. and Mrs. Frank G. Logan Prize, Wilson L.
Mead funds, 1974.230.

Originally a British movement of the late 1950s, Pop Art utilized images from popular or consumer culture, but interpreted them with strong doses of black humor, irony, and criticism. In its American manifestation, however, Pop Art came to celebrate the everyday visual environment by selecting such subjects as comic strips, advertisements, consumer products, and movie-star portraits (see p. 157). One of the leaders of American Pop Art was Andy Warhol, whose constant presence on the social scene and eccentric personality made him a virtual star, as well known as the celebrities he painted.

For Warhol, the direct application of pigment with brush to canvas was outmoded and limiting. Early in his career, he hit upon the technique of rendering his imagery photographically and transferring it to a canvas via the silkscreen process. This allowed him to "mass-produce" his images in a workshop called The Factory. *Mao* is one of a series of portraits of the Chinese Communist leader Mao Zedong that Warhol painted in 1973. The monumental size of the canvas is suited to its subject, a larger-than-life political figure whose image was displayed throughout China in this familiar pose and often on a gigantic scale. Warhol appropriated an image whose familiarity directs the viewer to examine the painting itself rather than the subject. Painted and silk-screened areas are played off against one another: the red applied to Mao's cheeks and lips and the blue applied to his eyelids are, despite their incongruous resemblance to cosmetics, powerful painterly statements.

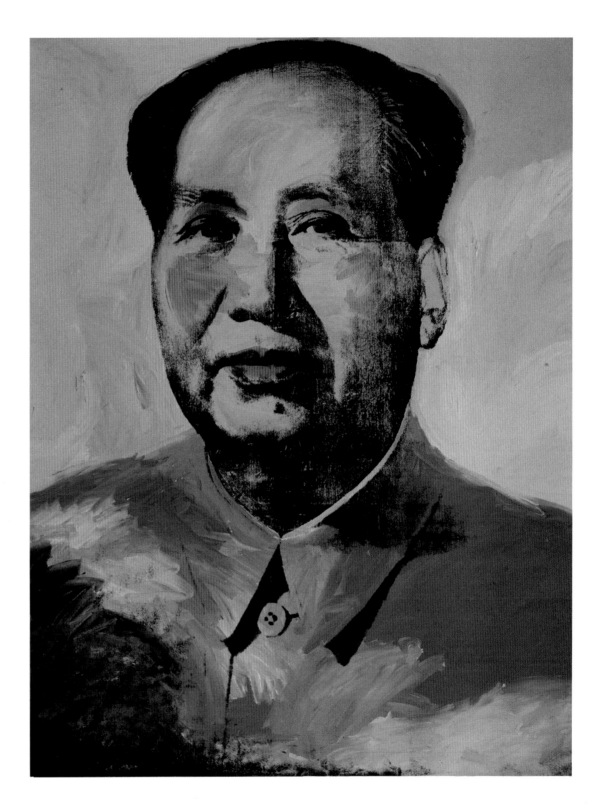

Philip Guston
American, 1913 - 1980
Green Sea, 1976.
Oil on canvas.
46³⁄₈ x 116¹⁄₈ in. / 117.8 x 295.9 cm.
Restricted gift of Mrs. Frederic G. Pick;
Charles H. and Mary F. S. Worcester, Grant J.
Pick, Twentieth-Century Discretionary funds;
anonymous gift, 1985.1118.

Philip Guston, acclaimed as the creator of luminous, delicately worked canvases in an Abstract Expressionist style, shocked his followers in the late 1960s by abandoning abstraction and introducing broadly rendered, cartoonish figures and objects into his painting. Guston created an unusual repertory of images that includes spindly, repulsive pink legs; odd, broadly worked shoes; the stylized face of his wife; the hoods of Ku Klux Klansmen; and the artist's self-portrait, a stubbly, one-eyed head often confronting an empty bottle, in reference to the artist's alcoholism.

Green Sea is one of a series of paintings Guston did in 1976 featuring a tangle of disembodied legs, bent at the knees and wearing flat, ungainly shoes, grouped on the horizon of a deep green sea against a salmon-colored backdrop. While this particular image, repeated in increasingly abstract terms in subsequent paintings, recalls the bunched brushstrokes that were so characteristic of Guston's abstract works, its meaning eludes us. The knobby knees seem to suggest, in their knotted huddle, an adolescent awkwardness and insecurity. Perhaps a metaphor for an abstract artist's struggle, late in life, to come to terms with figurative painting, this mysterious, personal composition has considerable poignancy.

Frank Stella

American, born 1936
Gobba, zoppa e collotorto, 1985.
Oil, urethane enamel, fluorescent alkyd,
acrylic, and printing ink on etched magnesium
and aluminum.
137 x 120⅛ x 34⅜ in. /348 x 305.1 x 87.3 cm.
Mr. and Mrs. Frank G. Logan Prize, Ada
Turnbull Hertle funds, 1986.93.

Frank Stella's success came at an extremely
young age. His 1970 retrospective at the
Museum of Modern Art, New York, when he
was thirty-three, was an unprecedented event
and was a testament to the importance of his
art. After this exhibition, Stella chose to move
away from his Minimalist style — one of severe
geometry, formal purity, and intellectual
rigor — for which he had become famous. In
hindsight, Stella's choice of a more exuberant,
three-dimensional approach seems prophetic of
the renewed interest in the 1980s in the expres-
sive properties (as opposed to theoretical possi-
bilities) of art and has assured him a position
of continuing vitality and importance.

Stella has always worked in well-defined
series. Between 1984 and 1987, he returned to
the geometric forms of his early career in his
Cones and Pillars series, in which he juxtaposed
these monumental forms with the curving,
irregular shapes so characteristic of his work
of the 1970s and '80s. Constructed of various
elements of etched magnesium and aluminum
that thrust out from an expressionistically
painted "backdrop" panel, *Gobba, zoppa e collo-
torto,* like all of Stella's relief works, is meant
to be viewed primarily as a painting. A rich
complex of planes, colors, and textures defines
the composition in a painterly, rather than
sculptural, way. The title, from a chapter head-
ing in Italian writer Italo Calvino's *Italian Folk-
tales,* was chosen by Stella after completion of
the work and bears no direct relationship to it.

Leon Golub

American, born 1922

Interrogation II, 1981.

Acrylic on canvas.

120 x 168 in. /304.8 x 426.7 cm.

Gift of the Society for Contemporary Art,

1983.264.

Leon Golub's often harrowing paintings are the expression of his commitment to the possibility that art can effect social and political change. In the 1960s and early 1970s, Golub's political activism and his pursuit of a painterly, figurative style ran counter to the prevailing Pop Art and Minimalist styles. It was not until the 1980s,

with the renewed interest in figuration, that Golub's monumental canvases finally received critical and popular attention.

One of three depictions of brutal torture sessions that Golub painted in 1981, *Interrogation II* shows four mercenaries and their naked, hooded victim, who is bound to a chair. A black torture rack provides the only interruption to the intense red-oxide color field that creates a symbolically bloody backdrop for such heinous activity. The rawness of the action is reinforced by Golub's technique of scraping the applied paint down to the tooth of the canvas. Themes of atrocities are not uncommon in the history of art. Yet, how different *Interrogation II* is, for example, from Edouard Manet's *Mocking of*

Christ (p. 52), where Christ's torturers seem distracted from their awful duty by the simple humanity of Jesus. Golub's perpetrators, on the other hand, seem ruthless and determined. An image of cruel intensity, the Art Institute's composition is made even more disturbing by the torturers' grinning faces and the direct eye contact they make with the viewer, drawing one into uncomfortable complicity with their terrible acts.

Anselm Kiefer

German, born 1945
The Order of the Angels, 1983/84.
Oil, emulsion, shellac, straw, and lead
on canvas.
129⅞ x 218½ in. /330 x 555 cm.
Samuel A. Marx Fund; restricted gift of
Nathan Manilow Foundation, Lewis and
Susan Manilow, 1985.243.

One of the most important artists to emerge in the 1980s, Anselm Kiefer is known for his spectacular, large-scale paintings laden with expressive power and complex meanings. Born in Germany at the end of World War II, he has concerned himself with themes of nationalism and imperialism, destruction and resurrection, mythology and the occult. Using a wealth of literary, historic, and symbolic references, he insists that art play a crucial role in transmitting and clarifying the historical record and in making liberation and redemption possible.

To carry the weight of his message, Kiefer has evolved a truly original technique, loading his work with such materials as straw, lead, pieces of clay, photographs, and blistering the surfaces with heat. In *The Order of the Angels,* he has created a vista whose deep perspective is reinforced by the furrows of earth that fan out across the canvas. In this work, based on writings attributed to Saint Dionysius the Ar-eopagite on the hierarchy of angels, Kiefer has represented the nine categories of angels by numerals associated with huge boulders, which are connected by lead strips to names written on the distant horizon. The presence of the large snake at the center of the painting is explained by Kiefer as a reference to a tradition that identifies snakes, like angels, as existing between man and God. While this landscape could be a stretch of German farmland, devastated and scorched by war, its magisterial breadth and depth and the infusion of symbols — snakes, numbers, rocks, words — transform it into a mythical, primeval realm.

Index of Artists

Albright, Ivan
Into the World There Came a Soul Called Ida (The Lord in His Heaven and I in My Room Below), 135

Bacon, Francis
Head Surrounded by Sides of Beef, 150

Balthus (Balthasar Klossowski de Rola)
Patience, 144

Baselitz, Georg
Woodman, 160

Beckmann, Max
Self-Portrait, 141

Blume, Peter
The Rock, 147

Bonnard, Pierre
Earthly Paradise, 111

Boucher, François
Are They Thinking About the Grape?, 41

Bouts, Dieric
Mater Dolorosa, 18

Bradford, William
The Coast of Labrador, 86

Braque, Georges
Harbor in Normandy, 113
Landscape at La Ciotat, 112

Caillebotte, Gustave
Paris, a Rainy Day, 58

Cassatt, Mary
The Bath, 99

Cézanne, Paul
Basket of Apples, 69
Madame Cézanne in a Yellow Armchair, 68

Chagall, Marc
The Praying Jew (Rabbi of Vitebsk), 130

Chase, William Merritt
The Park, 94

Chirico, Giorgio de
The Philosopher's Conquest, 122

Church, Frederic Edwin
Cotopaxi, 83

Cole, Thomas
Niagara Falls, 82

Constable, John
Stoke-by-Nayland, 50

Copley, John Singleton
Mrs. Daniel Hubbard, 76

Corot, Jean Baptiste Camille
Interrupted Reading, 51

Correggio (Antonio Allegri)
Virgin and Child with Saint John the Baptist, 20

Cotán, Juan Sánchez
Still Life, 25

Courbet, Gustave
Mère Grégoire, 53

Davis, Stuart
Ready-to-Wear, 152

Degas, Hilaire Germaine Edgar
The Millinery Shop, 60
Uncle and Niece (Henri de Gas and His Niece Lucie de Gas), 57

Delacroix, Eugène
Combat between the Giaour and Hassan in a Ravine, 49

Delaunay, Robert
Champs de Mars, the Red Tower, 116

de Kooning, Willem
Excavation, 148

Demuth, Charles
And the Home of the Brave, 137

Dove, Arthur
Silver Sun, 132

Dubuffet, Jean
Genuflection of the Bishop, 153
Supervielle Grand Portrait Bannière, 145

Eakins, Thomas
Mary Adeline Williams, 104

El Greco (Domenico Theotocopuli)
The Assumption of the Virgin, 23

Estes, Richard
Drugstore, 159

Fragonard, Jean Honoré
Portrait of a Man, 42

French (Picardy)
The Last Supper, 17
Madonna and Child, 16

Gauguin, Paul
Ancestors of Tehamana, 71
Old Women of Arles, 67

Giovanni di Paolo
The Beheading of Saint John the Baptist, 15
Saint John the Baptist in the Wilderness, 14

Girodet de Roucy-Trioson, Anne Louis
Portrait of the Katchef Dahouth, Christian Mameluke, 44

Glackens, William
Chez Mouquin, 107

Gogh, Vincent van
Bedroom at Arles, 66
Self-Portrait, 63

Golub, Leon
Interrogation II, 164

Gorky, Arshile
The Plow and the Song II, 146

Goya y Lucientes, Francisco José de
Monk Pedro de Zaldivia Shoots the Bandit Maragato, 45

Gris, Juan
Portrait of Picasso, 117

Guercino (Giovanni Francesco Barbieri)
The Entombment of Christ, 35

Guston, Philip
Green Sea, 162

Harnett, William Michael
For Sunday's Dinner, 96

Hartley, Marsden
Movements, 120

Hassam, Frederick Childe
The Little Pond, Appledore, 95

Heade, Martin Johnson
Magnolias, 92

Hemessen, Jan Sanders van
Judith, 21

Hey, Jean (The Master of Moulins)
The Annunciation, 19

Hobbema, Meindert
Wooded Landscape with a Water Mill, 36

Hockney, David
American Collectors, 158

Hodler, Ferdinand
James Vibert, Sculptor, 110

Hofmann, Hans
The Golden Wall, 156

Homer, Winslow
Croquet Scene, 84
The Herring Net, 89
Mount Washington, 88

Hopper, Edward
Nighthawks, 142

Ingres, Jean Auguste Dominique
Amédée-David, Marquis of Pastoret, 48

Inness, George
Early Morning, Tarpon Springs, 100

Kandinsky, Wassily
Improvisation with Green Center (No. 176), 119

Kensett, John Frederick
Coast at Newport, 87

Kiefer, Anselm
The Order of Angels, 165

Klee, Paul
Sunset, 138

Kupka, Frantisek
Reminiscence of a Cathedral, 121

La Farge, John
Snow Field, Morning, Roxbury, 85

La Hyre, Laurent de
Panthea, Cyrus, and Araspus, 32

Largillière, Nicolas de
Self-Portrait, 38

Lawrence, Thomas
Mrs. Jens Wolff, 47

Léger, Fernand
Follow the Arrow (study for *The Level Crossing*), 126

Lichtenstein, Roy
Brushstroke with Spatter, 157

Louis, Morris
Earth, 155

Magritte, René
Time Transfixed, 140

Manet, Edouard
The Mocking of Christ, 52
The Reader, 62

Manfredi, Bartolomeo
Cupid Chastised, 26

Martorell, Bernardo
Saint George Killing the Dragon, 13

Matisse, Henri
Bathers by a River, 124
Interior at Nice, 128
Woman Before an Aquarium, 129

Miro, Joan
Personages with Star, 139
Portrait of a Woman (Juanita Obrador), 125

Modigliani, Amedeo
Jacques and Berthe Lipchitz, 123

Mondrian, Piet
Diagonal Composition, 127

Monet, Claude
The Arrival of the Normandy Train at the Gare Saint-Lazare, 59
Japanese Bridge at Giverny, 72
On the Seine at Bennecourt, 54

Moroni, Giovanni Battista
Gian Lodovico Madruzzo, 22

Mount, William Sydney
Walking the Line, 81

O'Keeffe, Georgia
Black Cross, New Mexico, 133

Orozco, José Clemente
Zapata, 134

Ostade, Adriaen van
Merrymakers in an Inn, 37

Penniman, John Ritto
Meeting House Hill, Roxbury, Massachusetts, 78

Phillips, Ammi
Cornelius Allerton, 79

Piazzetta, Giovanni Battista
Pastoral Scene, 39

Picabia, Francis
Edtaonisl (Ecclésiastique), 118

Picasso, Pablo
Daniel-Henry Kahnweiler, 115
Girl with Pitcher, 114
Mother and Child, 131
Nude under a Pine Tree, 151
The Old Guitarist, 108

Pissarro, Camille
The Crystal Palace, 55

Pollock, Jackson
Grayed Rainbow, 149

Poussin, Nicolas
Landscape with Saint John on Patmos, 33

Quidor, John
Rip Van Winkle, 80

Rembrandt Harmensz. van Rijn
Old Man with a Gold Chain, 30

Remington, Frederic
The Advance Guard, or The Military Sacrifice, 97

Reni, Guido
Salome with the Head of Saint John the Baptist, 34

Renoir, Pierre Auguste
Two Little Circus Girls, 61
Woman at the Piano, 56

Reynolds, Joshua
Lady Sarah Bunbury Sacrificing to the Graces, 43

Rothko, Mark
Purple, White, and Red, 154

Rubens, Peter Paul
The Holy Family with Saints Elizabeth and John the Baptist, 28
The Wedding of Peleus and Thetis, 29

Sargent, John Singer
Venetian Glass Workers, 91

Seurat, Georges
Sunday Afternoon on the Island of La Grande Jatte, 64

Sheeler, Charles
The Artist Looks at Nature, 143

Smibert, John
Richard Bill, 75

Snyders, Frans
Still Life with Dead Game, Fruits, and Vegetables in a Market, 31

Stella, Frank
Gobba, zoppa e collotorto, 163

Stuart, Gilbert
Major-General Henry Dearborn, 77

Tanner, Henry Ossawa
The Two Disciples at the Tomb, 109

Tiepolo, Giovanni Battista
Rinaldo Enchanted by Armida, 40

Toulouse Lautrec, Henri de
At the Moulin Rouge, 70
In the Circus Fernando: The Ringmaster, 65

Turner, Joseph Mallord William
Dutch Fishing Boats, 46

Twatchman, John Henry
Icebound, 98

Vedder, Elihu
Fates Gathering in the Stars, 93

Vonnoh, Robert William
Spring in France, 101

Warhol, Andy
Mao, 161

Whistler, James Abbott McNeill
An Arrangement in Flesh Color and Brown (Arthur Jerome Eddy), 103
Nocturne in Grey and Gold, 90
Violet and Silver—The Deep Sea, 102

Wood, Grant
American Gothic, 136

Wtewael, Joachim Antonisz
The Battle between the Gods and the Titans, 24

Zurburán, Francisco de
The Crucifixion, 27